ALL ABOUT
techniques in
PASTEL

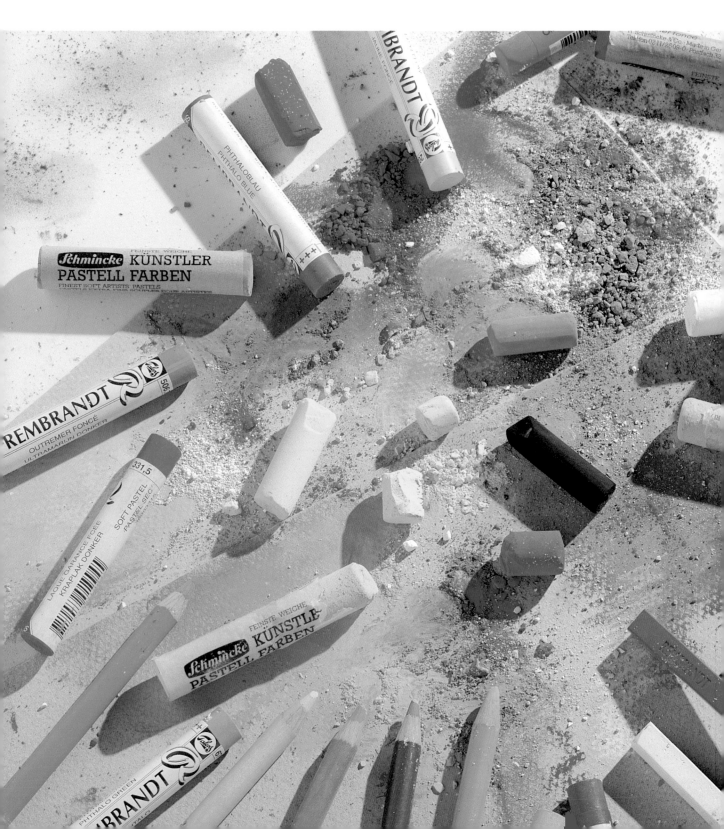

ALL ABOUT

techniques in

PASTEL

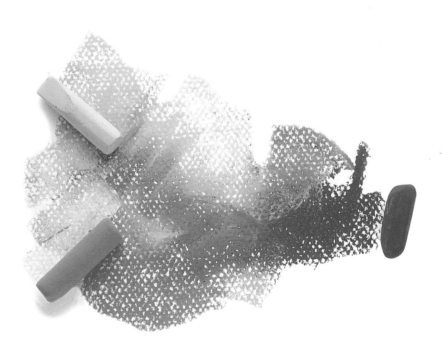

BARRON'S

Contents

Preface

The development of pastel in the history of art parallels the development of drawing as an independent technique separate from painting. The word "pastel" is derived from the word paste, the mass formed when powdered pigment is mixed with a gum to bind it together.

Pastel was first used as a dry medium to add quick touches of color to portrait and figure drawings in order to increase their sense of depth and make them more realistic. In the eighteenth century it was already one of the most commonly used techniques and had ceased to be subordinate to drawing; in fact, it had become a major painting medium in its own right. Since then, pastel has been used in every genre and style.

This book will show you all the "tricks" of working in pastel and provide detailed explanations of the medium's creative and expressive potential. We describe the basic materials and equipment available in stores and how to use pastel to render a wide range of objects, textures, and characteristics. We also offer an overview of the infinite possibilities of pastel in painting.

The practical chapters of this book present information through images accompanied by text, so that you can quickly and easily understand materials, techniques, methods for problem solving, and use of color and light in various subjects.

This unique manual is designed for fine arts teachers, students, beginners, and professionals who wish to broaden their knowledge of this medium and explore its full potential.

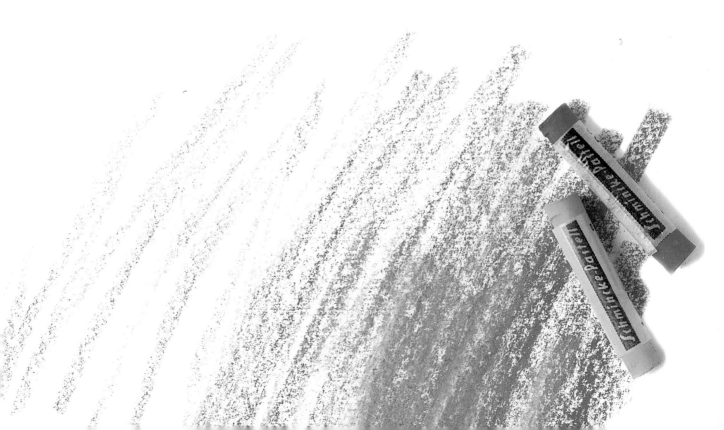

Pastel

Many artists are attracted to pastel as a painting medium, both for its intense, luminous colors (the result of the high proportion of pigment to binder in the sticks), as well as for the simplicity of its application. Unlike watercolor and oil, there is no need for palettes, brushes, or solvents, and because it is a dry medium, there is no need to wait between layers. Pastel is also extremely versatile; it can be used for painting thin or thick lines, layering, applying glazes, and also for impasto.

COMPOSITION

Pastel paint is composed of pigment, plaster, and gum. These ingredients are mixed into a paste that is then molded into sticks and dried. The quality and the type of pastel depend on the proportions of its components; good quality pastels, which contain no plaster, are virtually pure pigment. That is why the colors of pastel are so intense and bright.

CHARACTERISTICS

The most important quality of pastel is its immediacy. Since it is a dry technique, there are no lengthy preparations before you begin to paint or long waits for it to dry between layers. Pastel is applied directly to the surface without using palettes, brushes, or solvents.

Because pastels are difficult to mix, manufacturers offer ranges of up to 500 colors to make mixing unnecessary. Once applied, most pastel paint is stable—its colors do not change or fade over time. However, pastel pigments that are light-sensitive may fade after years of exposure to direct light.

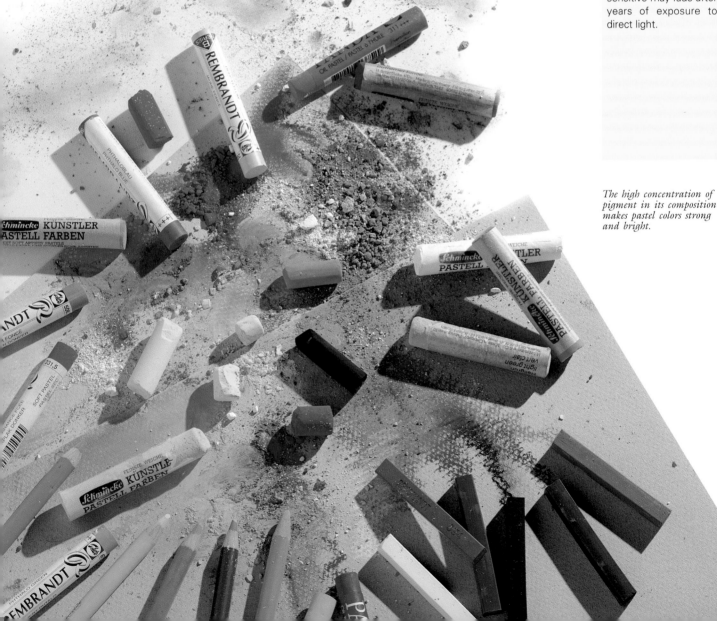

The high concentration of pigment in its composition makes pastel colors strong and bright.

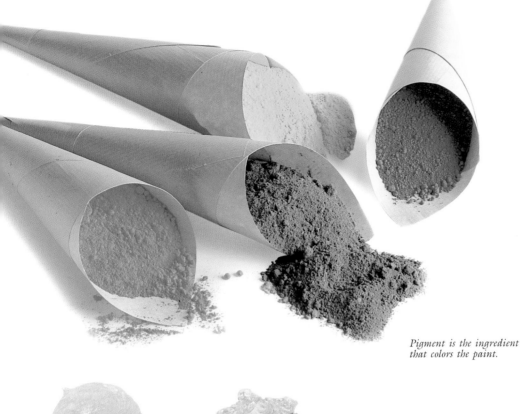

Pigment is the ingredient that colors the paint.

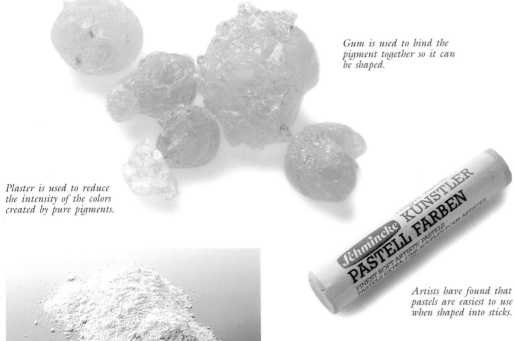

Gum is used to bind the pigment together so it can be shaped.

Plaster is used to reduce the intensity of the colors created by pure pigments.

Artists have found that pastels are easiest to use when shaped into sticks.

PIGMENTS

Pigments are the fine powders of vegetable, mineral, animal, or synthetic origin that color paint. The quality of a pigment depends entirely on its covering power, tinting strength, and permanence. Permanence means that a pigment is light-fast (won't change its color after exposure to direct light) and stable (won't break down or change in time). This is important because any alteration of color will affect a work's overall appearance.

BINDER

The binders for pastel paints include gum arabic (which is also used for watercolors) and gum tragacanth. In pastels, however, the amount of gum is very small; only enough is used to mold the paste into durable sticks.

Hard pastel sticks contain a greater proportion of gum than soft ones.

FILLERS

Fillers are included in paints to give them more volume and to affect their texture or color; for instance, plaster is often used to make pastels. While professional quality pastels contain very little plaster, those intended for students may have a larger proportion. The tinting strength of a pastel and the intensity of its color are directly related to the amount of filler used—the more filler and the less pigment it contains, the weaker the resulting color.

QUALITIES

The quality of a pastel depends on the amount and quality of its component pigment. A pastel composed almost solely of pigment will have the most tinting strength and covering power and the purest and most intense colors. This is especially true if the pigments are of a high quality; the best pigments yield the most luminous colors.

Good-quality soft pastels, which are virtually pure pigment, crumble easily and produce extraordinarily intense colors.

MATERIALS AND EQUIPMENT

TYPES OF PASTEL

There are several kinds of pastel paint, varying in composition, shape, and size. These differences have no bearing on the quality of the product. Each type is used for distinct purposes.

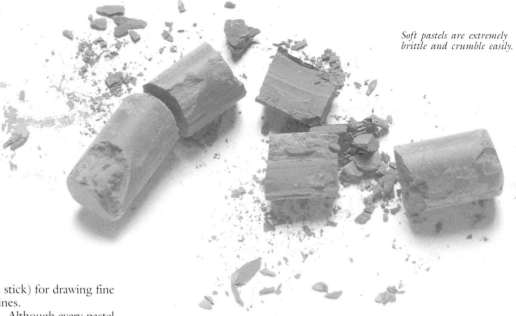

Soft pastels are extremely brittle and crumble easily.

SOFT PASTELS

The traditional soft pastel comes in cylindrical sticks that crumble easily with pressure. Because they contain a high proportion of pigment, soft pastels produce areas of intense color. You can use them with a variety of techniques such as impasto, glazes, and even (using the edge of a stick) for drawing fine lines.

Although every pastel of this type is soft, the degree of softness varies among brands, qualities, and colors. Students' pastels, for instance, are usually harder than artists' pastels; darker values of a given hue are generally harder than lighter ones (which contain more plaster).

Because soft pastels are also the most popular, manufacturers offer wide ranges of colors and assorted sets for painting certain subjects such as portraits, figures, landscapes, or seascapes.

They are sold in half sticks, whole sticks, and thick sticks, all of which can be bought either loose or in boxes.

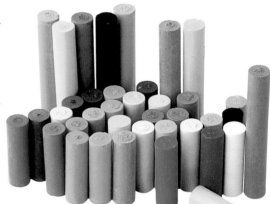

Half sticks allow you to buy twice as many colors for the same price and are also easier to handle because of their length.

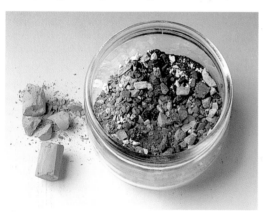

Fragments of pastel left over from sharpening or crumbling can be used to paint backgrounds.

A foam pad protects your soft pastel sticks and keeps your colors in order.

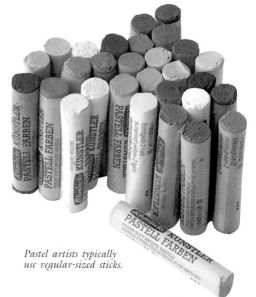

Pastel artists typically use regular-sized sticks.

Thick sticks are good for painting in large formats.

HARD PASTELS

Hard pastels come in square or round sticks. They are hard because the pigment is mixed with a large proportion of binder and because the sticks are lightly baked after being shaped. Hard pastels contain less pigment than soft pastels, which gives them less tinting strength and covering power. Although not suitable for impasto work, their hard, sharpened edges are ideal for work that requires precision.

Hard pastel can be used by itself as a painting medium, or together with soft pastel. Because it does not fill the tooth (or grain) of the paper as much as soft pastel, it is good for preliminary drawings and for adding small details. Hard pastels do not come in the same wide range of colors as soft ones.

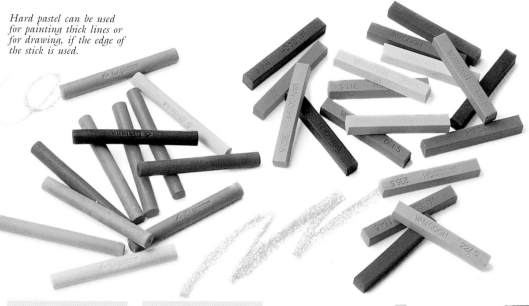

Hard pastel can be used for painting thick lines or for drawing, if the edge of the stick is used.

PASTEL PENCILS

Pastel pencils have a thin, hard pastel core. Their wood covering makes the pastel easy to sharpen and protects the brittle pastel. Pastel pencils are used for drawing, sketching, and for adding small details to pastel paintings.

They can be bought individually or in small or large sets.

CHALK

Chalks are small, hard pastel sticks that come in sets of colors ranging from black to white, or in assortments of red and earth tones such as sepia.

WATERCOLOR PASTELS

Watercolor pastels, which can be diluted in water and applied with a brush, can be used with either dry or wet techniques. They can be bought in stick or pencil form and work well in combination with other kinds of pastels.

OIL PASTELS

Oil pastels produce different effects than regular soft pastel because their pigment is bound with oil instead of gum, giving them a different consistency. Oil pastels adhere much better to the support, although they don't blend as easily as conventional pastels. They can also be diluted in turpentine to create washes or other effects. Their consistency is similar to that of artists' wax crayons.

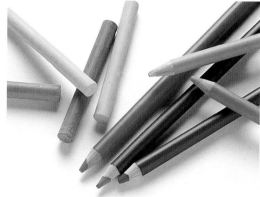

Watercolor pastel can be diluted.

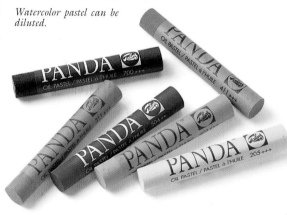

Oil pastels are used differently from regular pastels because their composition is different; they can even be diluted in turpentine.

Chalks are simply hard pastels in limited ranges of colors.

Pastel pencils are good for drawing thin lines, since their protective layer of wood makes them easy to sharpen.

Color Charts

Because pastel paints do not mix easily, manufacturers offer extremely wide ranges of colors and tones. Artists sometimes have sets that contain up to 500 pastels to make sure they have exactly the right tone on hand. In this chapter we will show you a range of colors that can be used as a reference, but there are still many more colors available commercially.

WHAT IS A COLOR CHART?

A color chart is the range of colors and tones that a paint manufacturer has on the market. You can use these charts to choose which colors you need without going to a store to see them. You should keep in mind, however, that the printed color is sometimes slightly different from the color of the actual paint.

By keeping a color chart in the studio, you will find it easy to identify a tone that you may want but don't have. Color charts also include information that indicates each color's lightfastness and the type of pigment each contains.

Color charts are samples of the ranges of colors and tones produced by each manufacturer. Next to each color sample there is information about the type of pigment and its lightfastness.

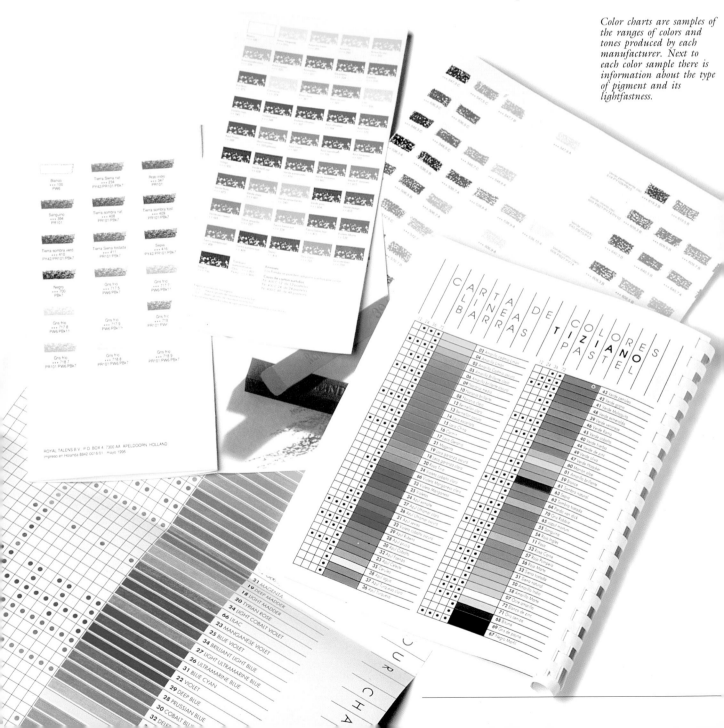

HOW MANY AND WHICH COLORS DO YOU NEED?

When you are trying to figure out how many different colors you should have, keep in mind that "more is better." Pastels are simply not suited to mixing so it's best to have a wide variety of tones and shades on hand.

The important thing to consider when you are choosing colors is which best suit your usual subject matter (special ranges are sold for painting figures, portraits, landscapes, or seascapes). However, the best method for building your set of pastels is to buy a basic set, then acquire the rest as you need them. Before long, you will have a multipurpose palette ready to paint any subject.

Pastel manufacturers produce a wide range of colors because pastels are difficult to mix. A range like the one shown on this page is enough to paint any subject, since additional hues can be made by glazing or mixing.

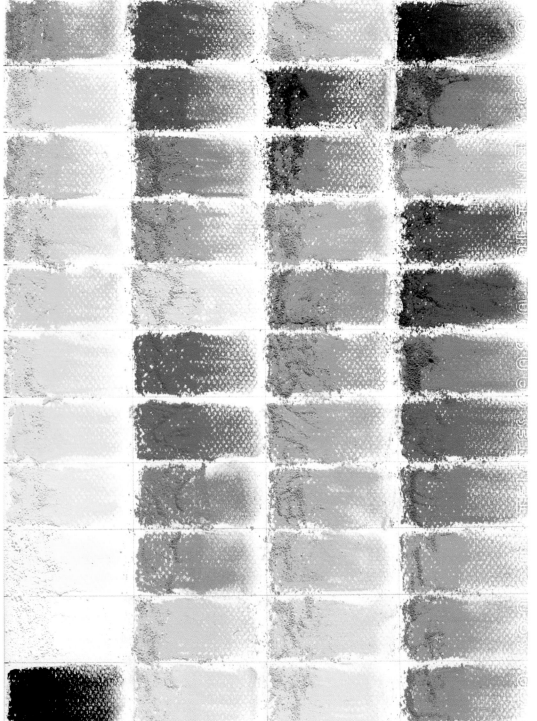

NAMES AND CODES

You should not be tempted to choose your colors by name, since names of pastel colors do not necessarily coincide with those used in other media such as oils or watercolors—they might even be completely different.

Each pastel stick has a label that contains the name of the color and a reference number. You should refer to this number when you want to buy the same color again.

Color charts often use a combination of asterisks and crosses to indicate the colors' stability and lightfastness. Each brand uses its own code, although as a general rule we can say that the more symbols displayed for a color, the more permanent it is.

Paper and Other Supports

Because of the simple composition of pastel paint, it does not adhere to surfaces as well as other media and relies on the tooth, or grain, of the paper to hold the paint and keep it from falling off. Supports for pastels also have to withstand rubbing, blending, and erasing. Paper is the best support for pastel painting but it is not the only one. Any durable surface with an adequate grain can be used for this medium and may even lead to interesting discoveries.

THE BEST CHARACTERISTICS FOR PASTEL

Paper for pastel painting must have a large enough tooth, or grain, to shave the pigment off the stick and hold it; pastel applied to a very fine-grained or smooth paper will leave only a trace of color. Pastel paper should also be sturdy enough to withstand rubbing, blending, and erasing. That is why fine, delicate supports such as silk papers are not useful.

Thick or medium grain paper easily captures the pigment while letting the background color show through.

The surface of smooth papers does not take pigment well.

PAPER

Paper is the most popular support for pastel painting because it is extremely versatile. A wide range of techniques can be used with paper, and it comes in an assortment of thicknesses and colors. Another factor is its low cost.

Paper is best because it is lightweight and convenient to carry, easy to cut or fold to any size, and comes in more thicknesses, weights, textures, and qualities than any other support. Paper ranges from the inexpensive and mass-produced to the expensive and handmade. It also comes in rough, medium, and fine grains, all in a wide range of colors. It should be easy to find one that meets all your artistic needs.

Fine-grain papers are easily saturated with pigment, limiting the application of additional colors.

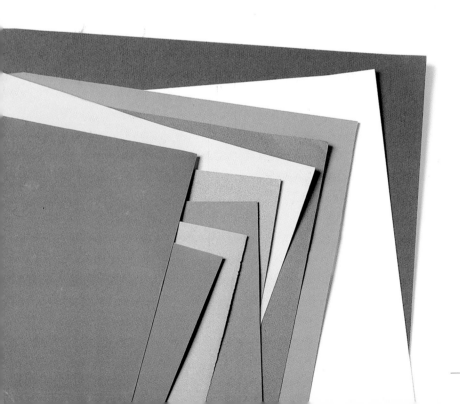

To avoid effects like this, pastel paper should be durable enough to permit rubbing, blending, and erasing.

DIFFERENT FORMATS

Pastel paper can be bought in specialty stores in gummed or spiral-bound pads, loose sheets and rolls. The format you choose will depend on your needs but keep in mind that pads are easiest to transport.

USEFUL TYPES OF PAPER

There is plenty of paper available that is manufactured specifically for pastel, although you can use pastel on any paper with the right characteristics; watercolor paper, for example, is sturdy and comes in a variety of grains. You can also use most kinds of drawing paper and even industrial papers such as packaging and recycled papers.

PAPER BRANDS FOR

Pastel papers are the same as those used for charcoal, pencil or sanguine drawing. These include:

Mi-Teintes, by Canson, 65% rag, rough grain on one side (1) and fine on the other (2), in a range of 50 colors.

Ingres Vidalon, by Canson, mold-made paper with a laid finish, high percentage of rag, available in a wide range of colors (3).

"C" is a grain, by Canson, double-gummed, white drawing paper, suitable for pastel painting despite its fine grain (4). Papers by Arches, Fabriano, Holbein, and Rembrandt are also available.

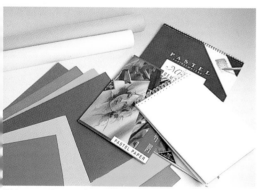

Pads of paper for pastel painting can be bought in several sizes, types, and qualities.

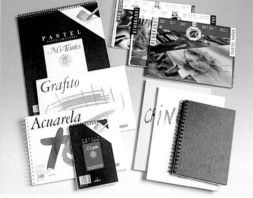

This type of paper is sold in sets, loose sheets, or rolls.

QUALITIES

Paper for pastel painting must be able to withstand repeated blending and erasing. The best-quality papers are those made from rag that have been chemically treated to prevent yellowing and the development of fungi. The best pastel papers help you realize the full potential of this medium, although each artist, of course, has his or her own preferences; some may even prefer to work on other kinds of supports.

Pads of paper can be either gummed or spiral-bound.

1

2

3

4

WATERCOLOR PAPER

Its surface is treated to withstand a thorough wetting, making it good for creating diluted effects such as those for backgrounds. It also holds up well when rubbed with chalk or erasers. Very well suited to mixed techniques and for producing different effects. Sold in fine, medium, and coarse grain (5).

5

PAPER COLOR

In pastel painting, the color of the paper affects the final result. In order to avoid saturating the paper with too much paint, you may choose to leave areas of the colored paper unpainted to suggest part of a background or sections of the subject that are similar to the paper's color. You should also keep in mind that light tones on dark paper will give you a strong contrast, as will dark tones painted on light-colored paper. The samples on this page show how the color of the paper affects the color of the paint when it's next to a painted area as well as when it's underneath the paint, bleeding through the stroke.

Ignoring the color of the paper will limit your technique, and may create problems instead of solving them.

See: Background Color, pages 50–51.

1

2

3

SPECIAL SETS OF PAPER

You can buy special sets of paper that contain an assortment of colors. These sets allow you to practice painting on different-colored backgrounds.

4

Mi-Teintes paper in a range of colors.

5

6

7

8

9

10

TINTED PAPER

Tinted papers for pastel have exactly the same compositions, strengths, and grains as their white equivalents; the only difference is the color added during the manufacturing process. Because pastel paint does not mix easily, manufacturers offer wide ranges of paints and papers. As you can see in the color charts on these pages, there is a wide range. of tones and hues so you can find whatever suits your style.

The light tones of neutral colors—creams, ochres, and grays—can be used as the background for almost any subject. They are ideal for producing correctly balanced colors and for unifying your overall work. Intense colors (reds, greens, black) produce vibrant colors that are good for striking images and sharp contrasts.

Mi-Teintes papers by Canson (1,2,3,4,5,8). Rembrandt, laid finish (6,7,9,10).

OTHER PAPERS

We explained earlier that any paper that is sturdy and has the right texture to hold pigment can be used for pastel; therefore, there is a vast range of papers that can be used for this medium.

You can use special papers for their texture, color (as in the case of recycled paper), or low cost. Wrapping paper, for instance, is popular for its color among artists who draw and paint in pastel. We have included several additional paper samples on these pages:

Sansfix, by Schmincke, pastel paper with a surface similar to sandpaper, holds paint well and produces interesting textures. It is sold in several colors (1). Semicoarse sandpaper, available in hardware stores (2). Laid finished wrapping paper; it has an interesting weave and is inexpensive and very popular (3). Handmade paper; thick grain and irregular weave (4). Newspaper; delicate, does not withstand blending, although the print provides interesting background for experimentation (5).

1

2

3

4

Range of colored papers, Ingres Vidalon.

5

6

7

8

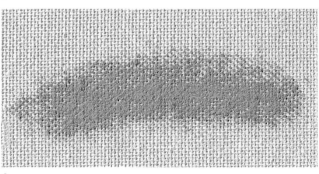

9

10

OTHER SUPPORTS

Since pastel is a dry medium consisting mainly of pigment, you can apply it successfully to any porous surface and should experiment with such diverse materials as clay tiles (6), plywood (7), printed (8) and plain (9) fabric, packing cardboard (10), or any other rough surface.

OTHER TEXTURES

Paper for pastel can be divided into three main grains: fine, medium, and rough. Each one has its peculiarities, but they are all used in more or less the same way.

With special surfaces, you may have to treat your paint differently. Wood or Sansfix paper, for instance, make blending difficult, and the smooth surface of a tile may not have the right texture for impasto work.

Boxes

Pastel sticks are extremely fragile so you may want to keep them in a box to protect them and keep them in order. Pastel boxes—sold separately or with pastels—usually have a foam inlay with indentations for each stick so that colors don't mix or damage each other.

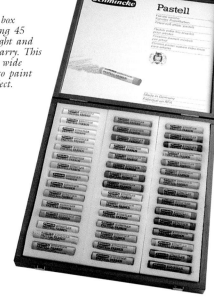

Wooden box containing 45 colors, light and easy to carry. This range is wide enough to paint any subject.

TYPES OF BOXES

The quality of boxes sold with pastels is usually directly related to the quality of the pastels. Quality pastels usually come in attractive, sturdy boxes; you can also find special cardboard boxes in art supply stores. Which box you choose depends on your needs; if you want to carry it around with you, the box should be durable.

Pastels in boxes come in a range of sizes and qualities. There are even special sets for such specific subjects as landscapes, seascapes, or portraits. Pastels are also sold loose.

SOFT PASTELS

This type of pastel stick is found in the widest ranges of colors. The largest available set comes in a spectacular wooden box containing 525 colors arranged in four trays. While such a box may be a pastel painter's dream, the price may make it somewhat prohibitive.

For those with more modest budgets, there are still ample assortments available in smaller boxes. Quality pastels usually come protected by a foam inlay in wooden boxes.

You can also buy medium-quality pastels in wooden or cardboard boxes; the latter are cheaper, but not as durable.

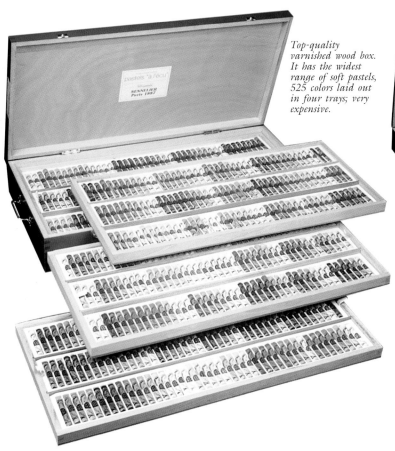

Top-quality varnished wood box. It has the widest range of soft pastels, 525 colors laid out in four trays; very expensive.

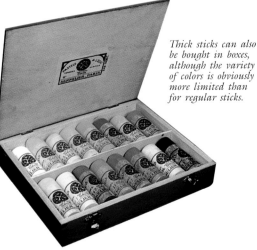

Thick sticks can also be bought in boxes, although the variety of colors is obviously more limited than for regular sticks.

Cardboard paintbox containing 30 colors; its foam inlay also fits into most of the empty wooden boxes on the market, if you decide to buy one later.

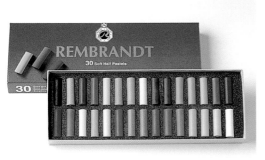

With a box of half sticks, the artist can, for a similar price, buy double the number of colors in a standard box.

HARD PASTELS AND PENCILS

Sets of hard pastels are sold in wood, cardboard, or metal boxes, but usually in a plastic tray instead of a foam inlay. Manufacturers are expanding their ranges of color as this kind of pastel becomes more popular.

Single color ranges of grays and earth colors for drawing are also available.

Pencils are sold in cardboard or metal boxes. They are also sold in a wide variety of sizes as are other kinds of pastels.

Hard pastels can be purchased in attractive wooden, metal or cardboard boxes. There is a wide range to choose from.

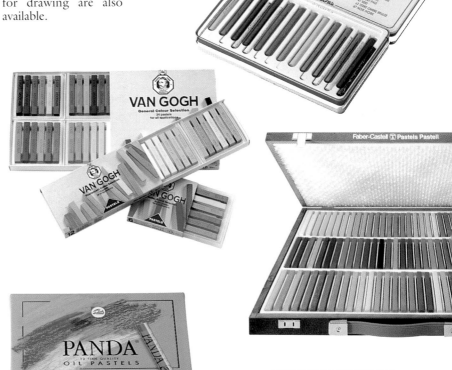

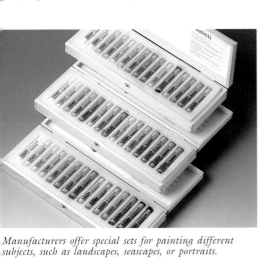

Manufacturers offer special sets for painting different subjects, such as landscapes, seascapes, or portraits.

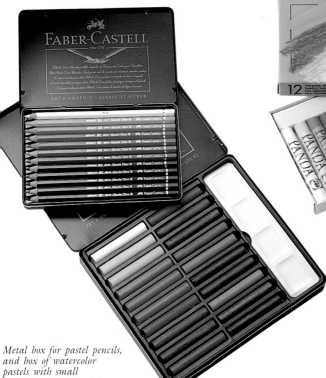

Metal box for pastel pencils, and box of watercolor pastels with small compartments for mixing the colors with a brush.

Box containing 12 oil pastels. These come in boxes of up to 48 colors.

EMPTY WOODEN BOXES

If you already have your own pastels, or want to develop your own palette, empty wooden boxes with a foam inlay are available. This kind of box can also be useful for those who started with a cardboard box and now want a sturdier one.

Hard pastels are also sold in ranges of tones for single-color paintings.

Drawing Boards, Easels, and Tables

Although you really only need a piece of paper and a paintbox for pastel painting, there are other materials and equipment that can make your work in this medium easier. Most pastel painters have drawing boards, easels, and tables, as well as folders for storing paintings and organizing them in the studio.

DRAWING BOARDS

These wooden boards are used to support the material you are going to paint on, especially paper. Attaching paper to a board keeps it taut and helps it withstand rubbing or erasing without ripping or crinkling. You can also move it to vertical or slightly tilted positions so that excess pigment will fall away when you paint.

A board should be larger than the paper; about two spare inches (5 cm) on each side is enough. The paper can then be easily attached to the center using thumbtacks, clips, or masking tape. The empty perimeter lets you hold the board without touching the paper.

This type of board should be smooth or the texture of the wood will affect the painting. It should be hard enough to provide support, but light enough to carry easily. Plywood, MDF (medium-density fiberboard), or laminated boards with a polished surface are the most common boards for pastel painting.

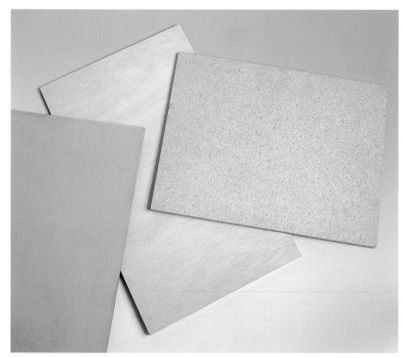

These drawing boards are not usually found in art supply stores, but most lumberyards or hardware stores will cut them to size for you. Any kind of board is suitable as long as it is smooth and lightweight.

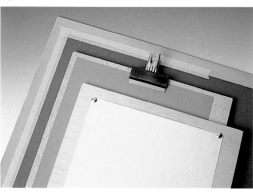

There are several ways you can attach paper to your drawing board: Clips leave the paper intact but can be a nuisance when you paint; thumbtacks obviously leave holes; masking tape is good for holding down the paper but may damage it when removed.

Easel with built-in board. It has been especially designed for drawing and painting on paper.

EASELS

Most artists use an easel to support their drawing boards, although it is not essential. It can be adjusted to hold your board vertical or tilted and should keep your board steady when you press down on it with your pastel or eraser. Those with four legs are the most stable. Easels with built-in boards are also useful, although they can only be used for painting on paper. Beginners painting at home may find that small, easily transported, tabletop easels are the most convenient.

TABLES

You will need a table or some other surface to put your paintbox on while you work; paintboxes are usually too heavy to hold and you need both hands free so you can paint with one and hold a rag or eraser in the other.

Your table can be quite simple—even a large board resting on two easels is enough to hold your box and other equipment. Many artists, however, prefer to have a few drawers as well for organizing their large sets of pastels.

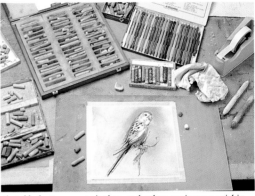

A table keeps your paintbox and other equipment within easy reach.

Tilting the drawing board that supports your paper makes it easier to paint. If you do not have an easel, you can rest the back of your board on a brick or some books.

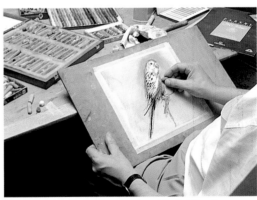

You can also tilt the drawing board by holding it on your lap and resting the back of it on the edge of the table while you paint.

Studio easel. The most sturdy of all, it is equipped with a nonslip feature that keeps it in place even if you press down hard. The drawback is that it is awkward to carry.

Tabletop easel. Ideal for artists who do not have a great deal of space but prefer to paint vertically.

FOLDERS

It is best to store your finished work carefully in folders, first protecting them with tracing paper. Folders are also good for storing spare paper so it doesn't get smudged or crumpled before it can be used.

Folders should be rigid enough so they don't bend when you move them, or your paintings or paper may warp.

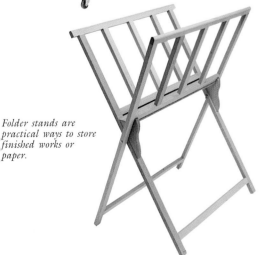

Folder stands are practical ways to store finished works or paper.

Folders and pieces of tracing paper.

MATERIALS AND EQUIPMENT

Other Materials and Equipment

Pastel artists have a variety of additional materials that they use when they are attaching or cutting paper, painting, experimenting, or finishing off a work.

Scissors and utility knife.

OTHER MATERIALS AND EQUIPMENT

Before starting to paint, you have to decide which size paper you are going to use and how to attach it to your board. When you are painting, you will need to blend and mix colors, experiment and investigate, create particular effects, and then, in many cases, permanently fix the colors of the finished work. There are a variety of materials and equipment available that expand your options as you work—or that simply make painting easier.

CHARCOAL

Charcoal is used for drawing preliminary sketches of your subject and making visual notes. Depending on the nature of your work, you may want to have both thin and thick charcoal sticks available.

CHALK AND SANGUINE

Besides charcoal, most pastel artists have chalk and sanguine, a warm, red chalk. These

Chalk and sanguine.

are used for single-color or two-color sketches. Pencil versions are best for sketching without getting your fingers dirty.

SHARPENERS

A pastel sharpener is simply a piece of sandpaper attached to a small piece of wood. You rub your pastel stick across the sandpaper and get new edges perfect for drawing thin lines.

Standard sharpeners are used for pencils. See: Using Pastel, pages 24–33.

ERASERS

Erasers are an essential tool for painting with pastels because they are not only used for removing mistakes, but for opening up white spaces and creating other effects. Kneaded erasers or soft plastic erasers are best. See: Using Pastel, pages 24–33.

SCISSORS AND UTILITY KNIVES

Scissors and utility knives are essential tools for making clean, accurate cuts to reduce the size of a paper or make stencils. A utility knife is also useful for sharpening sticks or pencils.

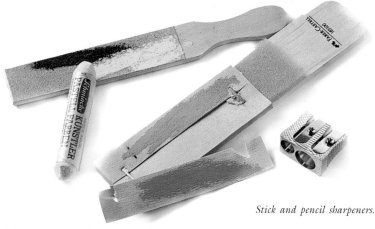

Erasers.

Charcoal.

Stick and pencil sharpeners.

RULER AND SET SQUARE

These are used for drawing straight lines and for measuring and cutting paper to size.

CLIPS, THUMBTACKS, AND MASKING TAPE

These are used to attach paper to the drawing board; each painter has individual preferences: thumbtacks are small and handy, but leave holes in the paper; clips are easy to use but can get in the way when painting; masking tape is ideal for attaching all the edges to the board, but can damage the paper when you remove it. Tape is also used for reserving areas (keeping them unpainted) or for making straight edges.

RAGS

Rags are used for a variety of purposes, including cleaning your hands and the pastels sticks, blending large areas, and coloring a background.

Ruler and triangle.

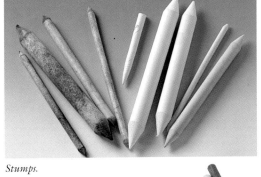

Stumps.

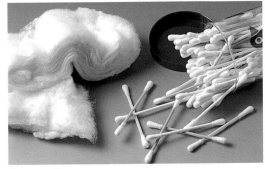

Cotton swabs.

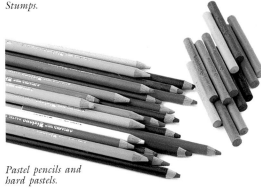

Pastel pencils and hard pastels.

STUMPS (ALSO CALLED TORCHONS)

Designed especially for blending colors, stumps are made of paper and readily absorb pigment and spread it over the surface of the paper. See: Using Pastels, pages 24–33.

COTTON

Cotton wool, balls, and swabs are also used for blending, but produce slightly different effects. Because they are softer than regular stumps, their effects are more transparent. See: Using Pastels, pages 24–33.

BRUSHES

Brushes can be used to dilute pastel with water, blend colors, or remove traces of pigment or particles of eraser from paper.

SPONGES

A wet sponge lets you clean the pigment from your fingers quickly and easily.

HARD PASTELS AND PASTEL PENCILS

Hard pastels are ideal for making preliminary sketches. Their sharp edges are particularly good for painting small details.

Fixatives.

FIXATIVES

Since pastel paint does not adhere well to paper and comes off with the slightest contact, you can apply fixative to your finished work. Fixative is also used to stop colors from falling off when they are blended.

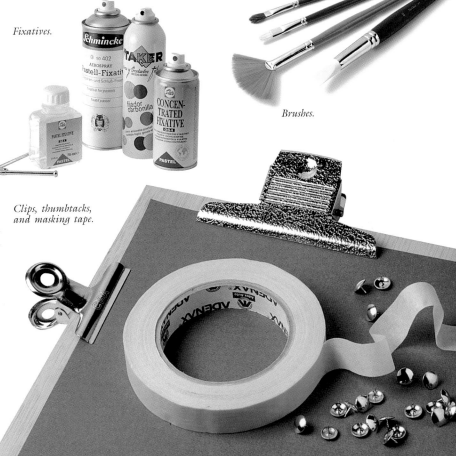

Clips, thumbtacks, and masking tape.

Brushes.

Cloth.

Sponge.

Using Pastels

The pastel medium uses what is called a "direct" painting technique, or the simple contact of pastel with paper. Variations on this basic act can produce a wide spectrum of results. For instance, pastels can be applied with fingers or other instruments. You can experiment with the density and character of the pastel stroke to suggest volume, light, and texture.

APPLYING PAINT

The way pastel is applied to the paper determines the effect. We will show you several different techniques that you can use, depending on the subject you are painting and, ultimately, what you are most comfortable with.

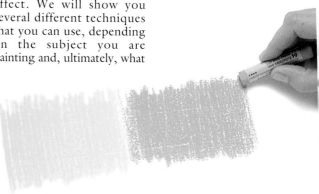

APPLYING PAINT

CONTROLLING THE DENSITY

The character and tone, or lightness or darkness, of the color produced by a pastel depends entirely on the pressure used to apply it to the paper. The greater the pressure, the more pigment remains on the paper to give you an intense, opaque color. The opacity, or density, of pastel makes it possible to apply light colors over dark ones, and work in impasto and with glazes.

Gently stroking the pastel over the paper reveals its texture. The result is similar to that of the "frottie" technique in oil where paint is applied in a thin, transparent glaze that lets the underlying color show through.

Applying thick amounts of pastel produces an impasto—saturated, opaque patches of color that completely cover the paper and fill the grain (see page 66).

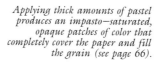

Another way to get transparent colors is to stroke the pastel gently over the surface of the paper and then blend the resulting color. This produces a delicate, almost translucent, effect, like the one in the photograph.

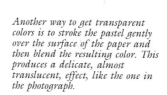

The opacity of pastel means that a light color can be superimposed over a dark one without losing its brightness.

Dark colors can also be painted over light ones.

NOTE

When painting impasto, the surface of the paper becomes saturated with color and the thick layers of paint sometimes don't adhere completely to the paper. To prevent this, you should apply only a little paint at a time or treat each layer with a fixative.

APPLYING PAINT — WITH A PASTEL STICK

The shape of pastel sticks gives you a variety of ways to apply them. Stroking the paper with one part of the stick will give you a thin line that is good for painting small details. When you use the sides of the stick, you'll have a thick stroke that can fill a large area.

The circular end of a new stick, or the sharpened edges of a used one, can be used to draw the fine lines of preliminary sketches or add details later. You can also use these sticks to create interesting effects, such as optical mixes of color. As the pastel's edges become worn away, the lines it makes will become thicker. If you only use the flat tip of the pastel, the thickness of the line will stay the same. The stick can also be laid flat on its side for painting large areas quickly.

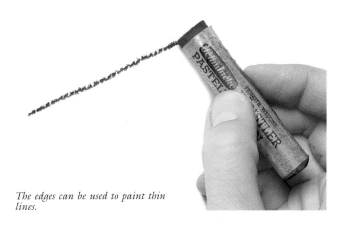

The edges can be used to paint thin lines.

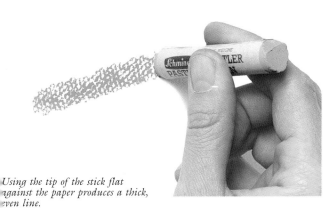

Using the tip of the stick flat against the paper produces a thick, even line.

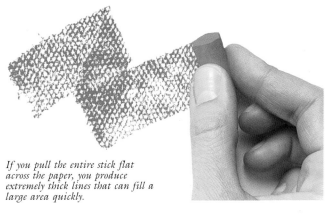

If you pull the entire stick flat across the paper, you produce extremely thick lines that can fill a large area quickly.

APPLYING PAINT — WITH FINGERS

Pastel sticks crumble easily, but you can paint with these bits of pastel by using your finger. This produces different effects than painting with a stick. The intense pressure combined with the natural oils from your skin make the powder bind slightly and results in a more compact paint and dense color.

To apply paint with your finger, simply pick up a little of the crumbled pigment on your fingertip and stroke it onto the paper. You can also crush a small amount of pastel directly onto the paper, producing a more impasto-like effect.

1. Take up some pastel on the tip of your finger.

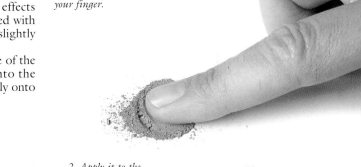

2. Apply it to the paper, blending the color as you press down.

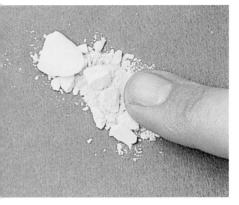

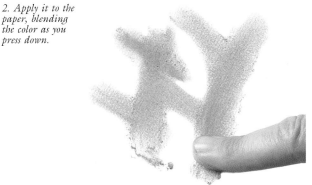

To get an impasto effect, simply crush a small portion of pastel directly onto the paper. This will produce an area of thick, opaque color.

APPLYING PAINT — WITH A BRUSH

To use a "wet" painting technique, load a wet paintbrush with powdered pastel, then apply it to the paper. The resulting color is delicate and light, as if you had used a stump to blend it. This technique cannot be used for impastos. Unlike colors applied with your finger, brushes produce gentle, transparent effects.

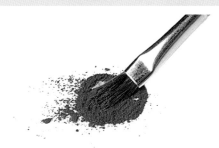

1. To apply pastel powder with a brush, simply pick up a little with the bristles.

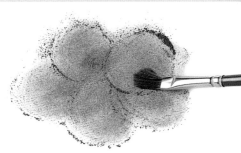

2. Stroke the paper gently with the brush.

APPLYING PAINT — WITH COTTON

Cotton is another efficient way of applying pastel to a large area because it can absorb a large amount of paint. Cotton is ideal for filling in backgrounds quickly and producing a delicate, transparent effect, but cotton, like brushes, is not useful for applying thick, opaque colors. Cotton is also good for removing excess paint.

NOTE

Erasers are almost as essential as pastels when you are painting because they help open up white or light areas in fields of colors. See: Tricks of the Trade, pages 36–41.

1. Absorb paint with cotton.

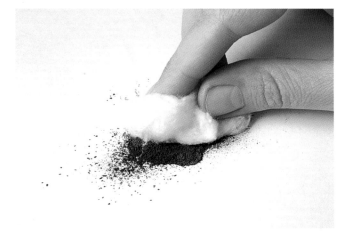

2. Spread it gently on the paper.

SHARPENING — SHARPENING PASTEL STICKS

The edges of pastel sticks wear down with use so you will need to sharpen them regularly or snap them in two to make new edges. To sharpen a pastel stick, simply rub it against sandpaper until it forms an edge, or a point. Stores also sell pastel sharpeners that are basically pieces of either coarse or fine sandpaper glued to a small piece of wood; they sometimes include a small sponge for removing excess powder from the sandpaper. Because coarse sandpaper wears the pastel down too quickly and wastes paint, it is best to use fine sandpaper.

When a stick is sharpened, a large amount of pastel powder is produced; you should collect this in a container to use for painting with cotton balls, your finger, or a brush.

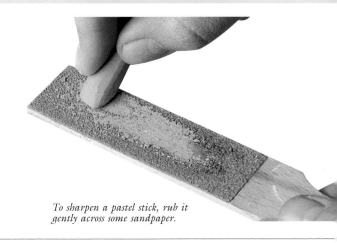

To sharpen a pastel stick, rub it gently across some sandpaper.

RECYCLING PASTELS | MAKING NEW STICKS

Sticks break with use or wear down into nubs, generating a lot of small pieces that can be used for impasto work or painting minute details. Some pieces are so tiny that they are difficult to handle; you should keep these seemingly useless fragments in a separate container.

Fragments of pastel, like the powder that is left after sharpening a stick, can be used when painting with your fingertip, cotton, or brushes, or they can be recycled and made into an entirely new stick.

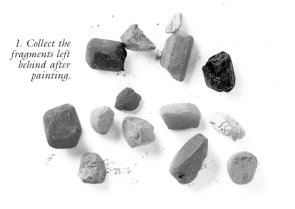

1. Collect the fragments left behind after painting.

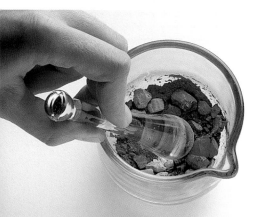

2. Put the fragments and leftover dust into a mortar and grind it together into a fine powder.

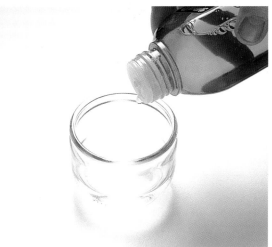

3. Prepare a binder by mixing gum and water (a drop of gum for each large tablespoon of water).

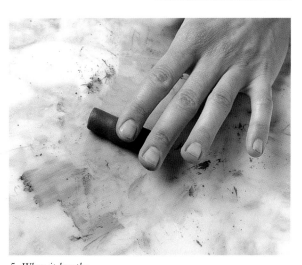

4. Add the binding medium to the powdered pastel and mix well with a palette knife.

5. When it has the consistency you want, roll it into a stick with your fingers.

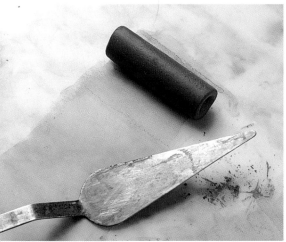

6. Let the soft stick dry for a few days before using.

NOTE

When recycling powdered pastel and small fragments of sticks, remember to consider the combined effects of their colors; random mixes usually result in dark, neutral colors.

BLENDING PAINT

Blending means spreading your paint to soften or blur the marks left by your stick on the paper. It is a basic technique in pastel painting, used to produce soft, translucent effects as well as dense areas of color. The effect depends primarily on the amount of paint on the paper and which technique was used to apply it.

To blend, stroke pastel onto the paper, then rub it with your finger, a stump, or other instrument, until the paint spreads out and any lines are blurred.

BLENDING PAINT — WITH A STUMP

A stump is an absorbent paper rod with sharpened ends that is used to spread and blend paint on the paper. Stumps come in many sizes, for both large-scale and detailed work. They are important because they allow you to blend without getting your fingers dirty (which would inevitably cause accidental smudges). The stump's sharp tip is particularly good for blending small areas of color.

The main drawback of this tool is that it gets dirty quickly and may affect the colors you have already applied. See: Preventing Colors From Mixing, page 32.

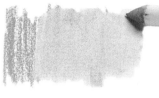

To blend, simply stroke pastel onto the paper, then rub the area with your stump to spread out the color and soften or blur the lines.

The tip is ideal for blending small areas.

BLENDING PAINT — WITH FINGERS

Many artists use their fingers to paint, apply impastos, and blend. In fact, fingers are the painting instrument you control best. When you blend with your fingertip, the fine layer of oil on your fingertip sticks to the pigment, so that the effect is more compact than blending with a stump. Your fingers also sweat; when you blend with them, both the oil and sweat cause the powdered pigment to bind, sometimes forming small lumps. To prevent this, you should keep your hands as clean as possible. It also helps if, before blending, you rub your finger with a little of the pastel you will be blending.

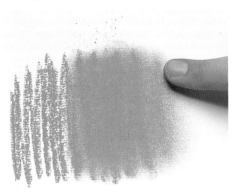

Paint a small area with pastel, then rub your fingertip gently over it to blend.

To prevent small lumps from forming, your hands should be free from oil. It also helps to rub a little pastel onto your finger before starting.

BLENDING PAINT — WITH COTTON

Cotton is a soft material that is good for spreading out and blending pigment, especially over large areas or when you want a delicate effect. Since cotton cannot be used very accurately, cotton swabs should be used for more detailed work.

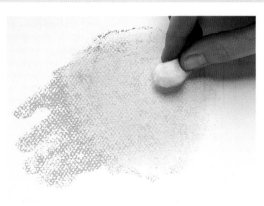

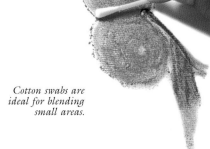

Cotton produces gentle, delicately blended colors.

Cotton swabs are ideal for blending small areas.

The brush, primarily used in mediums that are based on "wet" painting techniques, can also be used in pastel painting. A brush can be used to mix pastel powder with water, clean excess pigment from paper, or blend paint. Paint blended with a brush is different from that blended with other tools. Its fine hairs penetrate the tooth of the paper and spread the pigment evenly but softly, since too much pressure cannot be applied with hairs. That is why the effect of the brush is so gentle and transparent.

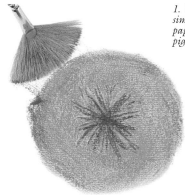

1. To use a brush for blending, simply rub it gently across the paper. It immediately lifts the pigment and spreads it out.

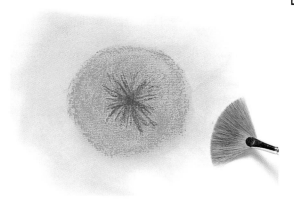

2. The color of the tomato has been extended onto the background to produce the surrounding effect. If a fingertip or conventional stump had been used, the tomato shape might have been erased by the pressure of the blending tool.

MIXING COLORS

You can mix powdered pastels together in a container and then apply the results with a fingertip or a brush, but pastel artists usually mix colors on the paper itself. Since pastel doesn't contain binding liquids, its adherence to the paper depends primarily on the pigment being held by the tooth of the paper's surface. When this fills up or becomes saturated, subsequent layers of paint have nothing to hold them and they don't stick. Since it is easy to saturate paper with pastel, adding more paint to mix a new color is difficult.

This problem explains the wide range of colors on the market. The best way to avoid saturating your paper is to have a wide range of paints on hand and avoid extensive mixing.

However, in everyday painting we sometimes have to make some simple mixes of two or three colors because certain hues are difficult to find in stores. Sometimes these mixes have more character and vitality than ready-made pastel sticks.

Mixing pastel colors is easy; simply apply one color over another and blend them together with a fingertip, stump, or brush. The pressure and friction will mix the two colors and create a third. The more you rub a particular area, the more uniform the resulting color.

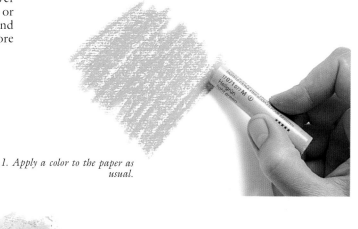

1. Apply a color to the paper as usual.

2. Apply the second color over it.

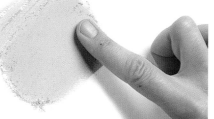

3. Mix with your fingertip, or other tool, as if you were blending.

NOTE
Remember when you are mixing colors that it is difficult to add new layers of paint when the pigment saturates the tooth of the paper.

MIXING COLORS GRADATING TWO COLORS

In pastel painting, gradating one color is easily done by spreading out the paint with a stump or your fingertip until the color starts to fade. Gradating two colors to achieve a gradual merging of the two is a little more difficult.

First, when two colors are gradated, a third is always created in between that can stand out like a stripe, spoiling the gradual blending effect. Also, because pastels smudge easily, you have to be careful to keep the darker colors from affecting the lighter ones. As with any other technique, mastering the use of gradations is simply a matter of practice and patience.

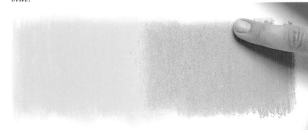

4. Gently spread the green over the yellow until the two colors blend together.

1. The first color is applied.

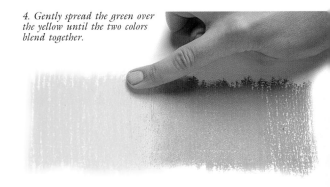

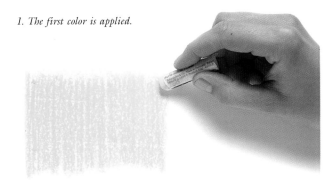

5. Do the same with the green and blue.

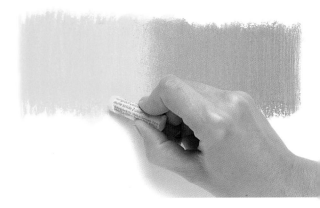

2. The blue is added up to the edge of the yellow.

6. If the lighter color becomes muddy looking, apply more pastel to it, then blend the paint again.

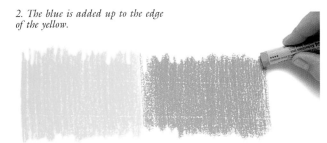

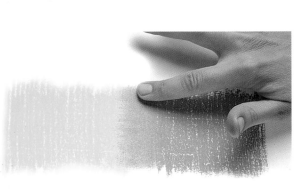

7. The result is a gentle gradation of the three colors.

NOTE

When gradating, one color should be pulled gradually in a single direction over the other. Going back in the opposite direction will produce an abrupt change in tone.

3. Blend the area where both colors meet until a third color is created, green in this case.

MIXING COLORS OPTICAL MIXES

In optical mixes, colors blend in the viewer's eye, not on the page. When colored lines or dots are closely juxtaposed, or glazes superimposed but not blended, the eye, at a distance, merges them into a single color. These colors often seem more vibrant and deep than ordinary colors. Since physical mixing of pastel is difficult, pastel artists often use these optical mixes instead. This type of mix can also produce a sense of depth when certain lines are superimposed on others.

A simple series of yellow cross-hatching over blue seems to produce a bluish green.

The same colors in reverse produce a different effect since it is the background color that determines the overall tone.

Here, juxtaposed lines produce a sense of movement and vibration, although no single color stands out.

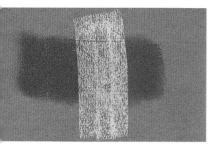

In glaze mixes, the upper color is usually stronger than the underlying color. In this case, yellow is stronger than red.

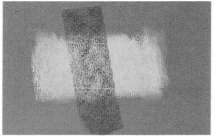

When red is superimposed over yellow, red seems predominant.

Several different colors of glazes are applied, creating a hazy sense of depth.

This is a mix of the previous colors but applied in lines. The result is the same color as before but more intense, and the visual effect and texture are totally different.

A meadow usually contains a wide variety of different hues and tones that seem to form a single green. In this case, the colored lines, while imitating the texture of the grass, achieve the same effect.

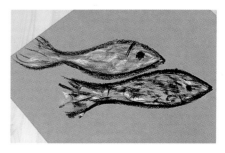

Mixes using colored dots produce a vibrant, dynamic effect and can also be used to suggest textures.

In the following exercise, we will show you, step by step, how to create an optical mix that produces in the viewer's eye the same effect as the subject itself.

1. We begin by blocking in the form of the house with a gray base and building it up with lines of a darker gray. Over that, we suggest flames with red strokes.

2. Yellow streaks are added to the red flames.

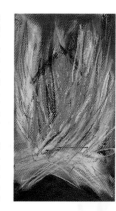

3. Finally, the background is filled in and the flames retouched to make them look more like fire. You can see that yellow is the predominant color in certain areas and red in others; the color resulting from this optical mix is orange.

PREVENTING COLORS FROM MIXING

The fine dust that pastel sticks are made of detaches easily and will stick to any surface—other pastels, fingers, stumps, clothing, and paper.

To avoid smudging the painting you are working on, keep your hands and painting materials clean and return your pastels to their compartments in the box after using them. When colors do get smudged, a dip in a container of rice or wiping them with a piece of cloth will solve the problem.

PREVENTING COLORS FROM MIXING — **KEEPING YOUR HANDS CLEAN**

You will get pigment on your fingers as soon as you pick up a pastel, and retain more and more as you continue working. Unfortunately, dirty fingers can cause ugly smudges when you try to blend light colors. A simple solution is to keep a piece of cloth or damp sponge nearby and clean your hands often.

Getting paint on your fingertips is inevitable when handling pastel sticks.

To keep your fingertips clean, just rub them on a damp sponge to remove any powdered pigment.

If there is only a little paint to remove, a cloth is sufficient.

PREVENTING COLORS FROM MIXING — **CLEANING THE STUMP**

Because the stumps artists use regularly for blending colors and gradating get quite dirty, they can also cause unwanted smudges. It helps to have several stumps, one for each group of colors. When those become too dirty, you should clean them.

1. To remove pigment from the stump, rub it across the pastel sharpener or coarse sandpaper to file off the dirty part.

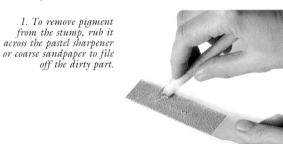

2. To form a point, rub it against the fine part of the sharpener. The result is perfect.

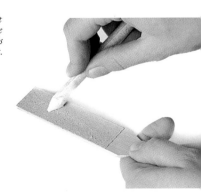

If you blend with a dirty stump, light colors will get smudged.

PREVENTING COLORS FROM MIXING

KEEPING STICKS CLEAN

When you use several different pastels at the same time, it's easy for your hands to transmit pigment from stick to stick. If you want to keep each color pure, especially the light ones, you have to wipe your hands after each color and keep your pastels in their proper compartments. A small container filled with uncooked rice can also be used to clean them; shaking them with the rice will remove any extraneous pigment. If the pigment seems stuck on, shake the box gently to rub the rice and the sticks together.

If the pastel is extremely dirty, you can clean it with a clean rag or paper napkin.

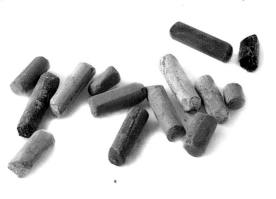

Sticks smudge each other when they touch.

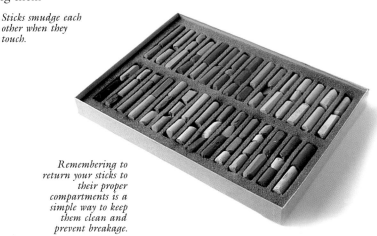

Remembering to return your sticks to their proper compartments is a simple way to keep them clean and prevent breakage.

A good way to remove powdered pigment from pastel sticks is to place them in a container with rice and shake it gently.

When a stick is extremely dirty, clean it with a cloth.

PREVENTING COLORS FROM MIXING

APPLYING FIXATIVE

Pastel is an opaque paint that lets you layer light colors over dark ones. You cannot, however, blend one color over the other without mixing them unless you first apply fixative over the initial layer. Fixative will keep the bottom layer intact while you blend or gradate the top one.

1. Fixative is applied to an area of black paint.

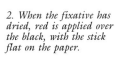

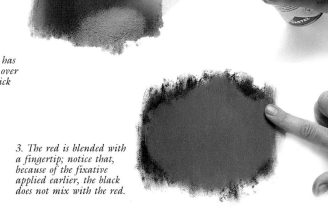

2. When the fixative has dried, red is applied over the black, with the stick flat on the paper.

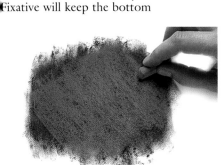

3. The red is blended with a fingertip; notice that, because of the fixative applied earlier, the black does not mix with the red.

Using Paper

Paper is the most common support for pastel painting, so you should know how to use it to maximum advantage. We will take you through all the necessary steps, beginning with attaching it to your drawing board. We'll even show you how to recoup used paper.

Masking tape is the safest way to attach paper to a board because it securely fastens all the edges. When it is removed, it leaves a sharp, blank margin that can be used for framing the work. Unfortunately, it sometimes spoils the paper when it is removed, especially if it has been left on for several days.

ATTACHING THE PAPER

Paper is flimsy and can't be painted on unless it is completely supported. You can work most comfortably if it is attached to a drawing board, although the way you attach it does affect the final result since thumbtacks leave holes, clips interfere with the painting, and masking tape can spoil the paper.

Thumbtacks can be useful but leave a hole when removed.

Clips are the quickest way to attach paper, but they are not entirely stationary and sometimes the paper moves or wrinkles when you paint energetically.

RECOUPING PAPER

CLEANING AND REUSING

You may find yourself with a painting you do not want to finish, or perhaps you just don't like the background. We will show you how to remove almost all of the paint, except for faint traces, so that you don't waste the paper.

Most of the remaining pigment can be removed with an eraser.

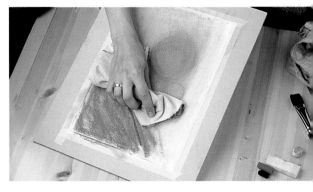

The bulk of the paint can be removed with a rag. It won't remove all the paint, but the leftover color may be an interesting background for another painting.

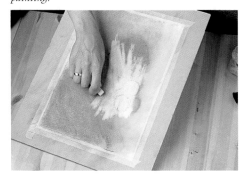

If your paper is water resistant, like watercolor paper, most of the paint can be removed with a damp sponge.

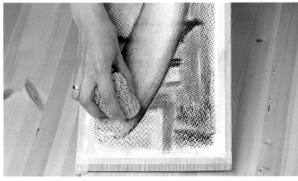

CREATING TEXTURES

Paper manufacturers offer products in a wide range of colors and grains but you may want to create your own unique texture.

There are several ways to do this. One is to rest the paper on a textured surface. When you paint, the underlying texture will be revealed.

You can also glue sand or other materials to the paper and paint over that, or texture the paper before painting with indentations from a paper clip or other tool.

CREATING TEXTURES — WITH SAND

Painting on paper you have covered with sand will give you effects that are similar to those created by painting on sandpaper, although the paper you prepare yourself will have an uneven surface that you can change to suit yourself.

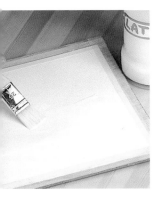

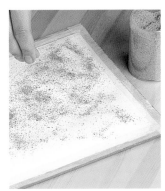

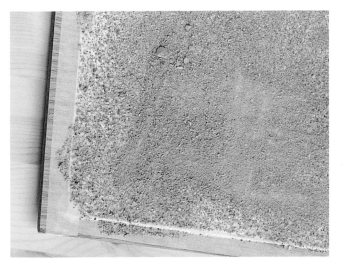

1. Apply latex or any other glue to your paper.

2. Sprinkle on sand.

3. Once the glue has dried, the sand remains stuck to the surface of the paper and can be painted over.

CREATING TEXTURES — WITH A PAPER CLIP

Another way of creating textures is to use the side of a paper clip or other object to press designs into the surface of the paper; you can use anything that won't ruin the paper. When you paint over the paper, hints of the lines traced by the paper clip will appear.

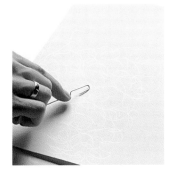

1. A pattern of lines is drawn with a paper clip.

2. Paint on the paper.

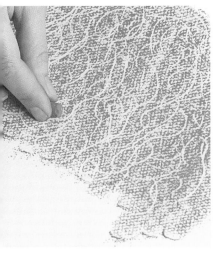

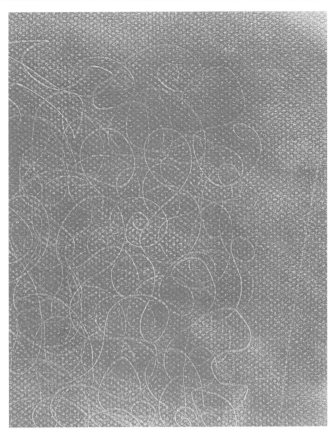

3. This is the result after the color has been blended. You can see the subtlety of the effect and its potential for suggesting shapes.

Tricks of the Trade

These are the tricks and secrets artists use to increase their range of expression when painting, to correct mistakes, create interesting effects, suggest textures, and, in general, make their work easier. There are countless methods because artists are continuously experimenting with new ways to use pastel paints. In this chapter we will explain some of the most common "tricks."

ADJUSTING A COLOR

Because painting is a gradual process, it is usually necessary to adjust and correct existing colors as new ones are added. For instance, the background color affects those of the main subject, and any juxtaposed colors also affect each other. With all those variables, it is not unusual to have to retouch or adjust colors from time to time. This can involve mixing colors or applying glazes.

ADJUSTING A COLOR — By mixing

Mixes are not only used to create a third color; often, they are used to adjust a tone or hue.

2. We then blend this pink color to get the same effect as earlier but in a slightly paler tone.

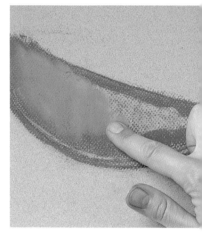

1. A second look tells us that the flesh of the watermelon is not quite right. A little pink lightens the tone of the red.

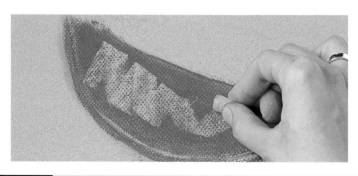

ADJUSTING A COLOR — With a glaze

If you need to change a color without blending and perhaps saturating the paper, or if you want a different effect that suggests texture or other characteristics, you might try applying a glaze. This is done by pulling the entire side of the stick flat across the paper.

Another technique for changing tones and hues while suggesting texture is to use cross-hatching of the background color.

1. This slice of melon is the wrong color and has a boring texture that could use some spicing up.

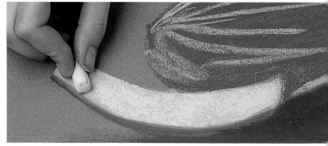

2. We apply a yellow glaze using the entire length of the pastel. Notice what a big difference it makes.

CORRECTING MISTAKES

Sometimes our hands disobey us, or we haven't calculated the right distance for a line and we end up with areas of color that are too large, lines in the wrong places, or unwanted marks. Don't worry. These common mistakes can be removed with a fingertip, brush, cloth, or eraser—or a variety of other means. Any remaining traces of paint can be covered by pastel; pastel is opaque enough to cover even dark colors.

CORRECTING MISTAKES WITH YOUR FINGERS

In pastel, it sometimes seems that the fingers are used more often than the paints, since a fingertip is the perfect tool for blending, mixing colors, and making minor corrections. To erase a line or small area of color, simply rub your fingertip over the mistake. That removes the paint and the mistake disappears.

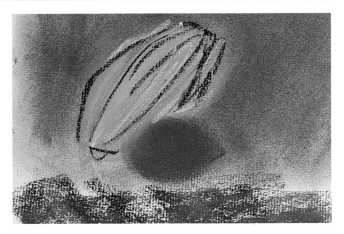

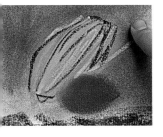

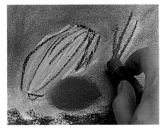

1. This line is removed simply by drawing a finger across it.

2. Since some of the background has also been erased, we apply a little more.

3. The added blue has been blended and the correction is now invisible.

CORRECTING MISTAKES WITH A BRUSH

In pastel painting, brushes are used for blending, applying paint, removing excess pigment or eraser residue, and correcting. One advantage of using brushes for corrections is that you won't get your hands dirty and inadvertently smudge the painting. The tip of a brush is also better suited to more delicate corrections, since it doesn't remove as much pigment as a finger.

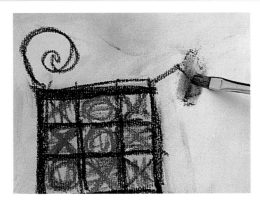

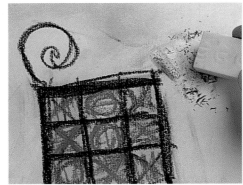

1. The shape of this line is a mistake, so we gently remove the pigment with a brush.

2. There are still traces of paint because black is an intense color; we remove them with an eraser.

3. When the mistake has been completely erased, we repaint the area.

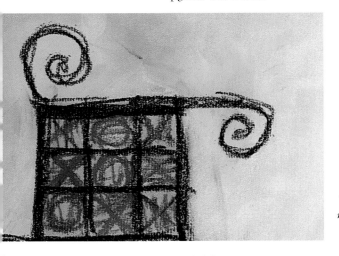

It is best to use a rag when a mistake involves a large area.

COMPLICATED EDGES

One challenge for pastel artists is defining the border between two colors, since they often smudge and bleed into each other. To get clearly defined colors, we can use masking tape or retouch the area afterward.

Retouching, a basic technique in pastel painting, is the most common method. Since pastels are opaque, you can paint over any color, no matter how strong.

The best solution, of course, is to paint with a steady and accurate hand.

COMPLICATED EDGES | **MASKING TAPE**

The same masking tape that is used by housepainters is ideal for attaching paper to your drawing board or reserving blank areas of a painting. If you paint on it, it can still be easily removed without spoiling the paper or removing background color. In pastel painting, tape is generally used when painting geometrical patterns or straight lines.

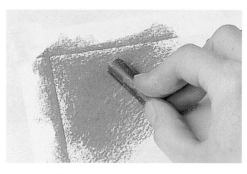

1. The masking tape can be painted over once it is stuck on.

2. You can see how the color is perfectly outlined when it is removed, leaving the background intact.

COMPLICATED EDGES | **RETOUCHING**

When one color is blended next to another, it is not always easy to keep the two colors from mixing. If the two colors belong to the same range, it's barely noticeable, but if they are contrasting colors, the mistake will be obvious.

To solve this problem, simply apply a little more pastel along one of the edges and gently blend it with a finger.

1. The border between the two colors is fuzzy and undefined.

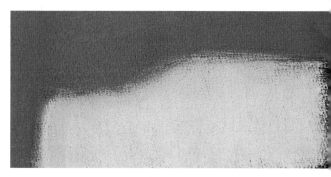

2. To correct this, repaint the edge of the color closest to the viewer.

3. Blend this additional paint with a finger.

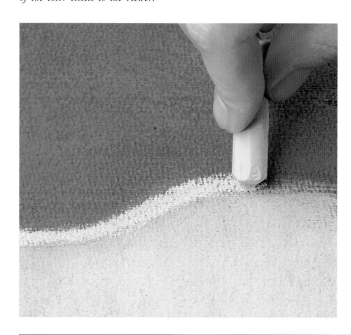

COMPLICATED EDGES USING A RULER

We sometimes use a ruler to draw the straight lines of, for instance, electric lines or the bars across a window. A ruler is useful to mark an area that will be colored in later. You can place the ruler flat on the paper or hold it slightly above to avoid smearing existing paint.

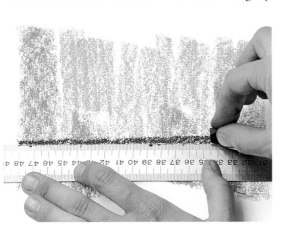

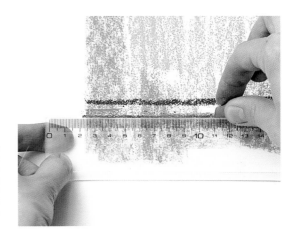

To draw a straight line, rest the ruler on the paper and pull the pastel along next to it.

If your painting is almost finished, you should protect your work by resting the ruler on your finger to separate it from the paper.

COMPLICATED EDGES MASKS AND STENCILS

Although painting with a mask or stencil is a little more cumbersome than painting directly, they are good for producing unconventional results; you can repeat the same figure as often as you like and are guaranteed perfectly defined colors every time.

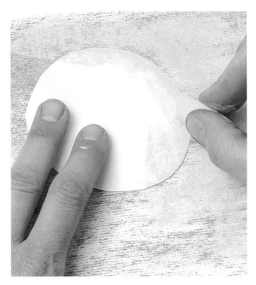

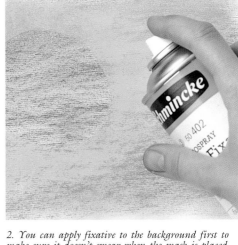

*1. Cut out a paper shape or mask and place it on the painting. Then hold it down firmly with one hand and paint around it with the other.
When you remove the shape, you will see that it has protected, or masked, the background color.*

2. You can apply fixative to the background first to make sure it doesn't smear when the mask is placed on it.

3. A stencil works in reverse. You are protecting the outside of a shape instead of the inside.

4. Both stencils and masks leave perfectly outlined shapes. You can add new versions to them to finish the painting or repeat the same geometric shapes over and over, perhaps in different colors.

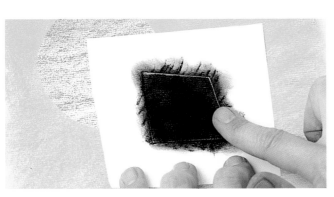

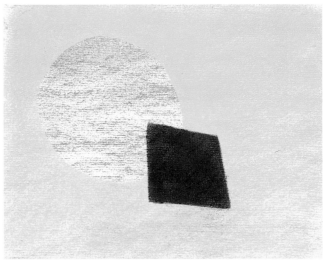

USING ERASERS — KNEADED ERASERS

A kneaded eraser has the consistency of putty and can absorb a lot of pigment. It is generally used to make corrections but can also be used as creatively as the pastel sticks themselves.

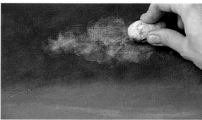

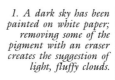

1. A dark sky has been painted on white paper; removing some of the pigment with an eraser creates the suggestion of light, fluffy clouds.

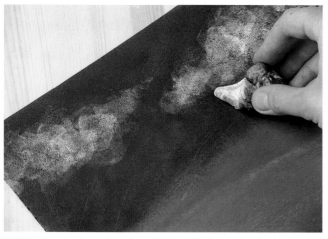

2. The eraser has been shaped to a point to do the smaller details.

3. The finished work shows clouds over a landscape at night.

USING ERASERS — PLASTIC ERASERS

Plastic erasers are also good for removing pastel, although some have a strong color that can actually tint your paper. Despite this, they are generally used to uncover the original color of the paper to create highlights or different tones. They can also be used to remove the actual color from tinted paper, producing a design.

1. Some of the color of the paper is removed with an eraser.

2. It has left clean, sharp lines that look painted.

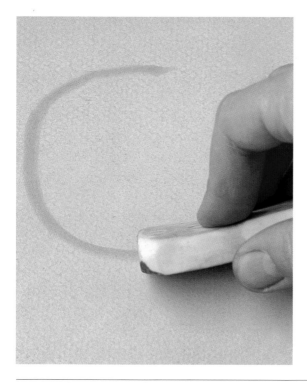

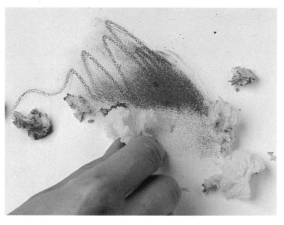

Plastic erasers can be as effective as other kinds.

EFFECTS SGRAFFITO

Sgraffito is the technique of removing paint by scratching it away. In other words, you draw by removing, instead of applying, color. Because of the powdery nature of pastel, we have to treat the paper before applying paint if we want to score marks in it afterward. This base, or "ground," can be made by applying several layers of gesso, also used to prime canvases.

1. Gesso is applied to the paper to create a soft, thick ground that can be scored.

2. When it has dried, we paint on it with pastel and add the sgraffito using a utility knife.

3. Utility knives can be used for opening up either fine lines or thick "strokes."

EFFECTS WITH WAX

Since wax colors are greasy, they easily absorb powdery pastel, making them good for background touches, suggesting textures, or creating an infinite amount of other effects.

1. First we paint the squiggles, using an artists' wax crayon.

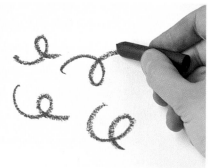

2. Pastel is applied over.

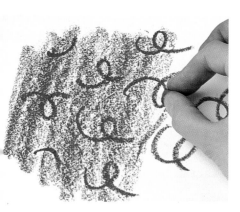

3. After the pastel has been blended, you can see that the wax squiggles have absorbed so much pigment that their color has changed, becoming a deeper tone of the pastel on the rest of the paper.

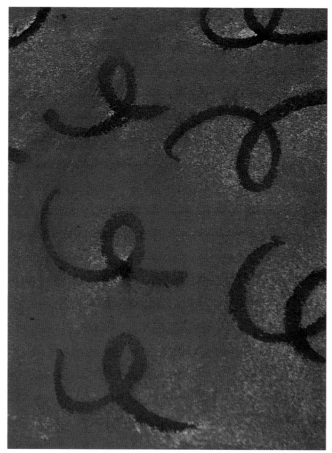

One Color

Painting a subject using only one color is an excellent exercise for practicing the use of tones and paint density while improving your powers of observation and perception. The restriction of painting with a single color can result in surprisingly sensitive and artistic works.

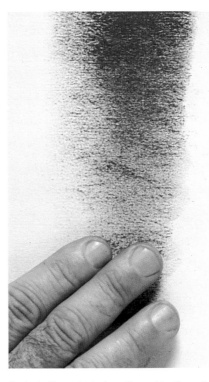

2. A similar principal applies to blending: the darkest areas are simply those with the most pigment. To soften these tones in one-color painting, you gradate them as shown in the photograph.

TECHNIQUE

The technique for one-color painting in pastel is similar to that used for charcoal drawing. First, you have to be able to interpret your subject only through its varying intensities of light and color. Second, you create volumes by careful use of value—the lightness or darkness of tones—instead of additional colors. This means you will have to develop the entire tonal range of your chosen color by learning to vary the pressure of your strokes; heavy strokes leave more pigment on the paper, making a darker tone, and vice versa. If you want to include light colors and highlights, you must use the color of the paper, either by masking sections or by opening up white areas with an eraser.

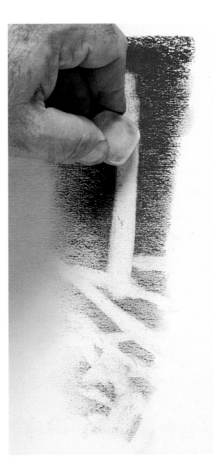

NOTE

When choosing a paper for one-color painting, remember that only the color of the paper can provide contrast for your chosen pastel.

1. The pressure of your stroke determines the amount of pigment transferred to the paper and, finally, the intensity of the resulting tones.

3. Erasers are constantly used in this kind of exercise since the color of the paper is the only one you can use to create contrasts.

STILL LIFE WITH PUMPKIN

We are going to paint this exercise on a light, cream-colored paper. For a strong contrast of values, we have chosen a dark reddish pastel with a wide range of tones, ideal for painting intense highlights on the fruit.

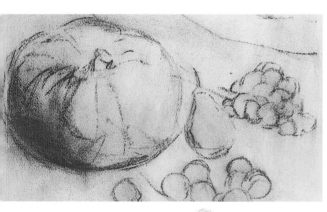

We have arranged this still life especially for this exercise. It offers an interesting range of tonal values from the light background to the dark fruit. The pumpkin and pear provide intermediate tones.

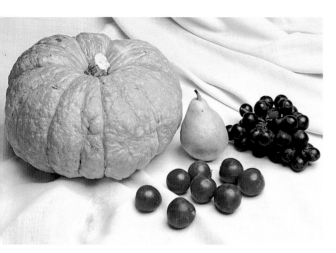

1. After making a preliminary drawing, we tint the paper using a piece of cloth, and gradate areas of the pumpkin.

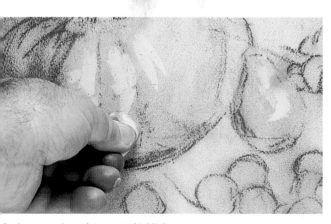

2. An eraser is used to create highlights.

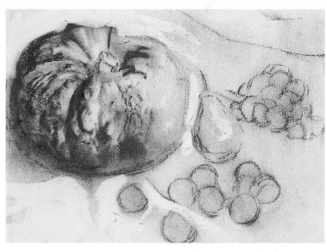

3. The irregular surface of the pumpkin is built up by the interplay of light (obtained with the eraser) and shadow.

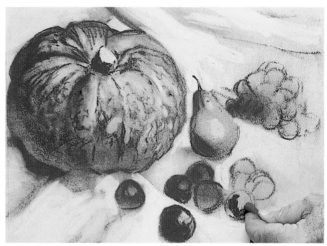

4. The darkest fruits (the plums and grapes) are painted using a generous amount of pastel.

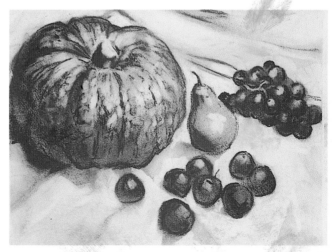

5. The final painting. Notice how an entire range of values has been used, from the light background to the darkest fruit.

NOTE

When painting in a single color, an eraser is essential for recovering the color of the paper.

Two Colors

After painting with a single color to discover the different effects of blending and how to use the eraser and produce a range of tones, we can move on to exercises using two colors.

WHY TWO COLORS?

When you work with two colors, you are halfway between one-color painting (an exercise in tones and values) and the potential of a wider range of colors. An exercise in two colors introduces color-mixing techniques, while you still practice tones and values.

Except for colors like white that only let you develop a range of tones, mixing two colors always produces a third that should also be used.

JUG OF MILK

Working with two colors can actually be a form of one-color painting if the range of only one of the colors is developed, or, as in this case, only one has a wide range of tones.

When one of the two colors used is white, the result is similar to a one-color painting. Working with pastels of two different hues, or colors, is much more interesting than working with two different tones, or shades, of the same color.

The two colors we have chosen for this exercise are a pale yellow and a dark gray; mixing them produces a gray with a slight greenish tone.

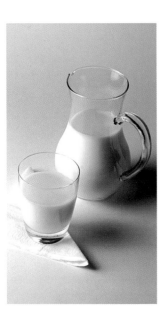

This image is essentially two colors, since the main element, the milk, is white, and the remaining colors are a range of grays. It will be interesting to paint it using similar tones, but with a few subtle changes to differentiate it from a study in black and white.

1. We use the gray pastel to draw a preliminary sketch on the cream-colored paper.

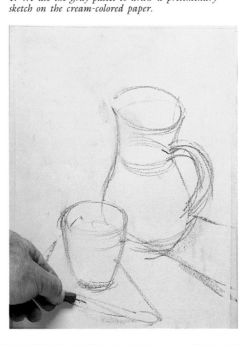

NOTE
Part of mastering pastel painting is learning how to handle the sticks nimbly and how to hold more than one in your hand as you paint. This saves time and prevents mistakes you might make looking for the right color.

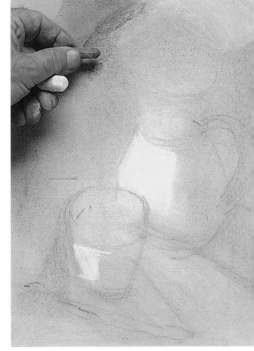

2. The next step is to lightly shade in the background. These first steps are carried out quickly with sure strokes, so we hold both colors of pastel in one hand.

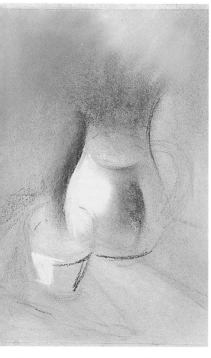

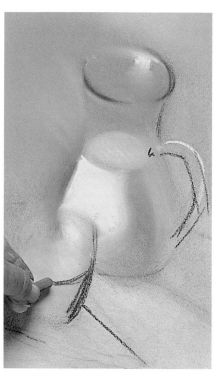

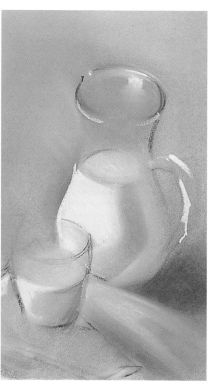

3. The shadows have been gradually darkened and the highlights brightened to establish the scale of tonal values for our painting.

4. You can see how the previous colors have been blended and the outline of the glass intensified by the addition of a simple gray line.

5. The table has now been painted, along with the shadows cast by the jug and the glass. A few touches of light have also been added to the mouth and handle of the jug.

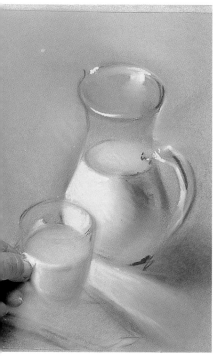

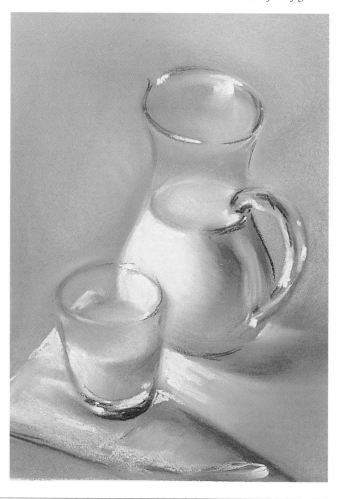

6. The paint has been blended again and gray added to define the shapes of the objects; after this, the highlights are corrected.

NOTE

When you paint in two colors, the color that best suggests light will be the one palest in its pure form and vice versa; mixes of the two will produce all the intermediate values.

7. In the finished painting, you can see how convincingly the glass's shine was suggested with only a few yellow lines. Gradations of the two colors rendered the volumes. Notice also the different hues that resulted from mixes of the two colors.

Three Colors

While the composition of pastel makes it difficult to mix, you will still need to mix colors in almost every painting, either physically or as an optical effect. The best way to learn how to mix is to interpret a multicolored scene using only three colors and the different hues you can create by mixing them. This will help you master mixing techniques and familiarize yourself with how colors react to each other. When you have mastered color mixing, a three-color painting will look as if it were done with a wide palette.

MIXES

Working with three colors is really like working with six when you consider the hues that result from mixing the first three.

There are two kinds of color mixes in pastel painting: physical and optical. Physical mixes are on the paper when two colors are mixed to get a third; in optical mixes, colors are blended in the eye of the viewer when two colors are closely juxtaposed. See Using Pastel, pages 24–33.

During this exercise, we will use different kinds of mixes, adjusting the technique to the needs of the painting.

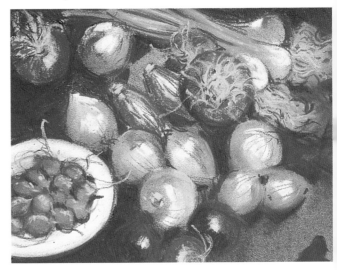

At first glance, nobody would believe that the range of colors used in this still life of onions was made using only three colors: green, red, and yellow.

The mix of red and green produces a very dark earth color, with shades of one or the other depending on the proportions used.

This orange was made by mixing red and yellow. You can get a more intense color or an entirely new hue depending on the proportions you use.

An optical mix, using green and yellow, produces this vibrant effect, with an acid-green tone.

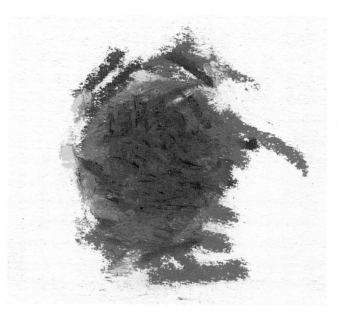

Another vibrant effect created by the optical mix of the three colors. In this case, the colors were only blended slightly so that you can still see the direction of the strokes underneath.

The effect of optical mixes depends directly on the order in which the colors are applied; in this case, we have made a dark color with shades of red because it was put on last.

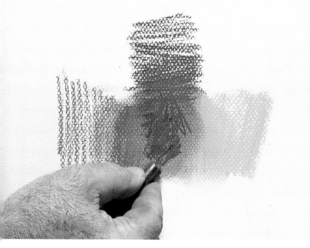

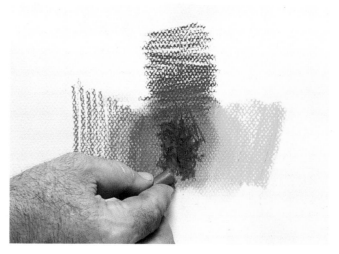

1. To mix three colors, you have to superimpose them one over the other. You have to decide beforehand which one is going to be the predominant color, keeping in mind that dark colors are generally stronger than lighter ones.

2. Here, the red is applied over the green. The order of the colors determines the final nature and intensity of the shade.

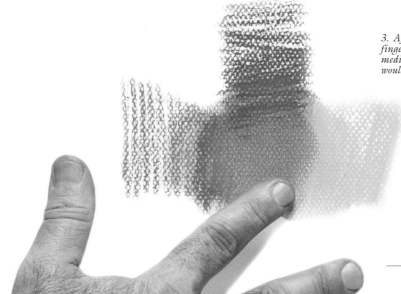

3. After adding the yellow, the three are blended with a finger. Since yellow is a light color, the result is a medium ochre tone. If the order were reversed, the result would have been a dark brown.

NOTE

The result of a mix depends on the proportions used of each color and the order in which they are layered.

A STILL LIFE WITH ONIONS

For a three-color exercise, you can choose pastels that are completely different colors than your subject, creating a work with sharp contrasts. Or, as is the case here, you can carefully choose three colors that represent the range of the actual subject.

Before starting, you should test several colors on pieces of scrap paper, as we have done earlier, so you can pick the ones that give you the mixes you want and work well together in your composition.

Three colors have been used to paint this still life: dark green, medium yellow, and red. When physically mixed, they produce a color similar to burnt sienna.

Reds are the most predominant shades in this still life, although there are also a lot of greens and yellows.

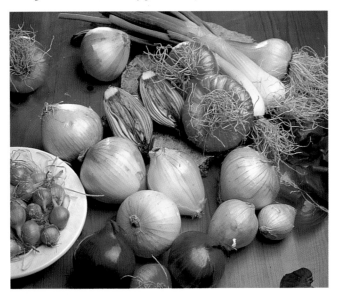

NOTE

You can also slightly blend the lines of optical mixes, as we have done with the green stalks of the onions.

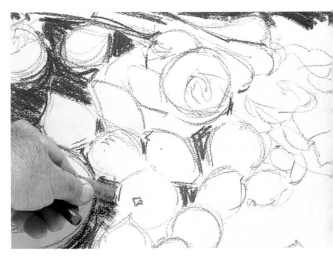

1. The preliminary sketch is drawn in green. The background is red painted over green.

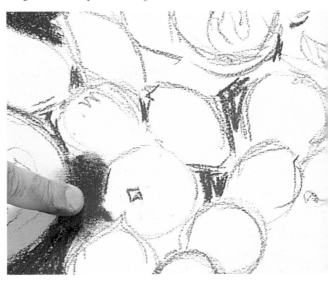

2. Both colors are blended together to produce a dark earth color with a shade that hints at the original colors.

3. Little by little, more colors are added. Notice how the light green of the stalks is indicated by using an optical mix of green with yellow.

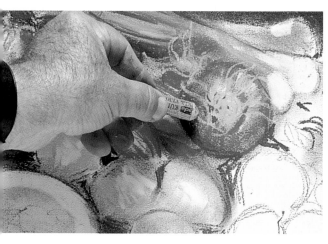

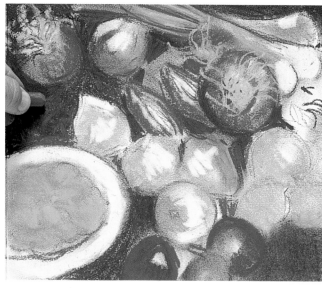

4. Our yellow is just the right color for painting the roots; we don't need to mix it with anything.

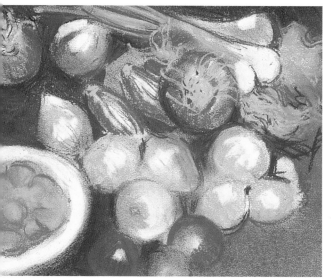

5. The background color is gradually adjusted as the painting progresses.

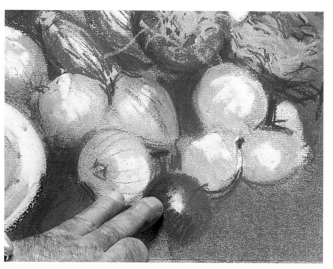

6. When the final color of each object has been determined, all we need to do is retouch the shadows and add the final details.

7. A touch of green intensifies the shadows of the onions in the foreground.

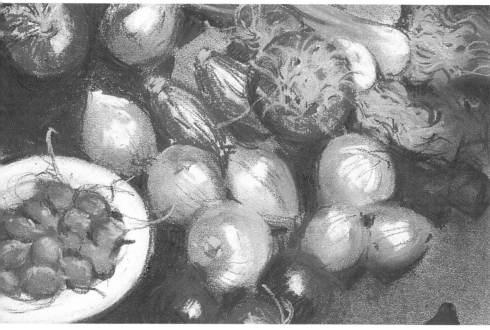

8. The final work reveals the effects of mastering color techniques and the extraordinary range of colors that can be developed using just three colors.

NOTE

When so many mixes are used, colors will need to be adjusted periodically during the course of the painting.

Background Color

The color of the paper or whatever surface you may work on strongly affects the final painting. Dark paper offers a contrast for light colors. A medium-toned paper will produce a series of balanced tones. Dark colors stand out well on a light background. You can also use various techniques to create your own backgrounds.

THE BACKGROUND AND THE SUBJECT

In pastel, it is always best to choose the paper color that best suits your work. If you want to introduce strong contrasts, you should choose a color that has a color opposite to what you are going to paint; if you want to create a more harmonious effect, choose a similar color. This way you can use the color of the paper to suggest some areas of color.

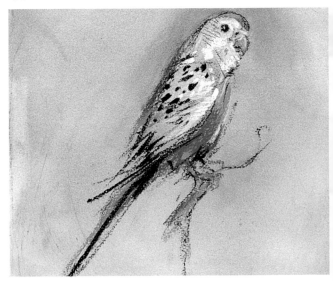

This is a fairly neutral background; it doesn't take advantage of either lights or shadows but it suits the bird's coloring.

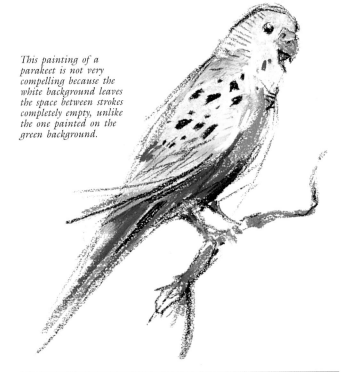

This painting of a parakeet is not very compelling because the white background leaves the space between strokes completely empty, unlike the one painted on the green background.

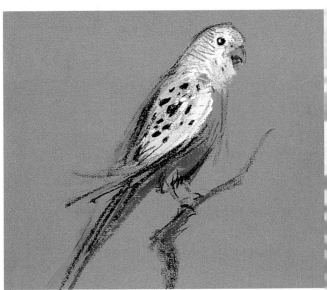

When the color of the background matches part of the subject, it can be used to suggest that particular part, such as the feathers on the bird's breast, then saturating the paper is no longer a concern.

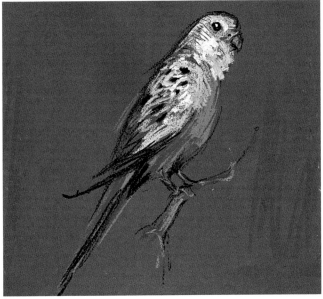

Light areas contrast strongly with a background as dark as this. Where the white background dulled this subject's highlights, this one intensifies them.

NOTE

In pastel, the paper's color is an essential element in the composition and balance of the work. The color of the background can even be substituted for an area of pastel.

PAINTING THE BACKGROUND

Although there is a wide range of tinted papers for pastel available in stores, many artists still prefer to color their own.

One simple way to color the background is to apply paint as usual, then blend it. Other methods can also be used that, although a little more involved, can create very interesting effects.

If you decide to treat the background with a method that involves water, such as diluting the pastel, make sure to use watercolor paper and attach it properly to the board so that it does not warp. Watercolor paper also stands up well to water and brushing. Fixative is not necessary with this kind of background; nor is it absolutely necessary for a dry pastel background. Whether you use fixative or not depends on your subject, the method you use, and the need to keep separate layers of color intact.

PAINTING THE BACKGROUND

USING COTTON

Cotton is the gentlest tool to use to apply pastel and produce delicate, transparent effects. Coloring a background with it is the best way to get an evocative, misty effect.

Since you are only applying a film of pastel, you have to consider how it will be affected by the color of the paper underneath. You should also use fixative if you want your layer of color to remain intact.

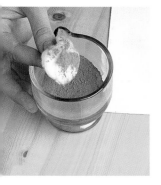

1. Absorb some powdered pastel with your cotton.

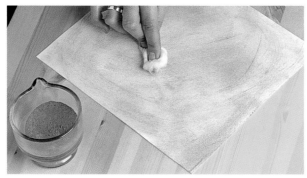

2. Apply it to the paper by rubbing firmly.

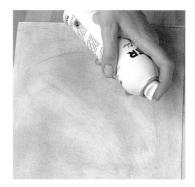

3. Apply fixative.

PAINTING THE BACKGROUND

DILUTING THE PASTEL

Another method for making interesting backgrounds is to brush water over applied pastel. You should really use watercolor paper with this system, remembering to attach it firmly to your board with masking tape.

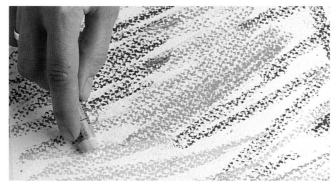

1. Stick pastel is applied.

2. The brush is dipped in a little water.

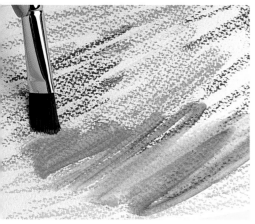

3. We wet the paint.

4. When the background color dries, we can begin to paint.

Drawing

It is unusual for a good pastel painter to draw poorly, since drawing is the fundamental technique on which pastel painting is based. Sketches of the subject, and the preliminary drawing to which the pastels will be applied, are all part of a pastel artist's work and can involve different media, from charcoal to pastels themselves.

DRAWING TECHNIQUES

The strength of the lines, their harmony with the colors, and the interpretation of the image all depend on the artist's mastery of drawing techniques. The preliminary sketch of the subject in which the forms, values, and colors are indicated is the basis for a successful pastel painting. The preliminary sketch can be drawn using any drawing medium, although, as a precaution against potential problems, some may require additional steps before you start to paint.

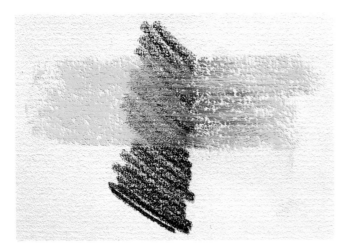

Graphite is a greasy substance that does not hold pastel. It will also smudge subsequent layers of paint.

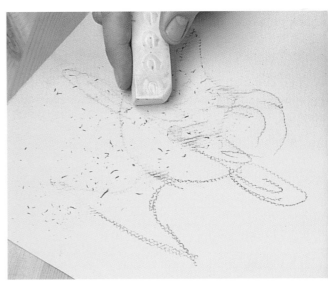

You should erase most of the charcoal before painting, since it tends to bleed into your paint.

It is best to draw the preliminary sketches using a color similar to your subject so it will not affect your color scheme.

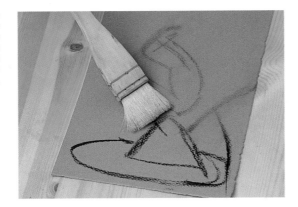

Pastel is the best medium for your preliminary drawings.

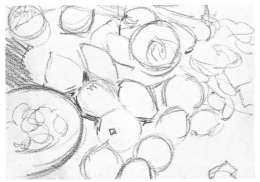

When the preliminary drawing has been made in pencil, it should be slightly erased before painting begins.

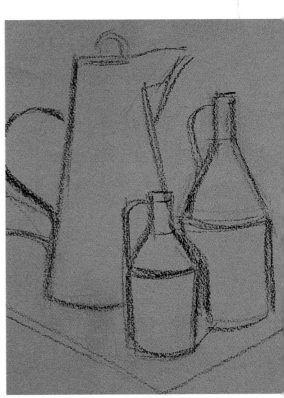

THE IMPORTANCE OF SKETCHES

Notes, drawings, and sketches of the subject drawn before painting begins often have a spontaneity and liveliness that the finished work lacks. Their appeal comes from their simple use of color, volume, texture, and shape.

We are going to reproduce the work, Noia, *by Baltasar Porcel, which is more a drawing than a painting.*

1. A dark earth color is used to draw the first few lines.

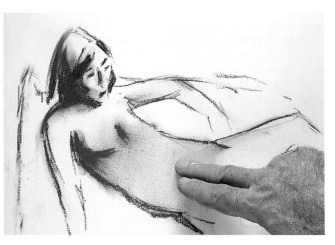

2. Shadows have been added and some of this paint extended to color some areas of the figure.

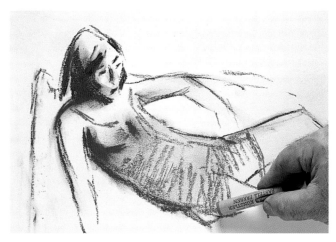

3. The strokes of red, besides adding touches of color, also suggest the wrinkles in the dress.

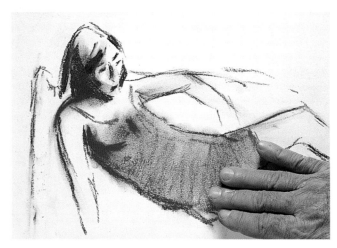

4. The red is blended only a little, so that the preliminary lines of the sketch remain visible.

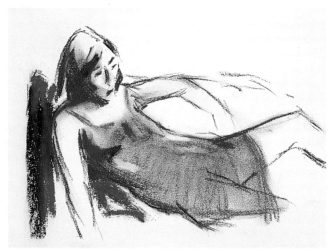

5. This is the finished reproduction. Notice that the blue areas have been added, but the colors of the cushion have been left out. You can see that the sketch is still strong, even without that additional contrast of red and blue.

NOTE

The importance of a sketch lies in the simplicity and spontaneity of its strokes and coloring.

Light and Shadows

The way light and shadows interact with an object is what gives the object a sense of volume and weight, in life as well as in art. Artists use this phenomenon to create the illusion of three-dimensionality. Light and shadows also play important roles in developing the overall tone of the painting.

TEMPERATURE AND LIGHT

The "temperature," color, and angle of light are essential elements in establishing the overall tone of any subject, real or imaginary. To understand the importance of light, think of any scene that you regularly see at different times of day—it can be a room, a landscape, or a street. Consider how the scene changes over the course of the day.

If, for instance, we look at a beach, we may notice that in the early morning, light makes the colors we see look cool and may have blue, green, or purplish tints. At midday, under a strong sun, our surroundings have warm hues, from the yellow, orange, and red range. At dusk, the sky fills with warm hues of yellow and orange that contrast with the long cool shadows objects are now casting.

TYPES OF SHADOWS

In light, every object produces two types of shadows: its own shadow and the ones it casts. The first describes the shadows on the object itself, while the second describes the shadows projected by the object onto another object or surface.

On the bright parts of the object, the tone is the color of the object itself.

Highlights are the brightest areas of an object.

This is the object's own shadow, the shadow one part of the paper casts on another part.

This shadow is cast by the object onto something else: the table.

FRONT LIGHTING

WORKING WITH COLOR

Front lighting, as its name suggests, means that the subject is lit only from the front. The light does not seem to create any shadows because they are hidden behind the object. This is the best kind of lighting for presenting objects just as they are, since shadows sometimes deform shapes. It is also the best lighting if you want to focus on color, since the absence of shadows means you must suggest volume through careful use of color contrasts.

Front lighting gives paintings a sense of openness, purity, and innocence; nothing is hidden. This explains why it has been used so much in portraits and in religious art.

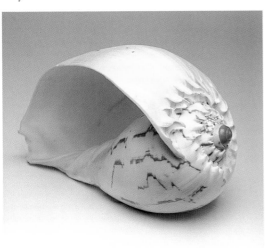

This seashell lit from the front has very few shadows; its volumes are perceived through its colors.

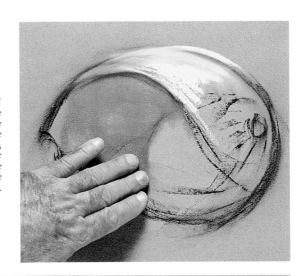

1. The brightest and darkest tones are applied first, the cream color on the outside of the shell, and the orange that belongs to the darkest part of the object.

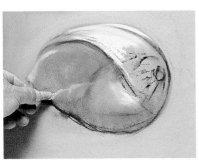

2. A lighter orange tone is used to increase the intensity of the areas that receive the most light.

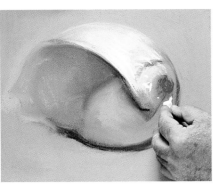

3. The part nearest the light source is usually the brightest, so white is used there.

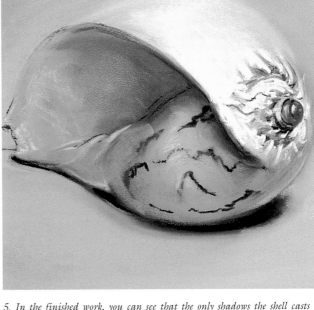

5. In the finished work, you can see that the only shadows the shell casts on itself are in its opening. This type of lighting makes even the inside of the shell clearly visible.

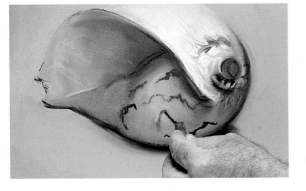

4. When the seashell is near completion, the pattern on the shell and various other details are added.

NOTE

Since front lighting produces few shadows, you have to use color to suggest volume.

BACKLIGHTING (SIDE) THE VOLUME OF SHADOWS

In backlighting, the source of light comes only from behind the subject. If it is perfectly centered there, the viewer sees only the silhouette of the object and not its volume because the visible side is in back, hidden from them. For this exercise, we have moved the backlighting slightly to the side; this still gives our subject the dramatic, mysterious air characteristic of backlighting, but it also reveals the dimensions of the shell. This type of lighting is also good for creating shadows, both on the object and surrounding surfaces. This increases the three-dimensional quality of the model. We are now going to recreate the subject through the use of light and shadow, that is, the interplay and contrast of tones from bright highlights to dark shadows.

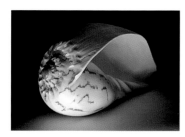

If you compare this photograph with the one for the previous exercise, you will see how backlighting creates strong shadows that suggest an air of mystery, a totally different effect from the front lighting of the same shell.

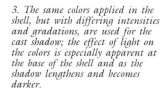

1. Yellow and orange are applied and blended to show the lightest part of the interior.

3. The same colors applied in the shell, but with differing intensities and gradations, are used for the cast shadow; the effect of light on the colors is especially apparent at the base of the shell and as the shadow lengthens and becomes darker.

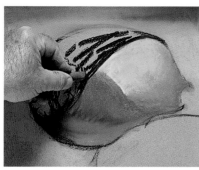

2. A dark earth color is used to suggest the darkest part of the shell's shadow. A pale cream color is applied next to it to render the shell's lightest area.

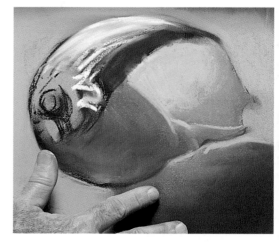

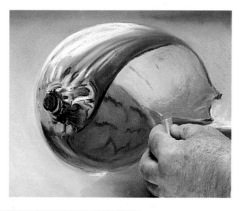

4. To finish, we add the details that suggest the texture of the shell and the subtle effects of the light.

NOTE

Backlighting always creates very dark shadows. If, unlike this shell, your subject is completely opaque, the dimension of the darkest areas will be hard to determine and may look flat.

5. In the finished painting you can see how important the cast shadows are for suggesting the direction of the light, and also how the colors of the shell change in shadowed areas. The dramatic effect that the light produces as it shines through the shell is particularly interesting.

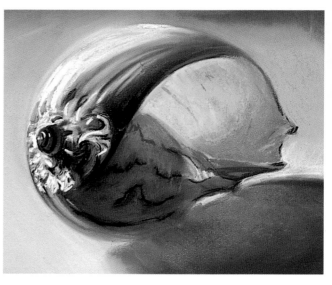

In overhead lighting, the light source is above the subject. As with any other type of lighting, if the light source is strong enough it will produce deep shadows that can distort the shapes and characteristics of the subject. For this reason, overhead lighting is never used for portraits; it will, however, give you interesting effects when you want to distort space or create a particular mood.

This kind of lighting has often been used in religious paintings; illumination from above implies a celestial source and conveys the impression of spirituality. On the other hand, light from above is also common in nature. Under the midday sun when there is little contrast of light with shadow, the upper part of a figure is bathed with light, throwing shadows onto the lower part until it can barely be seen.

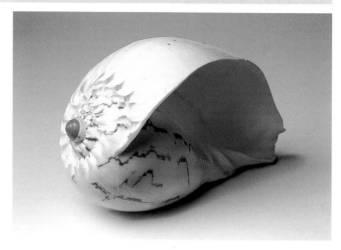

The seashell bathed in light from above and to the side, casts few shadows on the ground, although the shadows on the object itself are very strong.

1. We begin at the top, the lightest part of the shell, painting with the pale cream color.

2. The inside of the shell is not very dark, since it is partially translucent.

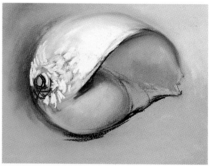

3. The background has been colored in, and the shadowy area of the shell has been worked on.

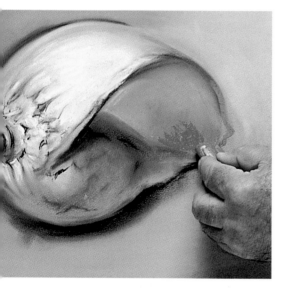

4. The different values are gradually corrected; highlights are brightened and shadows darkened.

NOTE

The object's own shadows are the ones that suggest its volume. Those shadows, like the ones that it casts, always follow the direction of the light.

5. In the finished exercise, you can see how the shell's shadow has been suggested with black and how interesting the contrast is between the upper part of the model, which receives the light, and the lower part, where the shell casts a shadow on itself.

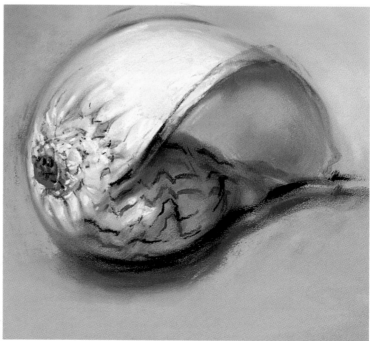

Methods

All pastel artists have their own painting methods; some even use a series of personal techniques that bear little resemblance to classical ones. While you will want to experiment later, you should consider working with the techniques we describe in our exercises until you gain some experience. This will guarantee the success of your first painting efforts and prevent your forming bad habits that will need correcting later.

EUCALYPTUS BRANCH

Anything can be a good subject for studying the classical method of pastel painting, but we recommend that beginners simplify matters by choosing subjects that will not move or change during their painting sessions.

Still lifes composed in the studio are, and always have been, the most common subjects for experimenting because they remain still during painting and they don't cost anything, since they can be composed using simple, everyday items.

METHODS

Even though all artists have individual methods developed from practice and experience, there is a classical procedure for pastel painting that is widely followed and guarantees success if you understand the basics of how pastel behaves.

We are going to give you a step-by-step demonstration of the classical method of pastel, using as our subject this simple, elegant still life of curved vase, eucalyptus branches, and white flower.

In the first stage, you make a preliminary drawing suggesting forms, and add a few strokes of color to indicate the basic hues fo each area. Next, volumes and depths are developed through the interplay of color and tones, especially highlight and shadows. Finally, tona values are adjusted and the final details added that give the painting vitality and realism.

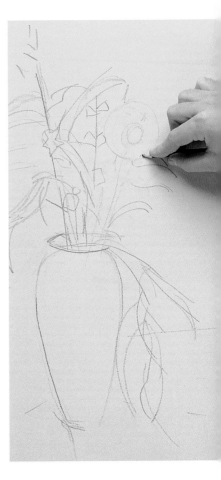

1. We have chosen an ochre colored paper whose hue is similar to the background of our subject. The first step of the painting process is to make a preliminary drawing of the subject on the paper. You can use a pastel or, as in this case, a pencil.

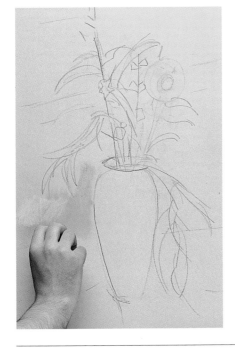

2. To figure out the right background color, we experiment with several different tones, weighing different intensities and hues.

NOTE

Graphite is a greasy substance that sometimes prevents pastel pigment from adhering to the surface of the paper; therefore, when you make a preliminary sketch in pencil, you should lightly erase the lines before starting to paint. In this exercise, we are going to leave them as they are so that you can see the basic drawing clearly in the sequence of photographs.

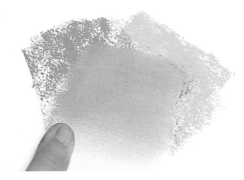

3. To avoid filling the surface of the paper, more tests are performed on a piece of scrap paper.

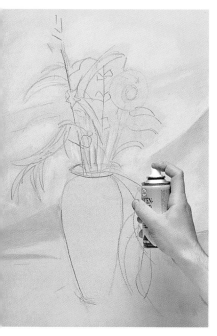

4. A homogenous tone has been used for the table; the background, however, has been painted with several different tones that suggest the wrinkles in the cloth. Fixative is applied over these initial colors.

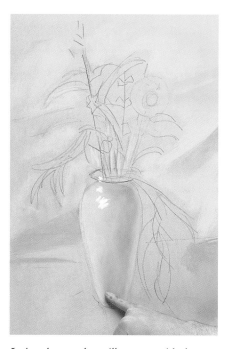

5. A cool green that will contrast with the warm-colored background is used for the gray of the vase. Several values are used and then blended gently. The light tones correspond to bright areas, and dark ones to the shadows. Notice how touches of white indicate the highlights.

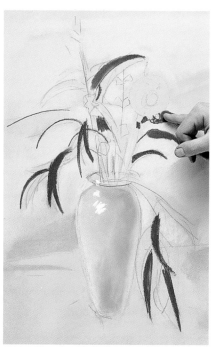

6. A dark green has been used for the leaves. This color is now blended gently. The fixative applied in step 4 prevents the colors from mixing.

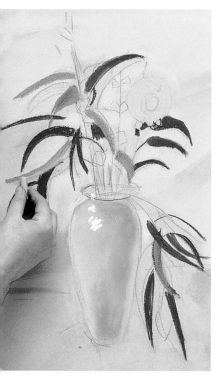

7. New tones of green help suggest the varying colors of the leaves, and how light reflects off them. This also begins to give them form and volume.

NOTE

The variety of colors and tonal values enables us to suggest the volume of objects and create the illusion of three dimensions.

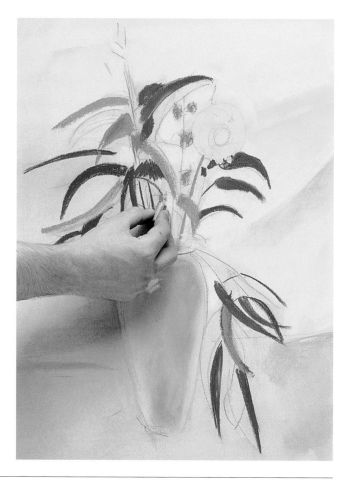

8. Several spots of red indicate the small eucalyptus flowers.

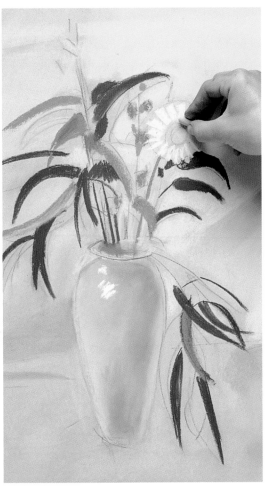

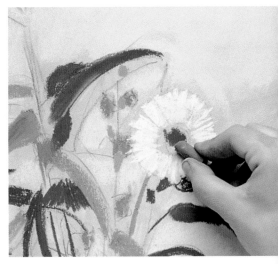

9. We use a white pastel to paint the white flower. Short, precise strokes suggest the petals.

10. The center of the flower is painted with a dark earth color.

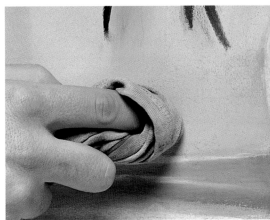

11. We use several different tones to develop the volume of the wrinkles on the cloth, then blend them with fingers and a cloth, which is particularly good for large areas.

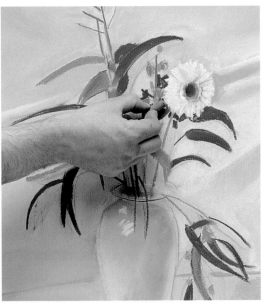

12. Accuracy is needed to make the right shapes when coloring in the spaces between the stems, leaves and flowers. We suggest the leaves in the midground, taking care not to paint over the existing colors.

NOTE

You should work on the background and the subject at the same time so that all the different colors and tonal values can be integrated naturally.

13. We alternate between working on the background and making corrections on our subject.

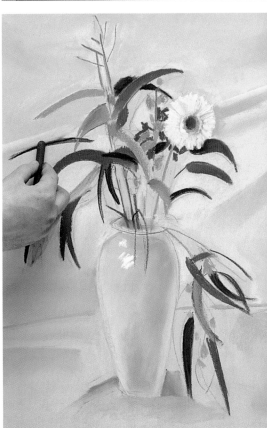

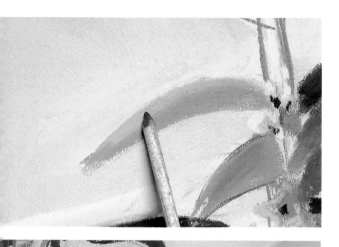

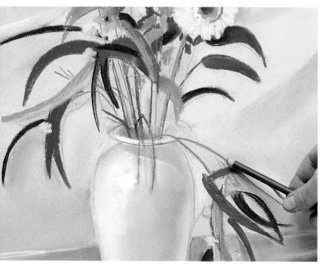

14. *A stump is used to retouch the areas where fingers would not be accurate enough.*

15. *Final touches of light are added to the table, correcting the initial values and further developing the volume of the subject.*

16. *A fan-shaped brush is used to slightly soften the wrinkles.*

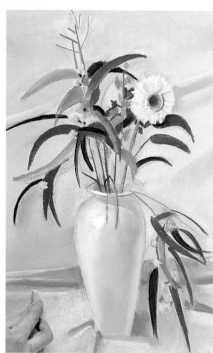

17. *The final details, requiring very fine lines, are drawn with a well-sharpened pastel pencil.*

18. *In the finished exercise you can see how we have established a harmonious balance of colors while refining the tones of the larger areas of color, such as the background and vase, and experimenting with the contrast of the different greens in the eucalyptus branches.*

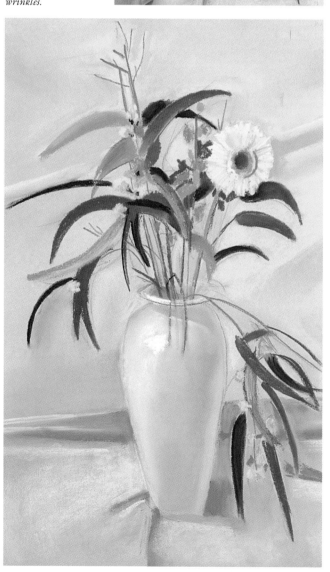

Painting with Lines

The very shape of pastel sticks and the fact that pastel is a direct method of painting (no solvents, brushes, and so on) means that an approach similar to drawing can be used; pure drawing, like pastel, also uses both one-color and multicolor techniques.

Playing with areas of color in a work that is characterized by the use of the line is a style that falls halfway between drawing and painting; taking elements from both techniques produces interesting results.

A CACTUS

For this exercise that combines the techniques of drawing and painting we have chosen a subject that lends itself to the use of lines throughout the entire process, even in suggesting its volume and texture. You will also see how an interplay of lines can be used for the sky.

The unusual shape of the arms of this cactus and the angle from which we are going to paint it make for an interesting exploration of this mixed technique.

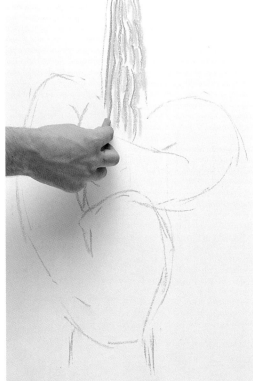

3. Detail: In step 2, all the straight lines are drawn by resting the entire stick on the paper, as you can see in the photograph. This gives us stronger, more accurate lines.

NOTE

The position of the stick on the paper determines the thickness of the line, while the pressure applied controls the amount of pigment that is transferred.

PAINTING OR DRAWING?

What is the difference between drawing and painting? Where does one end and the other begin? These questions don't really have definite answers, as there is such a range of opinions on the subject. For our purposes, let's just say that drawing is based on lines, while painting relies more on areas of color.

1. After sketching in the basic shape of the cactus, we use ochre lines and a deep earth color to begin suggesting its texture.

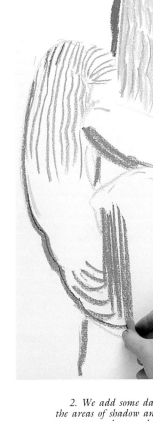

2. We add some dark green to indicate the areas of shadow and use a few decisive strokes to add some straight lines.

This exercise is called "Painting or Drawing?" because the final work could be described as a painting or as an elaborate drawing. The aim is to use the potential of both techniques to achieve new results and discover more about the nature of pastels.

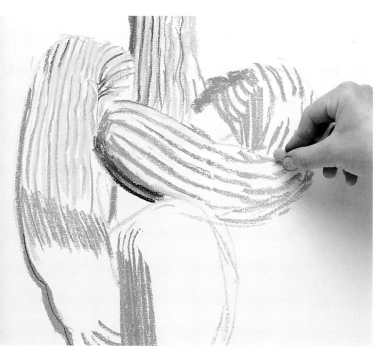

4. The direction of the lines is the fundamental tool for representing the shapes and volumes of the cactus.

5. A worn-out pastel stick can be broken in half to obtain perfectly flat tips and sharp edges.

6. We draw these thick lines by resting the stick vertically on the paper.

7. The value, or the light or darkness of the tones, is another basic tool for suggesting volume. This dark tone indicates areas of shadow.

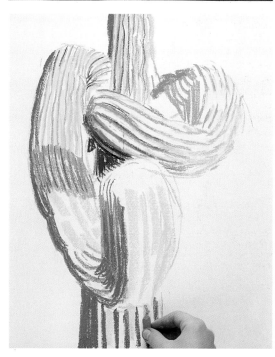

NOTE

The direction of the line and interplay of tones are fundamental tools for suggesting volume.

8. Irregular lines suggest the rough edges.

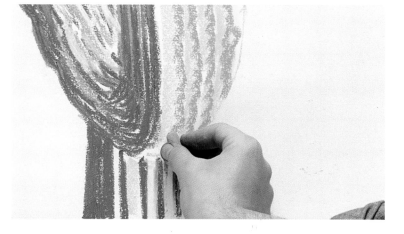

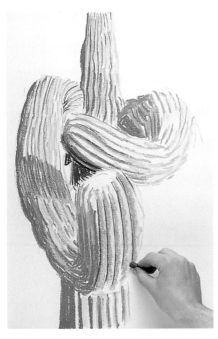

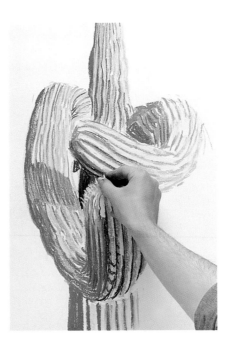

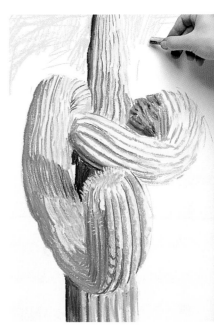

9. Thin, precise lines are drawn over the irregular lines we have just painted to suggest the grooves in the surface of the cactus. Because this area is in the foreground, we have to show more detail.

10. Small white lines indicate the thorns.

11. Before we can check that the tones used for painting the cactus are correct, we have to see how they are affected by the colors of the background.

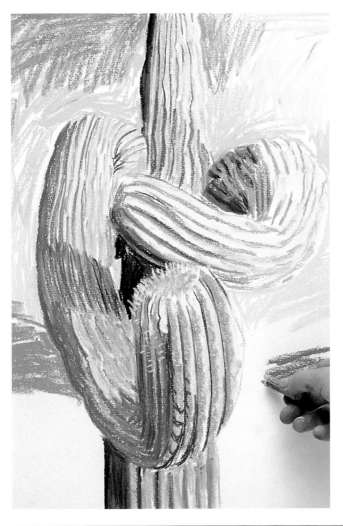

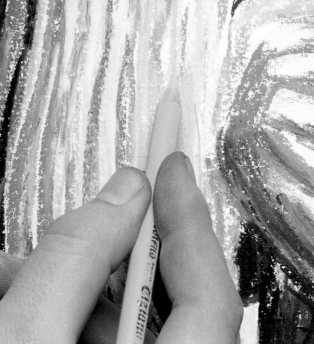

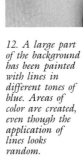

12. A large part of the background has been painted with lines in different tones of blue. Areas of color are created, even though the application of lines looks random.

13. Some parts of the cactus are retouched with fine lines drawn with a pastel pencil.

NOTE

To create areas of color, you do not need to blend your paint; groups or series of lines are also perceived as single fields of color.

14. We need to draw some fine lines with a color that we only have in stick form; a knife can be used to sharpen it.

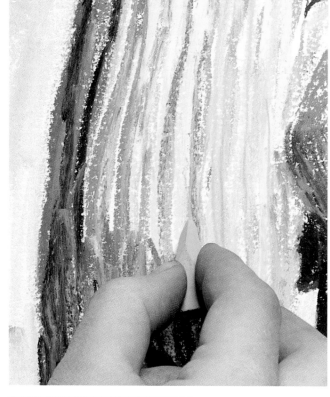

15. This sharpened tip is used for the details.

16. The background is completed.

17. Some shadows have to be darkened before the painting appears finished.

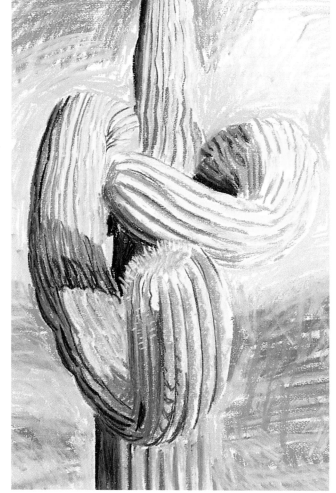

NOTE

The background color has a strong effect on all the other colors, so remember to take it into account when you adjust the colors of the central figures.

18. In the finished exercise, you can see how lines have been the chief ingredient used to construct the image of the cactus; we even used them to make the sky in the background.

True Painting

When pastel is applied with a brush, as with oil or acrylic, it is called "true painting." Thick layers of paint are applied in impasto, and only color is used to suggest volume, while most drawing techniques used in ordinary pastel painting are avoided.

IMPASTOS

The process of applying thick layers of paint to the support is called impasto. Because of Pastel's poor adherence, it cannot be layered as thickly as other media, such as acrylic, but the paper can still be filled with paint. "True painting" i pastel, however, does com close to painting in media lik oil, because developing area of color is still the most basi element; the line is onl secondary. Impastos can b produced either by applying large amount of paint at on time or adding successiv layers of paint.

One way of applying pastel as impasto is to rub a piece of pastel stick on the paper until all the paint is spread out.

1. An earth color is used for the preliminary drawing.

A STILL LIFE WITH TOMATOES

When painting with impastos, you should choose subjects with simple volumes, avoiding complex forms with lots of detail, especially forms composed of lines. Spherical shapes or an impressionistic treatment of your subject are key to working with pure colors and eliminating lines, so you can create an effect similar to that of other painting mediums.

A simple still life with tomatoes is a good example of the variety of shades that a single color can have; it is also a good subject for experimenting with impasto.

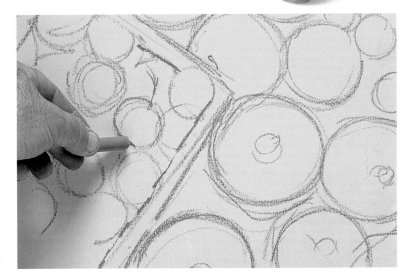

2. We begin to apply the colors that will define each part of the painting. Sky blue is used for the background, red for the small tomatoes.

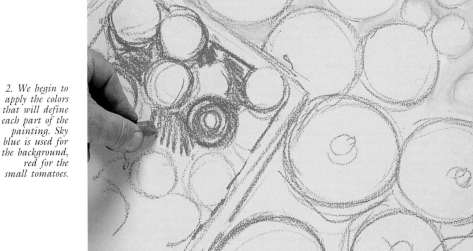

NOTE

You should test the color of each element in the composition right from the beginning so you can make any necessary adjustments as you work.

3. The tomatoes in the center have been painted in
vermilion, then blended.

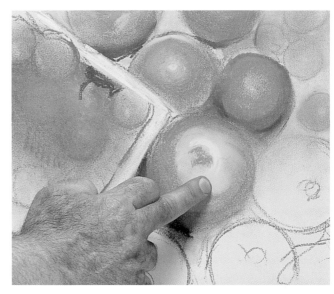

4. The yellow is blended.

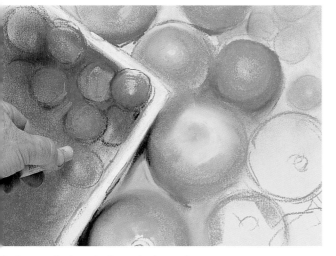

5. A sense of volume begins to develop as the
different tones are combined; in this case, a pink
has been used for the lighter areas.

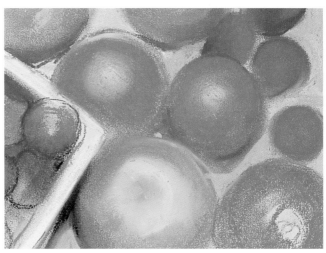

6. Each tomato is painted in a slightly different
shade, since this subject's appeal is the wide variety
of reds it contains.

7. We adjust the sky blue of the
background by adding a little
mauve.

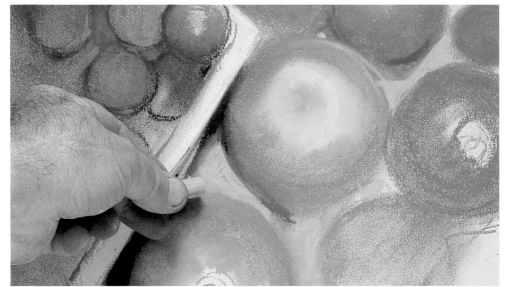

NOTE

The best way to widen the
variety of shades a color can
produce is to mix it with other
colors from the same range.

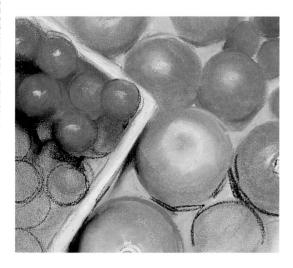

8. After painting the background, we sketch in the outlines of the tomatoes. These will be used to suggest shadows.

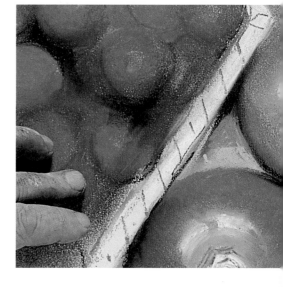

9. More paint is added to the thick layer that suggests the cherry tomatoes. We adjust the black of the shadows and also the red.

10. The moisture on the tomatoes is indicated by a few red dots.

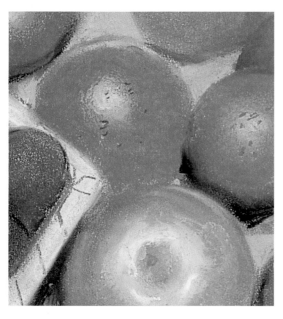

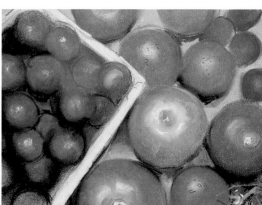

11. We now work on the painting as a whole, developing more contrast between the shades of the various tomatoes.

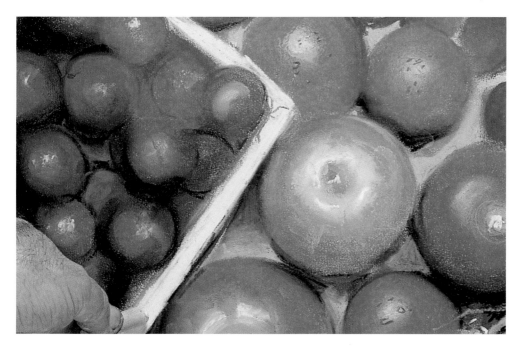

12. When we are satisfied with the volume of the tomatoes, we work on the basket.

NOTE

When objects are piled up, their shadows usually follow the line of their outlines.

13. We add still more paint to develop an interesting impasto.

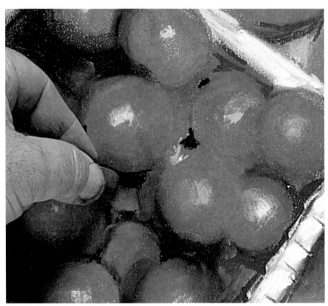

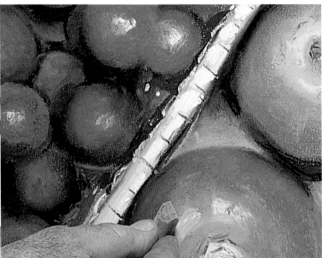

14. The same procedure is applied to the shadows, defining their shapes.

15. Holding the stick vertically, we add the final highlights that will suggest the moisture on the surface of the tomatoes.

16. In the finished exercise, you can see how carefully the thick layers of paint have been applied to achieve a dense color.

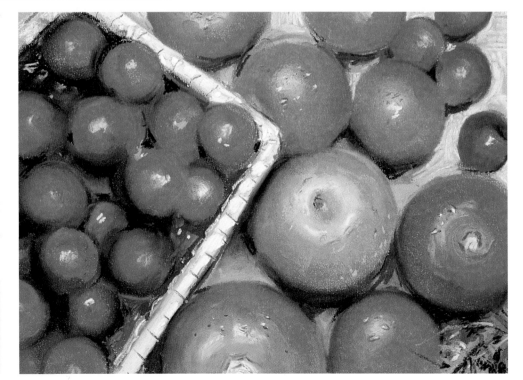

NOTE

A few touches of color are enough to suggest the moisture on the surface of the tomatoes.

Blending

Blending, one pastel technique that is used primarily to work particular areas of color, is sometimes turned into the main element of a work. This is either because it mimics the nature of the subject or because the artist is specifically attracted to the method. Blending paints into homogenous areas of color gives a work a veiled, transparent appearance that is different from that of a conventional painting that combines color blends with precise lines and vigorous strokes.

BLENDING PROCEDURES

Most pastel artists blend paint with their fingers or the palm of their hands—this is the fastest, most precise technique.

Blending with your fingers or hands, however, does have a few drawbacks. The natural oil of our skin sticks to the pigment and, as a result, produces areas of color that are more compact than those made with a rag or stump. Rags produce more subtle effects and are also easier to use when you want to work on a wide area. Stumps come in handy in the smallest areas where your fingers may be too thick. Not all artists use stumps, however, as they get dirty easily and are difficult to clean. See: Using Pastel, 24–29.

ANEMONES

A pastel work painted entirely with blended colors has a blurred, misty look with vague areas of color that give objects an ephemeral, magical appearance. Blending is a particularly good treatment for such subjects as a foggy morning or a scene viewed through a curtain, in which the painting style can suggest what the eye actually sees. You should also feel free to use this technique to interpret reality in your own way, perhaps giving an unusual feeling to an everyday scene.

1. We are using brown wrapping paper because blended colors will produce more interesting effects on it than on other papers. The sketch has been drawn using an earth-colored pastel stick.

NOTE

Wrapping paper is an economical option when you are experimenting with different methods; you only have to take into account that its surface tooth fills quickly.

2. Different shades of green have been used for the background and then blended, using fingers.

We have chosen this image because the shape of the anemones, a single field of color, and a blurry background lend themselves to blending.

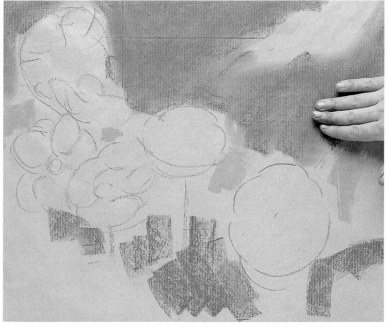

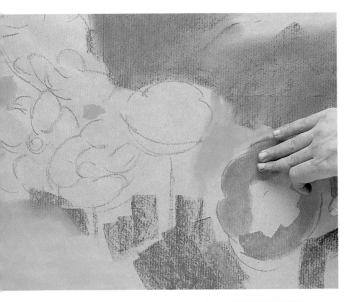

3. Once the right tone has been applied to the background, we can start to paint the flowers.

4. If you have a lot of pigment on your fingers, and are about to blend a light color, remember to clean your hands first with a cloth.

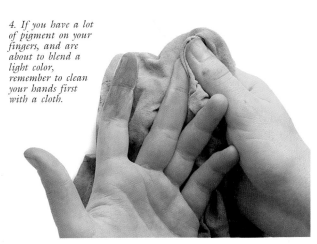

5. We applied the white with clean fingers, and now blend it using our fingertips. Notice how we follow the direction of the line when we blend the color in order to suggest the volume.

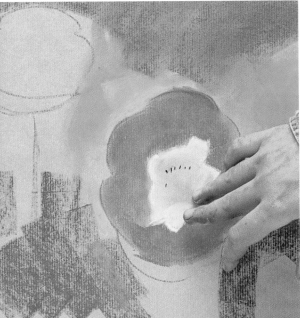

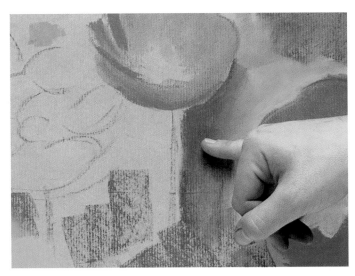

6. We work on the flowers and background at the same time. This results in a natural-looking meeting of colors.

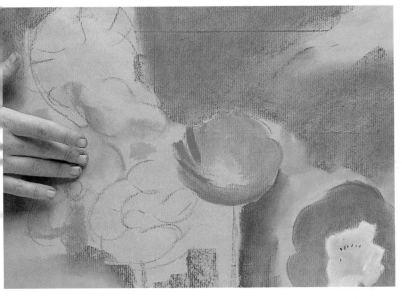

7. These mauve tones are the product of white and violet; the interplay of tones is used to distinguish one petal from another.

NOTE

Blending is also a method for mixing colors on the paper and obtaining other effects.

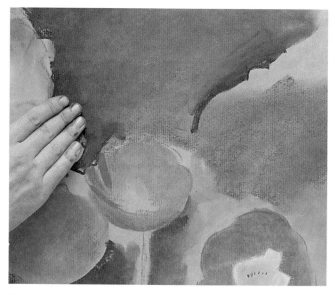

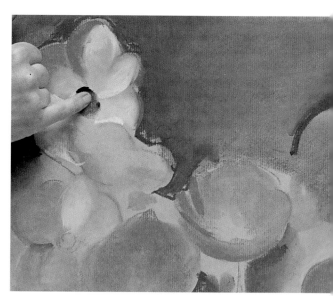

8. As the paper is gradually covered with paint, the tonal values must be adjusted; in this case, we want to darken some things.

9. A touch of brown is enough to indicate the center of the anemone.

10. You should use a damp sponge to clean your hands when a rag is not enough so that you don't inadvertently smudge your painting.

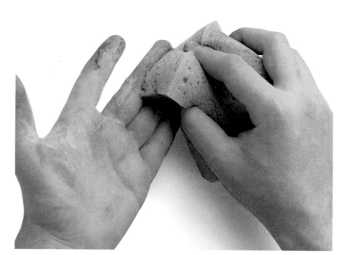

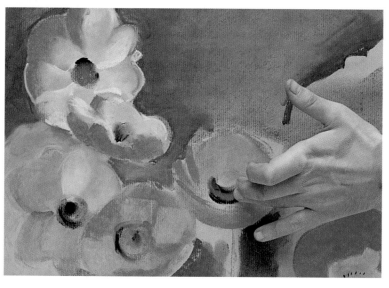

11. The larger areas of color are now blocked in and some flowers are practically finished. The background color is blended delicately to preserve the outline of the flowers.

12. After applying the paint, it is gently blended with a finger until it forms a button shape; the addition of this detail gives the flowers a more three-dimensional appearance.

NOTE

It is common for most blending to be done with fingers; you should keep them as clean as possible to protect your work from smudges.

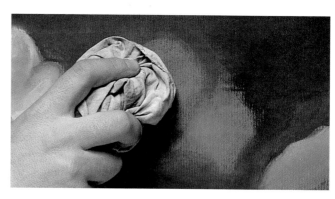

13. We add a few touches of yellow to brighten the light areas, then blend them with the green of the background.

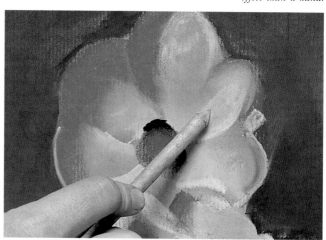

14. We continue to work on the background, using a cloth to blend it since it produces a softer effect than a hand.

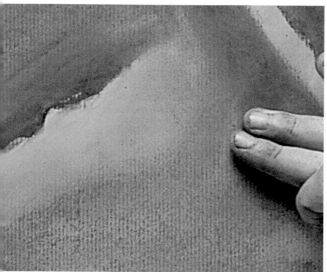

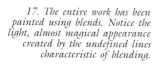

15. Smaller areas are blended with fingers.

16. As a last step, the flowers are retouched using a stump, as a finger is too thick to maneuver in such small areas.

17. The entire work has been painted using blends. Notice the light, almost magical appearance created by the undefined lines characteristic of blending.

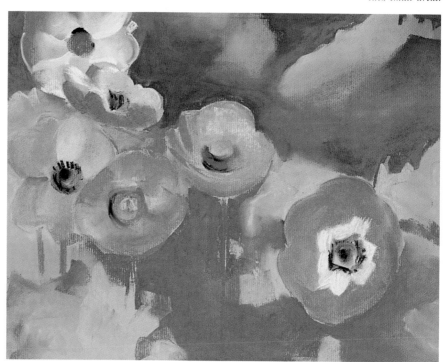

NOTE

One of the characteristics of blending is that the outlines are dulled, creating a light and airy effect.

Painting with Short Strokes

The expressive potential of the line, the texture of the paper, and the marks left by the pastel all combine to give you a variety of visual options in the versatile medium of pastel. Eventually, you will begin to prefer some effects over others as you develop a personal style.

A style of painting based on short, dynamic strokes and the vibrating color of optical mixes has its origins in the Impressionist movement that appeared in France in approximately 1860. Impressionism was loosely based on the idea that reality could best be represented by painting the effects of light and color in the human eye.

OPTICAL MIXES

Optical mixes are not created by physically mixing two colors to make a third one but by juxtaposing colors on the paper so that, at a distance, the viewer perceives a new color. Juxtaposing or superimposing short strokes of color are two ways of creating optical mixes.

Optical mixes produce dynamic, vibrant effects, quite different from those obtained using colors blended on the paper itself. They also allow you to show textures and create surprising hues.

This approach to painting is basically the same one used by the Impressionists, since it tries to capture the first visual impressions that the subject leaves on the eye by avoiding detail and building up forms and areas of color using short strokes of paint.

SALMON

Any kind of texture can be suggested by building up forms and volumes using short strokes of paint, optical mixes, and the texture of the paper; you don't need to mix colors, blend, or paint perfectly defined shapes. For this exercise, we have chosen a subject from nature whose combination of different textures will give you some practice with this technique and an opportunity to develop a sense of its possibilities.

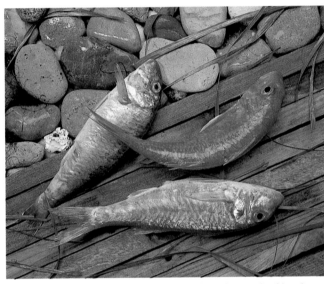

The texture of the salmon and their surroundings is a good subject for working with lines and optical mixes on rough paper.

NOTE

When painting with short strokes of color, you will primarily use optical mixes; if you are unfamiliar with how your colors are going to react, you should test them first on a piece of scrap paper. See: Using Pastels, pages 24–33.

1. We are using watercolor paper because its rough surface evokes texture, complementing the forms that will be constructed with short strokes of unblended color. The first step is to draw the preliminary sketch.

2. After positioning the different elements on the paper, we are ready to start painting. First, however, we experiment with colors for the salmon.

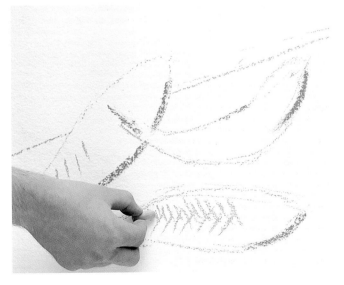

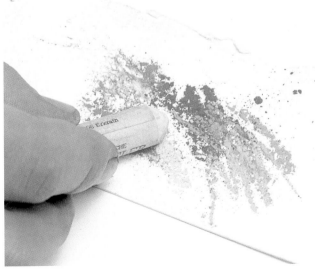

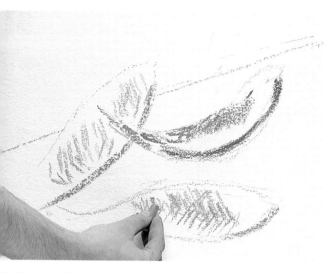

3. Crisscrossed lines suggest the scaly texture of the fish.

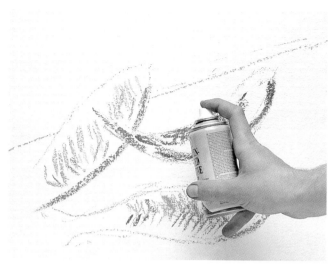

4. Fixative is applied to this first layer so it will remain intact when we paint over it later.

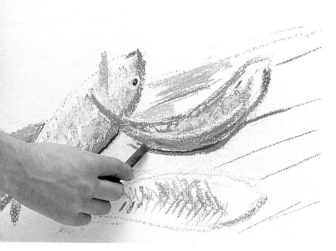

5. Once the two fish at the top have been painted, we begin to shade in the wood; a dark earth color suggests the shadow.

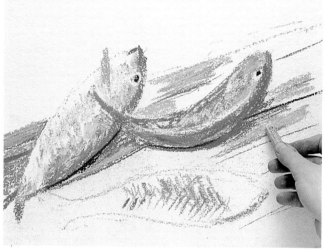

6. The wood is painted following the direction of its grain; notice how we combine different shades and tonal values to emphasize the idea of grain.

7. We return to the salmon. The rough texture of the paper prevents the pastel from completely penetrating the surface tooth; the bright paper bleeds through the paint, giving us scattered highlights; a little white intensifies them.

NOTE

Fixative slightly changes the tone of colors but is extremely useful in preventing colors from smudging or bleeding into each other when they are superimposed.

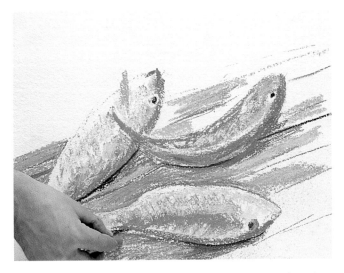

8. After developing just the right shades for the salmon, we work on the surrounding wood, taking great care not to paint over the fish.

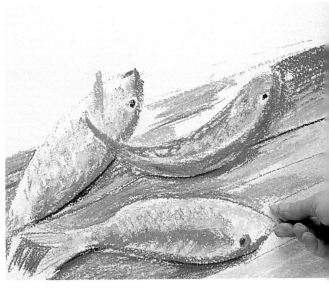

9. The lighter parts of the wood are painted in yellow ochre.

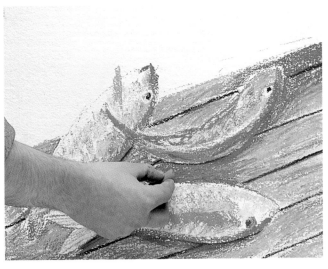

10. A darker tone is used for the shadows, still following the grain of the wood. The joints in the wood are rendered using a steady, straight line.

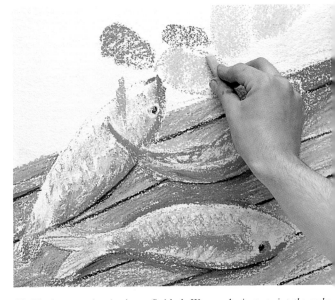

11. The lower section is almost finished. We now begin to paint the rocks, pulling the pastel flat across the paper. The resulting colors are uneven because of the deep tooth of the rough paper.

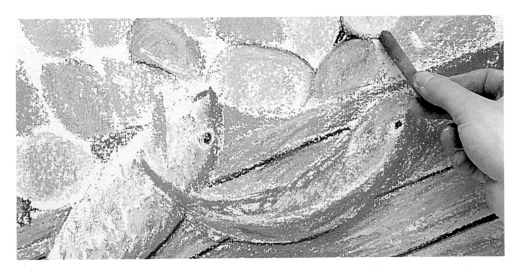

12. Notice how we made the rocks more interesting by painting them with free, spontaneous strokes. The edges of a dark-colored stick were used to touch up the shadows.

NOTE

The position of the stick on the paper creates the different thicknesses and types of line.

13. Light-colored pastel sticks get dirty easily; to clean them, simply wipe them with a cloth.

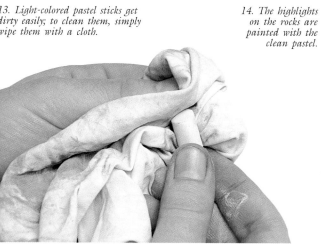

14. The highlights on the rocks are painted with the clean pastel.

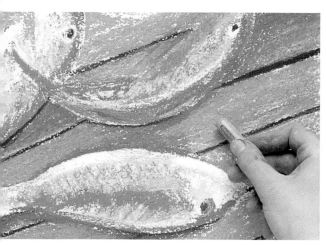

15. When we finish the rocks, the entire surface of the paper will have been painted. We take a minute to consider the work as a whole and realize that the tone of the wood needs to be slightly darkened. This is done by adding just a few strokes of paint.

16. The result is this dynamic, vibrant image created by optical mixes and small areas and dashes of color. This approach to color again shows pastel's versatility; in this case, it gives us an effect very similar to that of a wax painting.

NOTE

The combination of rough paper and unblended paint produces a pastel work similar to a wax painting.

Pastel Painting with Water

The composition of pastel paint means that it can be diluted in water and used the same way as watercolor. This interesting characteristic lets us create unique backgrounds, tint the paper, or paint an entire pastel work with a brush.

Combining a dry technique with a wet one gives us the chance to experiment, not only with the paint, which is versatile in itself, but also with the support. The reason for this is that we have to use a paper that can accommodate water as we work but not warp during drying.

PAINTING WITH WATER

To dilute pastel, simply apply it to the paper, then paint over it with a wet brush. The pigment is immediately diluted and spreads out easily under the brush. Color mixing is done the same way.

When working with "wet" pastel paint, it is essential to use good-quality paper that will not warp and is sturdy enough to withstand the pressure of the pastel stick. Watercolor paper is the best kind to use, since it is expressly designed for wet painting. You also have to remember to attach the dry paper firmly to your drawing board with masking tape to prevent it from warping when it gets wet or when it dries out.

FANS

The versatility of pastel paint allows it to be diluted and used the same way as watercolor. This lets us paint transparent glazes and mix colors on the paper. The basic difference between one medium and the other is that watercolors are purer than diluted pastel. Also, pastel painters do not generally use a palette; the color is applied to the paper with a stick, then diluted with a wet brush.

NOTE
When using water with pastel, you should have paper that can absorb water without warping. Watercolor paper is best.

This group of fans forms an almost abstract image with an interesting range of contrasting colors.

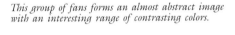
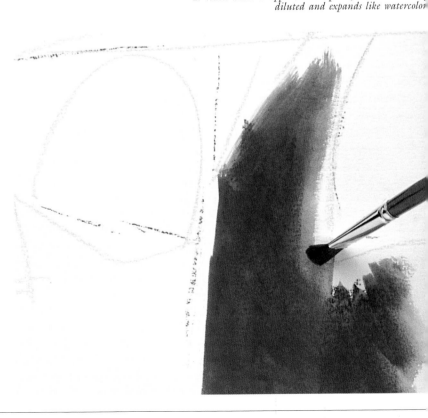

2. When water is applied to the paint, it is immediately diluted and expands like watercolor.

1. After applying some paint using a pastel stick, we slightly wet our brush.

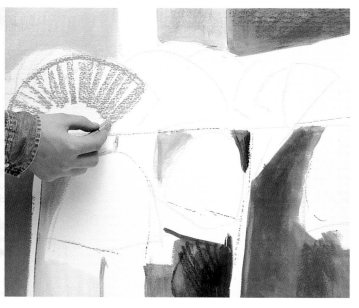

3. We start on the blue fan after painting the background.

4. Before diluting the paint on the paper, we rinse out the brush so the previous color won't mix with the current one.

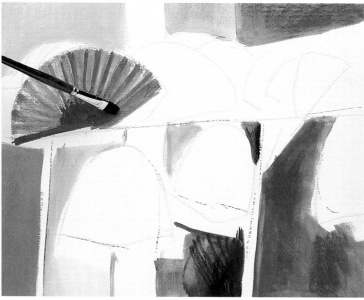

5. The clean brush is used to paint the fan.

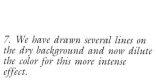

6. Before painting the red fan, we test the color on scrap paper to check the value of the tone.

7. We have drawn several lines on the dry background and now dilute the color for this more intense effect.

NOTE

Do not use a pastel stick on wet paper. If you need to paint with a stick on a section of paper that has already been painted, wait until the first layer dries; otherwise, the wet paper might tear.

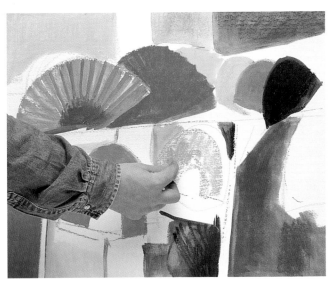

8. We then mix yellow and ochre.

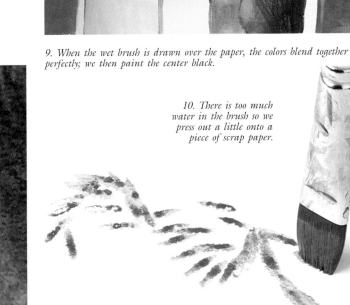

9. When the wet brush is drawn over the paper, the colors blend together perfectly; we then paint the center black.

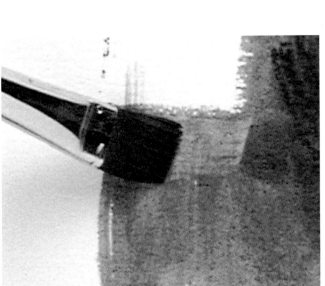

10. There is too much water in the brush so we press out a little onto a piece of scrap paper.

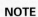

11. A very dark tone is tested on the same scrap paper.

NOTE
To darken a tone without waiting for it to dry, mix and dilute the paint on another piece of paper, then apply it.

12. We use this tone to darken several areas of shadow in the painting.

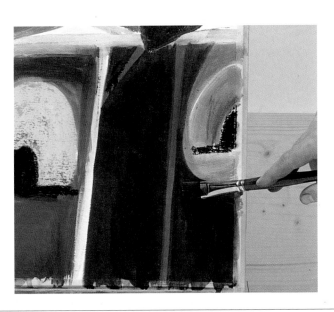

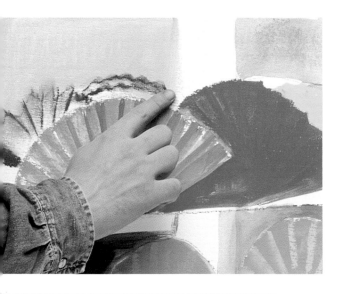

13. To suggest the lace texture of the black fan, we draw several lines, then blend them slightly.

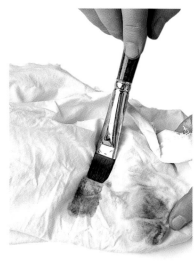

14. A cloth is then used to squeeze out the brush until it is damp, not wet.

15. Reducing the moisture means we get a hazy effect when the brush extends the paint.

16. The last step is to paint the folds of the fans.

17. The final result is a pastel work that looks like a watercolor. You could continue to work on this surface using both dry and wet pastel techniques. We only used the wet technique here so you could get a better sense of it.

NOTE

The effects produced by diluted pastels are useful for painting backgrounds, coloring large areas of the paper, or creating effects similar to watercolor.

Oil Pastels

Oil pastels are sticks of pigment that are bound with oil. Though the technique for them is different than for conventional pastel, you should also become familiar with this versatile and expressive medium.

Oil pastel is different from ordinary pastel because the pigment is bound with oil instead of gum. The oil produces effects closer to those of artists' wax crayons than to those created by conventional pastels.

Oil pastel does not crumble easily, is sticky to the touch, and cannot be blended, it can only be diluted with turpentine. The marks it leaves on the paper resemble the marks of a wax crayon more than a pastel, although an entire work in oil pastel is more like an oil painting. This type of paint is particularly good for painting on cardboard that is covered with canvas, especially if it is going to be used in its paste form.

You can paint comfortably over a diluted color.

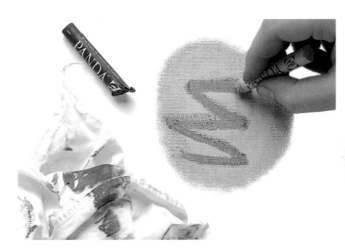

Oil pastel does not blend easily, as it is sticky.

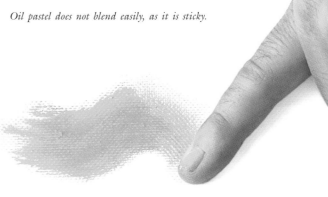

Oil pastel can be applied using a palette knife, since it is compact and doesn't crumble as ordinary pastel does.

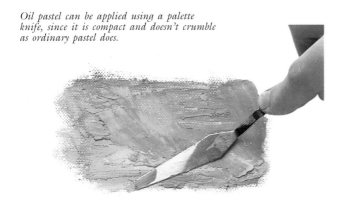

Another way of mixing it is to use turpentine and a brush to dilute the paint.

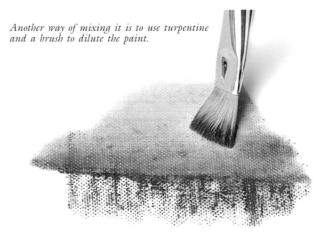

It has an ideal consistency for sgraffito work.

When colors are mixed directly on the paper, you end up with results like this gray, which is extremely thick.

The paint can easily be diluted with turpentine.

ROOFTOPS

An aerial view of any city always results in surprising discoveries of interconnecting rooftops, rooms, walls with unusual textures, drying laundry, and flowerpots. Part of an artist's skills is transforming a scene from everyday life into something compelling, like recalling an image seen through a window and converting it into a pastel painting.

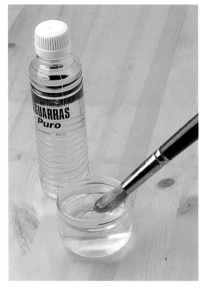

1. The brush is dipped in turpentine.

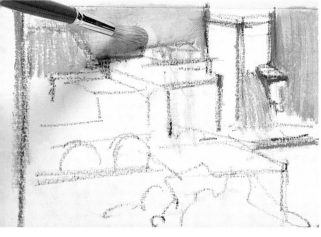

2. We use it to dilute the paint we applied during the preliminary drawing.

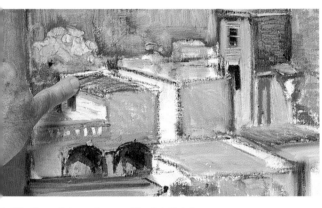

4. The lines of the rooftop are blended slightly.

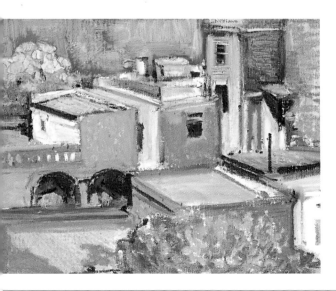

6. The result is halfway between an oil painting and a wax painting.

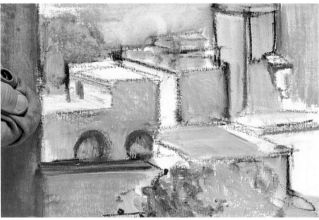

3. The buildings are worked on first; some areas of color are left as they are, while others are diluted. A cloth is used on the paint to suggest the texture of the wall.

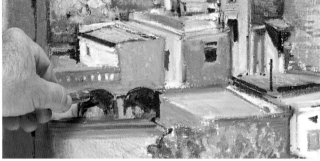

5. The vegetation has been rendered by applying small touches of paint with a stick. The shadows under the arches are darkened.

NOTE

You shouldn't paint directly on canvas with oil pastel unless it is supported by something else. Cardboard can be used, since it can withstand the rubbing pressure of either pastel sticks or fingers.

Skies

The sky can appear in any outdoor scene, especially in landscapes and seascapes, and, although it is usually just a secondary element, the sky can become the primary focus when the play of light, or dramatic presence of cloud masses or fog, make it sufficiently compelling. An especially dramatic sky can even provide the entire focus of a painting.

their colors, and the shapes of their clouds and of each cloud's shadow are always changing. You must study your sky very carefully before beginning to paint, making quick sketches, noting basic shapes and colors, and trying to imprint the rest in your mind. These preparations will help you as you paint, when the general forms and colors in the sky change.

end of the day, it is bathed in the warm hues of oranges, yellows, reds, and purples. At any hour, painting a clear sky involves gradating from darker tones toward lighter ones.

Since it is difficult to mix colors in pastel, preventing abrupt changes of tone, even in a simple gradation, requires a certain mastery of technique. As a result, a nicely executed gradation that involves blending several colors together, can be as impressive as a sky billowing with clouds.

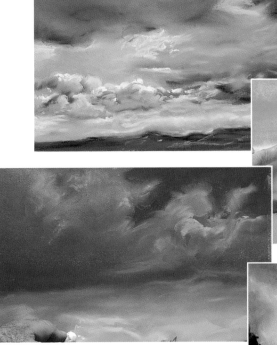

EVOCATIVE SKIES

The presence of clouds, light filtering through them, or the extraordinary colors of a sunset can make the sky a compelling subject for a painting. Skies are often secondary elements in landscapes, seascapes, and other types of outdoor scenes, but particularly evocative skies can be the main subject of a work, relegating whatever is below it to a secondary position.

Skies are especially good for evoking moods. A crisp, sharp sky with the intense blue of midday can suggest happiness; the warm colors of a sunset hint at romance. A gray, rainy sky seems sad, and an afternoon thunderstorm with menacing, dark clouds and beams of light filtering through them is loaded with all kinds of drama.

offers an astounding variety of oranges, reds, and purples. We also have to take into account the whites, grays, and browns of clouds and the varying shades of light that bathe them with color.

Considering all the colors of the sky, it is a good idea to have a wide range of paints when you are planning to paint it.

Build up gradations and fluffy clouds with a variety of base tones. Leave the most detailed work to the end.

CLEAR SKIES

A clear sky seems like a blue sheet, gradating to gray as it nears the line of the horizon. This image is at first flat and without depth, since there is nothing with volume to interact with either light and shadows—the two elements that suggest depth. The lack of shadows doesn't mean a clear sky is always the same color. At the beginning and

THE COLOR OF THE SKY

The color blue comes to mind first when we mention sky, but since its color is actually a function of light, it changes continually throughout the full twenty-four hours of a day. At night it can be black or deep blue; morning shades range from yellow to gray and sky blue. A sunset

TECHNIQUE

Because the steps for working in pastel are always the same, you will paint skies the same way you paint other subjects, such as water, fish, or flowers.

Skies, however, do require unique preparation, since

CLEAR SKIES

A CLEAR SKY

In any painting technique, rendering a clear sky means gradating and blending colors. Although this may seem easy, you should keep in mind that in pastel, blending several colors without producing abrupt changes in tone requires a certain mastery of the technique.

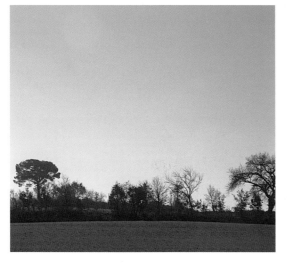

A wide, clear sky in the afternoon is the perfect subject for practicing gradations.

1. The upper edge of the paper is painted with approximately the same blue color seen in the photo. This will be the part of the sky from where the tone will begin to gradate.

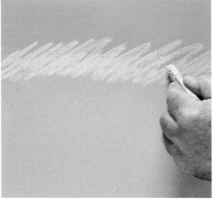

2. Depending on your preference, the lines can be blended with a finger or a rag.

5. The gradation of two tones in the previous step was relatively simple. Gradating becomes more complicated when we apply three colors at the same time: light blue, yellow, and white.

3. A lighter blue is added to begin the gradation.

4. This last tone is blended into the previous tone using fingers. We've managed to avoid abrupt tone changes.

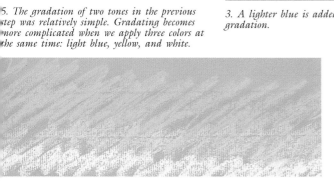

MORE INFORMATION

More information can be found concerning gradations and blending colors in the chapter Using Pastels, pages 24–33.

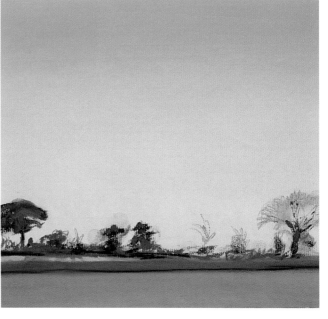

6. Just as before, the colors are blended until no clear strokes remain and the colors have dispersed out into a soft gradation.

7. On this finished exercise, you can see we used a dark pastel to paint in the vegetation outlined against the sky.

SKIES WITH CLOUDS

The arrangement of clouds in the sky is continually shifting. The forms and volumes of the clouds themselves also change from one minute to the next, producing new shadows and points of light. Their colors change too, since clouds reflect the color of light. They can be as white as snow, a deep coal-black, or the oranges, purples, and pinks of sunset.

Clouds, like other objects, also have two kinds of shadows: those that they project onto the land below, changing the tonal values of the terrain and producing an interplay of light and darkness, as well as those shadows clouds cast on themselves. Like any other physical object, it is the areas of light and shadow that allow us to perceive clouds as three dimensional objects.

The colors of the shadows within the clouds depend on the colors of the clouds and the character of the light that falls on them.

SKIES WITH CLOUDS	FOG

Fog is another element related to sky that you should know how to paint. Fog is usually produced at the beginning or end of a day. While clouds generally have definite shapes, even though they are always changing, fog is only a mist with no clear outline that throws a curtain over everything, blurring the forms behind it and muting colors.

In this seascape by Degas, fog was painted bathed in the warm, yellow light of sunrise.

1. We have chosen a bluish-gray paper, whose color will be used to suggest some tones of the work. The first colors are applied horizontally to suggest the clouds and horizon. They are slightly blended, but not enough to make a gradation.

NOTE

Remember, fog will distort colors and the direction of light; therefore, instead of gradating, it might sometimes be more accurate to create sharp contrasts in the tonal values of the sky.

2. After applying the ochres and darkest oranges, the lighter colors are added.

4. The color of water always reflects the color of the sky. This is taken into consideration by treating the water with the gray and blue shades of the horizon and the oranges from the sky. To indicate the brightest parts, we apply a touch of white, then blend it with yellow.

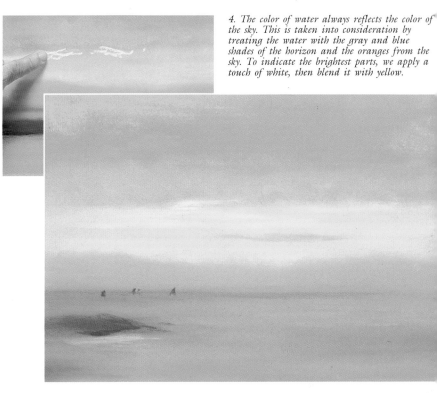

3. The new tones have been softly blended into the whole sky. A touch of black suggests the ground.

5. In the finished work, you can see how the color of the paper shows through the pastel and unifies the different blended colors. The importance of the land to the composition should be pointed out, as well as the way the water was made to reflect the subtle and vibrantly colored sky.

STILL WATER

REFLECTIONS ON WATER

Still water normally has a smooth and polished surface that reflects objects above it and catches flashes of light. When the calm is absolute, reflections look as perfect as those in a mirror; if there is the smallest movement in the water, the reflected images are distorted and fragmented by the ripples.

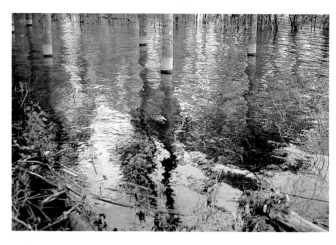

This flooded poplar grove is a good subject for capturing the character of water, including the reflections and flashes of light produced on its surface.

1. A violet-colored paper will provide our intermediate tones and contrast with the green and blue pastels that will be applied later. The preliminary sketch has been drawn with a dark green pastel that will remain visible through subsequent layers of paint. White is used to suggest the brightest areas.

NOTE

Notice how important the direction of the strokes was in the resolution of the work. They suggest the ripples in the water surface and the distortion of the reflected objects.

2. We continue to apply different colors, including the blue of the sky. We also establish the lighter areas; the darker areas are already suggested by the color of the paper.

6. Examining the exercise step by step, we can now appreciate the importance of step 4, when all of the colors were applied, suggesting the forms of the subject. You can see the final touches in the finished work. Obvious details are the small flashes of light that suggest the movement of the water surface and establish the rippling reflections of the trees and the light.

3. With a slightly lighter shade of green than that used for the initial sketch, we paint in the dark areas. Notice how all of our strokes are short and horizontal to suggest the ripples in the water's surface.

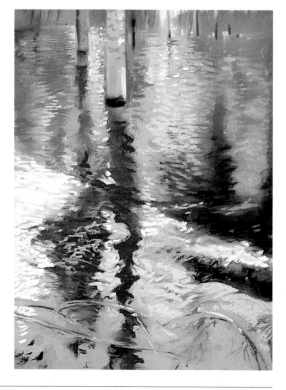

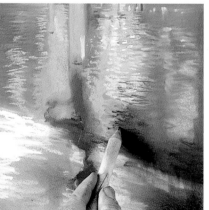

4. Once the basic colors have been applied to suggest the forms, we blend in a mixture of brown and black.

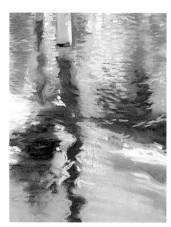

5. Next, we use the tip of the pastel stick to paint in details, especially the flashes of light and reflections that are characteristic of water.

A body of still water doesn't always have a polished surface that creates perfect reflections. A breeze blowing over water breaks up the surface so that it does not reflect details, only general areas of color and of light. A stronger wind will form small waves that change the water appearance still further.

The small waves on this peaceful lake give the surface a matte, undulating appearance. You can detect some reflections of the sky and sunlight in the water, but the roughness of the water makes them hard to spot.

1. The sketch was done in a black pastel on greenish gray paper that will bleed through subsequent layers of paint. Unblended dashes of color suggest the body of the kayak as well as the waves on the water's surface. A green with blue overtones is applied over them, then blended.

2. A greenish blue following the lines that form the ripples has been irregularly added over the color base applied in the previous step. This effect is heightened by applying lines of three different colors: gray, deep-sea blue, and cobalt blue.

3. The lines that suggest the waves are also blended.

4. The darker tones of green, blue, and black have been added to the three previous colors to render the waves' shadows. The highlights are painted with gray, and not blended.

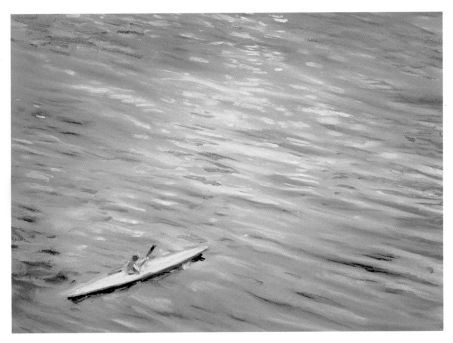

NOTE

This exercise shows how important planning is. It was essential to know how to develop the waves before any painting was begun. Suggesting the rough texture of the water from the outset contributed to the creation of a much more complex painting.

5. At this stage, we are stopping, although we could continue to work the waves with strokes of color in various tones. Notice how we used gray to show the areas where light is reflected.

WATER IN MOTION

Since water is a liquid, it is extremely sensitive to movement; even a small ripple will produce an infinite amount of changes in the reflections and texture on the surface of the water. These movements do not necessarily affect every part of the water. For instance, you might see rough waves in some areas, while surfaces elsewhere are still smooth and polished. Or there might be quiet water in one place, and in another, wild and foamy water cascading in a waterfall. Water always has the potential for motion. In any given moment, a body of water can generate a large wave or explode in foam and spray, returning afterward to an eddy of calm.

Because of its rapid changes, you have to paint water the same way you paint clouds, by making sketches and drawings that capture a sense of the moment and show you how to proceed in your later work.

WATER IN MOTION A WATERFALL

The movement of currents, such as those in rivers, waterfalls, or even a simple, running faucet constantly changes the colors and textures of water, so the bright, shining light characteristic of water can be juxtaposed with misty areas of spray. Using pastel to paint such images as bright water trickling over a rock and converting into a white, frothy mass is a challenge that you will be able to meet as you master the pastel medium.

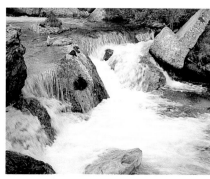

We are going to paint this waterfall to study the variations in moving water. We will try to render every nuance, including the fragility of the fine film of water flowing over the rock, the force of the waterfall, and the spray it produces.

1. We have chosen a bluish gray paper for this painting because its color is quite close to the tone of the spray. A dark earth pastel has been used to sketch the forms and we've begun to block in the water with an intense blue that is slightly blended into the pastel of the sketch.

2. The color of the water is basically constructed with blues and grays. Yellow and white are added to suggest the foam, and earth tones to indicate the rocks that are visible underneath the flowing water.

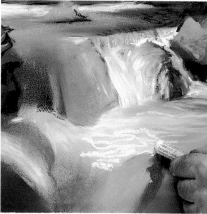

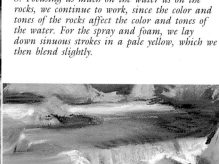

3. Focusing as much on the water as on the rocks, we continue to work, since the color and tones of the rocks affect the color and tones of the water. For the spray and foam, we lay down sinuous strokes in a pale yellow, which we then blend slightly.

4. The same technique that was used on the foam is applied now, using, in this case, a sky blue pastel to suggest the transitional area between the foam and the rocks below the water. Applying paint this way also suggests the movement, reflections, and character of the water.

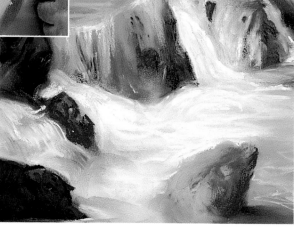

5. In the finished exercise, you can observe how an area that might have seemed terribly complicated, such as the fine film of water over the rock to the right, has been rendered with great simplicity by applying confident strokes in blue and yellow over the rock's base color.

WATER IN MOTION CLEAR WATER

The color of water is basically determined by the color of the ambient light; however, when you are dealing with clear water, the color at the bottom—and sometimes foam—are the determining factors. In this exercise, we will work with the interplay of these various elements and create a variety of textures and tones to evoke the transparency of the water and the foam riding its surface.

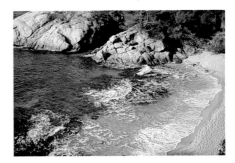

The color of the water of this small inlet is determined by the color of the substances at the bottom, which include vegetation and sand.

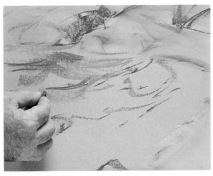

1. After drawing the preliminary sketch with a reddish earth color, the basic forms of the sand and rocks have been filled in with ochre. The color of the water is then blocked in with emerald green and a bluish green.

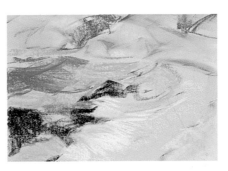

2. We paint the different areas of the water with colors that suggest the marine vegetation and sand below. On the shoreline there is a strip of wet sand that we reserve for the moment.

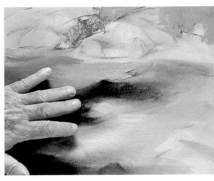

3. We blend the colors that suggest the water. The tinting strength and energy of black are striking when compared to the other colors.

NOTE

The color black has a stronger tinting strength than any other color in pastel. When you use it, you should apply it sparingly so that it doesn't overwhelm your painting.

4. After we finish painting the general area of the water, we are ready to work on the texture of the water surface; touches of blue and white suggest the foam.

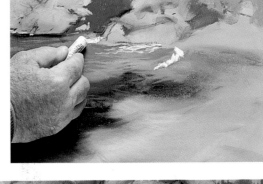

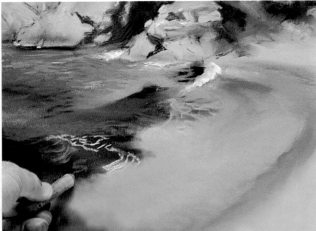

5. We now combine some of the separate colors that suggest the reflections, foam, and waves of the moving water. The strip of wet sand has been filled in with a reddish sienna.

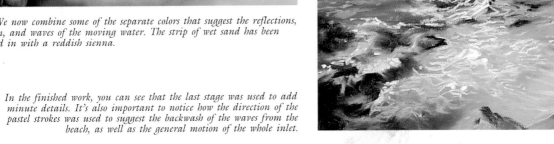

6. In the finished work, you can see that the last stage was used to add minute details. It's also important to notice how the direction of the pastel strokes was used to suggest the backwash of the waves from the beach, as well as the general motion of the whole inlet.

WATER IN MOTION **FOAM ON THE SHORE**

You can't rely on waves to convey the idea of foam because sometimes there is foam without them; that means you have to learn to how foam in the midst of stillness, at most giving a suggestion of soft movement. The best way to suggest the foam in this instance is through twisting white lines. Show the water through blocks of different blues. The careful selection of an appropriate paper color can be very helpful. Here, We have chosen a gray paper whose shade is just right to represent some areas of the water as well as the rocks.

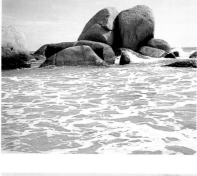

On the shore of this Caribbean beach, you can see the foam making random designs on the relatively calm surface of the water.

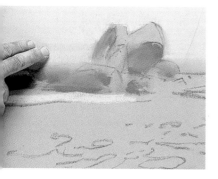

1. The sketch is made with a gray pastel, slightly darker than the paper but still a good match for certain areas of water and rock. Afterwards, we begin to block in some of the sky and the dark areas of the rocks, since these tones will influence the tone of the water.

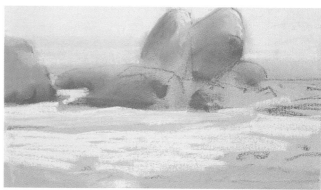

2. We have begun to paint the color of the water. We use a green for the area next to the rocks and a sky blue for the water in the foreground. From this point on, paint strokes should suggest the designs that the foam traces on the water surface.

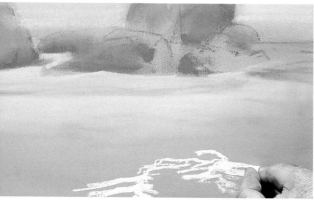

. In the area that has been reserved, or left untouched, the texture and ape of the foam is now painted in white.

NOTE

In this exercise, we let the color bleed through between strokes of paint to convey the color of the water; thus we avoid applying a new pastel color so the work looks fresher and lighter.

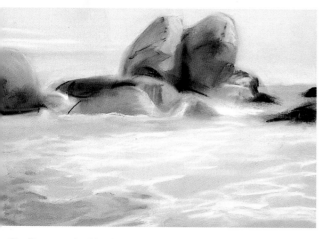

The lines traced with white have been blended slightly; a gray with rthy tones has been applied between them that suggests the sand beneath e water. Notice how we have continued defining the shapes and volumes the rocks and developing the range of their tonal values.

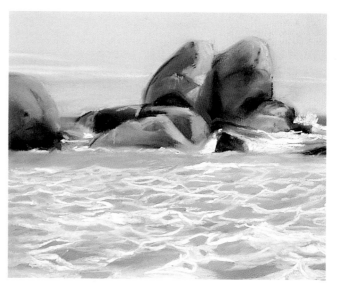

5. In the finished work you can see that a new shade of blue was applied in the middle area of the water and that it was carefully worked with white to make the designs and textures of the foam.

Vegetation

Aside from being an essential component of any countryside, you can also find vegetation on city streets, in gardens, or in a bouquet of flowers in your home. It appears in places where you least expect it and surprises you with its shapes, textures, and evocative colors. For these reasons we need to understand it, study it, and paint it with confidence.

A DIVERSE WORLD

The diverse world of vegetation includes the common weed in a meadow, the sensuous petals of a rose, and the endless variety of trees. Nature paints the world of vegetation with innumerable shades of greens, ochres, and yellows, some of the most stunningly bright colors, and some of the darkest browns. There are thousands of species with distinctive forms and colors, all widely varied. For this reason, you should always make preliminary studies.

Each season adds new variations in the appearance of vegetation: A tree can seem e n o r m o u s when it is luxurious and green in the s u m m e r; several months later it might look like a skeleton, naked a n d d a r k against the snow.

THE COLOR OF VEGETATION

In discussing vegetation, the first color we think of is green, even though there is every color imaginable in the plant world.

At the end of summer, many greens turn into yellows, ochres, reds, and even, with the onset of winter, dark browns and blacks. With the coming of spring, the palette of color widens and splashes of color are displayed on flowers and, later, fruits, which cover trees, plants, and bushes.

Since mixing is difficult in pastel, manufacturers make available a wide range of colors for painting landscapes that include all kinds of greens and earth tones.

These special color sets are extremely practical but, at one point or another, they still come up short; it is simply impossible to include all the reds, yellows, or violets that might be found in a field of flowers.

This glorious abundance of colors, which continuously surprises even observant artists, also includes the cold blues and deep blacks of shadows. The foliage of a tree, for example, can have very bright areas and others that are quite black.

TECHNIQUE

The main secrets of successfully painting vegetation are simply observation and sketching.

You should also remember that vegetation is alive and should convey to the viewer something other than a chair or a wooden post.

And when you consider the many effects we can create using pastel, keep in mind that the underlying element is always the sketch.

To ensure a successful painting, we must work carefully to establish the forms, their placement, and the colors in the preliminary sketch. A prior study of the structure of a tree trunk and the branches, for example, will strengthen your painting, since it will establish a coherent, logical, and natural placement of the foliage.

After the sketch, the second most important consideration in painting foliage is planning—work should be organized in stages. We begin by blocking in the largest areas of color to determine the color values; later, we focus on details and textures. It is also important to have an appropriate range of colors when painting vegetation since the right shades are fundamental to achieving a real likeness to the subject, as well as creating a sense of volume and depth.

TREES

The great size of trees makes them one of the most popular subjects in landscapes, either standing alone or in forests. Their complicated structure, however, sometimes makes them somewhat difficult to draw.

You have to remember that under the foliage of a tree there are branches supported by a trunk, and that the tree's form should be based on this structure. Difficulties arise when you don't know the exact underlying structure, either because the type of tree you want to paint is unfamiliar or because you haven't studied it before. Familiarity with other kinds of trees doesn't help too much because each type has a different structure that does not always resemble one you know. A palm tree, for example, composed of a long, erect trunk capped with a crest of palm fronds, has very little in common with an oak tree, whose trunk divides into branches relatively close to the ground.

TREES — A PALM TREE

The palm tree is an unusual tree that is found on five continents. It is composed of a long, slender trunk ending in a crest of palm fronds. While most other trees have compact, fluffy foliage that can be suggested with hardly more than an expanse of color, the palm tree requires clarity and definition when you suggest its branches.

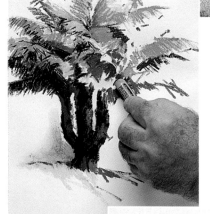

We are going to paint this palm tree. Its branches and narrow leaves create an attractive crest of green, but its trunk, divided into three symmetrical arms, is particularly interesting.

1. We draw the preliminary sketch using a dark-colored pastel that can establish the dark parts of the trunk and some of the shadows in the branches.

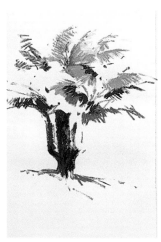

2. The work is continued with touches of pastel that already suggest the texture of the leaves. We avoid any blending that would ruin the effect of these clean lines; they give a precise rendering of the tree and add a sense of mood to the piece.

3. We continue by adding the lighter greens and touches of yellow for the brightest areas. A blue color is introduced into the shadows; this color complements the dark grays already in the shadows and creates interesting tonal contrast. Since the areas of light use warm hues, the cold hues in the dark areas create twice as much contrast, contributing to the development of the tree's volume.

4. Once the tonal values and temperatures of the palm tree are determined, we construct its branches and work on the trunk. Notice how striking the painting is when we work directly with the edge of the pastel and avoid blending and blurring the lines.

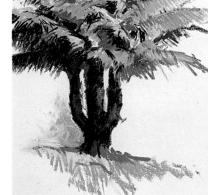

5. In the finished exercise, you really get a feeling of branches superimposed over each other, even though the only places where colors were layered during the course of our work were at the overlapping edges of our pastel strokes. By avoiding layering, blending, and overloading the paper with paint, we captured the freshness and clarity we want in a pastel painting.

NOTE
The structure of our exercise subject, a palm tree with luxurious branches and narrow leaves, is ideal for painting with pure colors, taking advantage of the edges of pastel sticks and avoiding blends. This way, we can convey the texture of the foliage, giving center stage to the tree, while relegating the background to secondary status.

TREES **A PINE TREE**

Although the foliage of a pine looks compact and fluffy at a distance, the asymmetry of its branches reveals its underlying structure. Sunlight filters through these gaps in the foliage, creating an interesting interplay of light and shadows. The pine needles, in spite of being small and thin, as a whole produce overall effects that can be easily suggested by pastels.

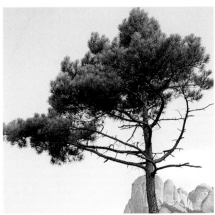

This pine tree is especially interesting. The absence of foliage in most of its crown reveals the structure of its branches and some of their interesting curves.

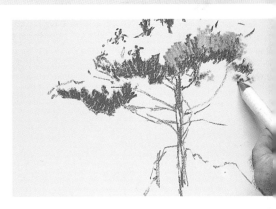

1. We use a dark earth color to do the preliminary sketch, then fill in the darkest areas of the foliage with gray. Notice how we use small parallel strokes that immediately begin to suggest the small, thin pine needles. After finishing these areas, we blend them slightly with the tip of a stump, taking care to keep that suggestion of texture the first strokes produced.

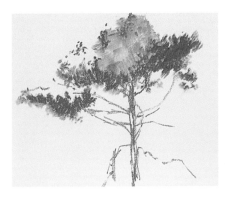

2. We apply light green and some touches of yellow for the lightest areas, then blend them slightly.

NOTE

The amount of light falling on the tree varies from one side to the other because sunlight comes from only one direction. Because of this, the interplay of light and shadow in vegetation will usually be stronger in some areas than others.

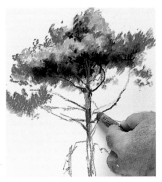

3. We continue painting the upper part of the foliage using yellow and light green. At the same time, we adjust the tones, adding some touches of blue, and at other points, black. The trunk is then filled in over the lines of the initial sketch.

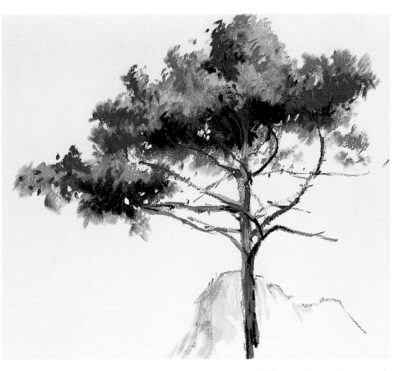

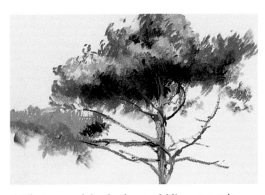

4. The tones used for the clumps of foliage cannot be used for the branch on the left, which has not yet been touched. Because of its location, light does not fall on it as directly, so the tonal values will be more intermediate. It will also have fewer highlights than the crown of the tree. We apply gray over the base tone of the trunk to provide texture and suggest the bright tone of the wood.

5. Once the exercise is finished, you can see a clear difference between the general foliage and the foliage to the left. Also obvious is the textural detail of the pine needles, which has been developed with small touches of color. Some points of white have been applied to suggest the gaps among the branches.

TREES A BALSA TREE

The balsa tree has an erect trunk and many small branches that are loaded down with leaves. Drawing the lines of its trunk and branches accurately is the basis for a realistic rendering of the tree. Factors to consider before beginning to paint are the weight of the leaves, which pulls the branches slightly downward, and the irregular configuration of branches on the trunk. Because the branches that are found in the foreground can be seen as easily as those that are behind the trunk, you have to be particularly careful to capture the depth of the foliage.

Since the balsa tree is obviously somewhat complex, you should take time to make a careful study prior to painting.

The balsa tree we have chosen has an elongated trunk that gives us a sense of its weight by drooping slightly to the left at the top.

1. The sketch has been made on a neutral gray paper, approximately the medium tone of our palette for this painting. Over the sketch we've indicated the dark areas with black and the lighter areas using green and yellow.

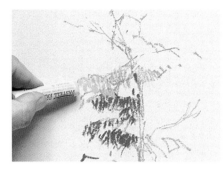

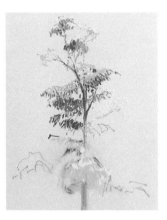

2. We've continued to fill in the rest of the foliage with the same shades used before, adding blue to the shadows to give them more depth and increase the contrast with the warm tones of the foliage. It is important to pay attention to the character of our strokes. By carefully using a combination of dots and tiny lines, we can suggest the texture and shape of the leaves.

3. We continue to fill in the foliage with the areas of light and shadow that will suggest its volume. Notice how we slightly blended the lower branch and applied a dark green for the area of shadow; a few short strokes of pastel established the form of the upper part. You will also notice how a slight blend of blue and black creates the upper shadows.

4. The background is not developed in detail. Our intention is to use its colors to balance the ones in the tree.

5. Once the exercise is finished, you can appreciate how much careful retouching and detail work was carried out in the last stage. You can also see the importance of the color of the paper and the tones of the background and shadows. Notice how the tones of the foliage were adjusted. The dead branches were painted at the last minute since they didn't involve any special difficulties.

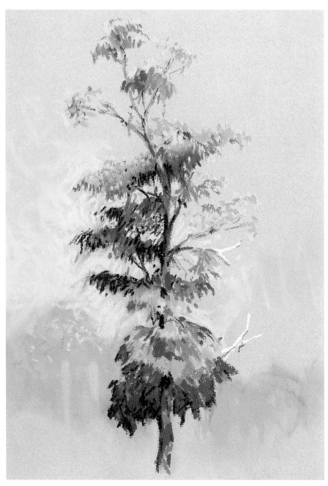

TREES | A FRUIT TREE

During certain times of the year, fruit adds splashes of color that contrast with the foliage of the trees. Fruit also changes the shape of the tree, since the weight of it pulls the branches down. In pastel, the challenge of painting fruit trees is integrating the fruit naturally within the foliage so that it doesn't look like artificial dots of color. One way to do this is by blending the outlines of the fruit.

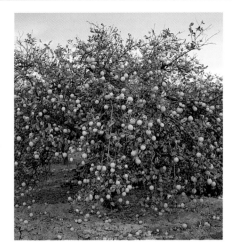

This lemon tree is our subject. You can see how its branches droop with the heavy fruit.

1. We have chosen a paper with a color very close to that of the foliage so we can minimize blending and avoid filling the surface with paint. Since the color of the paper is similar to that of the tree, its form must be silhouetted. We begin to do this by blocking in the background sky. Once it is suggested, the upper crown of the lemon tree can be given color, using the edge of the pastel stick.

2. The ground has been painted, then blended. Dots of color begin to suggest the lemons.

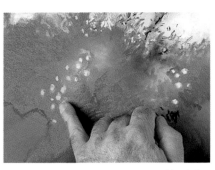

3. The dots that suggest the fruit are blended slightly. This gives character and mood to the work and facilitates the integration of the fruit into the foliage.

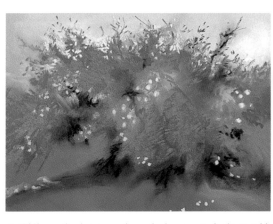

4. While continuing to work on the lemons, we begin to add detail to the upper crown of foliage. Notice that we've also been working on the ground under the tree. It is particularly important in this scene because the branches of the tree bend down almost to the earth. We also have to remember the fruit that has fallen to the ground; the image would lose drama without it.

5. More fruit is added to the tree. Shadows are indicated with touches of black; leaves are given detail with dashes of green.

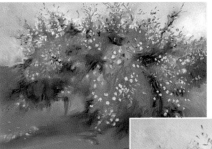

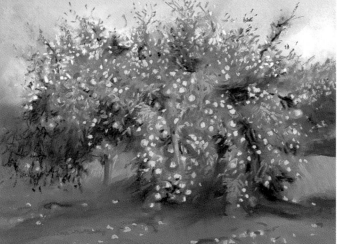

6. The result clearly shows the painstaking nature of this exercise, as well as the rewards of being meticulous and exacting. Clean, sharp strokes and dots of color with subtle blends have been used in this work. The outlines of the last pieces of fruit we painted have been blended with the point of a stump. A little blue, always a nice touch, stands out in the shadows.

NOTE

The complexity of this exercise is partially based on how we used the color of the paper. Because it is similar to the color of the foliage, we have to work in negative using the background color to silhouette the form of the tree. This, however, allows the foliage and the fruit to fit together perfectly, thanks to the light blends. Another method may have resulted in a fuzzy work with little definition or a work in which the fruit was nothing more than a series of artificial-looking dots.

GRASS

Grass is rarely the main subject of a work, although it should be studied because it is often a secondary element in landscapes. When grass is seen in the distance, its vast expanse has a uniform color that is only rarely interrupted by lighter areas of bare earth or the shadows cast by trees or clouds. Under these circumstances, you could easily render it as a simple swath of green. Grass in the foreground requires more work. The closer the grass is, the more you can observe its distinct shades of green and long, thin stems and leaves, offering contrasts of light and shadow. Because of this, the texture of grass in the foreground should be painted in detail with spontaneous, energetic strokes. This will create a variety of colors, tones, and textures needed to suggest individual blades of grass with distinctive characteristics.

GRASS | SOFT GRASS

While the soft grass of a meadow first seems to be a single carpet of fluff, a closer look reveals that it is composed of thousands of thin leaves of varying heights and textures. There are also areas of different tones and colors if, for instance, some of the grass is dryer than the rest.

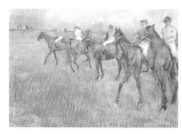

We are going to reproduce a fragment of the work by Degas, Jockeys in the Rain, *in which the artist took special care conveying the texture of the grass.*

1. We will be using paper with a green similar to the medium tone of the grass. We can take advantage of it by allowing it to bleed through the spaces between pastel strokes. The surface of the paper has been covered with a slightly lighter shade of green, along with some touches of yellow.

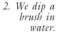

2. We dip a brush in water.

4. Once the paper has dried, we paint in the grass using short strokes in a variety of tones.

3. We dilute the color slightly to blend it; to prevent warping, we take care not to let too much water flow onto the paper. Notice that some areas are not brushed at all. This wash will be the background for the later stages.

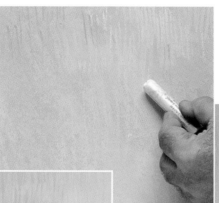

5. Some areas are slightly blended, but not enough to erase the individual lines.

6. Once the work is finished, you can see that the blue, green, yellow, and brown strokes produce an optical mix that suggests the light and dark areas. The strokes are also used to bring out the texture of the grass. This exercise is not particularly difficult; its only secret is the treatment of the background and the strokes that suggest the grass.

NOTE

You have to take into consideration the kind of paper you are using before you apply water to it, since some papers disintegrate or warp. See: Using Paper, pages 34–35.

MEADOWS AND FIELDS

Cultivated fields and meadows commonly appear in landscapes as secondary elements. Juxtaposing the two provides an interesting contrast for a painting.

Meadows, like fields, may be many shades of green. In the springtime, they may also be covered in a blanket of colorful flowers. Meadows in the summer can be a range of ochres and yellows. In the winter, occasional patches of earth might peek out from beneath the vegetation.

The most important characteristics of cultivated fields are the geometric divisions and parallel lines left by a plow or harvester. These features are easy to show in pastel.

MEADOWS AND FIELDS A FIELD IN SPRINGTIME

Vegetation offers the greatest diversity of colors in the springtime when the shades of bright greens of grass and weeds contrast violently with the reds, whites, blues, and yellows of the small flowers that grow among them.

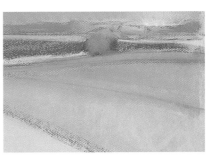

NOTE

Simple techniques can be used to capture the most strident contrasts of color. The keys are adjusting tonal values, brightening light areas and darkening shadows or applying cool shades next to warm ones.

The contrast of these green fields with the white and red flowers that fill them is the main attraction of this landscape.

1. The sketch is drawn with a dark green pastel on cream-colored paper. We then block in the medium-toned sections of each area. Notice how the poppy field is suggested with a wide swath of red, thin enough to allow the color of the paper to breathe through.

2. After filling in the entire paper, we begin work on the vegetation near the horizon. We blend their outlines slightly to create the haze of distance. The tree in the center has been painted in blue to contrast with the warm green and red of the flowers.

3. We use yellow to add more texture to the fields in the foreground. You'll notice that the fields' texture was first suggested with green.

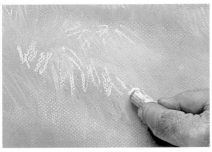

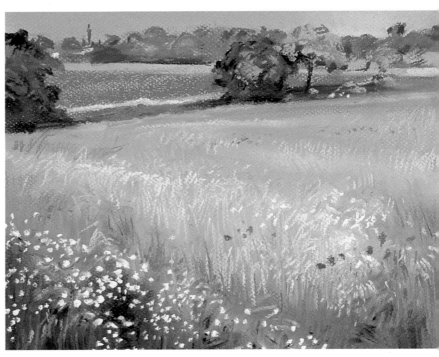

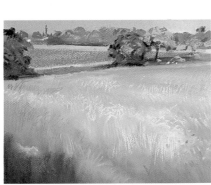

4. The basic texture of the grass has now been painted, using soft, thin strokes in some parts and blends in others. The poppy field has not been touched since the beginning; the initial swipe of red was enough to get the job done.

5. In the finished painting you can see how the flowers have been suggested with small dabs of color. The tone in the right corner has been intensified to create more contrast.

FLOWERS

The wide variety of shapes and colors of flowers is one of the reasons they are painted so often. The challenge for the artist is to capture their unique characteristics in paint.

Instead of painting flowers outside, you may find it more practical to bring them into your studio so that you can control the lighting, arrange the flowers, and choose a particular background bouquet—or even for a single flower.

Painting a flower, of course, is not the same as painting a bouquet. The difficulty of painting a single flower is due to its simplicity, while the difficulty of painting a bouquet is due to its combinations of form, color, and line.

It is also possible to make an arrangement of two or three flowers that are painted with the concentration and detail of close-ups.

FLOWERS — AN AMARYLLIS

The amaryllis is decked out in two contrasting colors that are loud, if not outright gaudy. Its unusual shape and pointy petals suggest a star. The challenge of painting the flower, given the star shape, is showing the sharp points and strident colors of the petals without making them rigid. The flower must look smooth and flowing, even at the edges.

This example of an amaryllis, which will be painted in natural light, offers interplays of light and shadow and important contrasts of color.

NOTE

When you want to work with pure colors and avoid blending them with lines of the preliminary sketch, you can use either light gray for the sketch, or—even better—the same pure colors that will be applied later.

1. The brown paper will suggest the color of the rock behind the flower and will also supply some intermediate tones. We make the preliminary sketch using several different colors, since the work will be performed with unmixed, or clean, colors. In this first step, we blend some of the lines to be sure that the paints produce the range of tones that we want.

2. We continue to paint, developing the background and the flower at the same time. Only pure red and yellow are used for the petals, since they produce intermediate tones when combined with the color of the paper and when they are mixed.

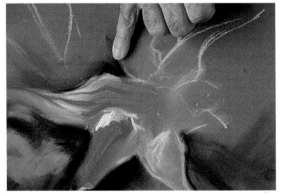

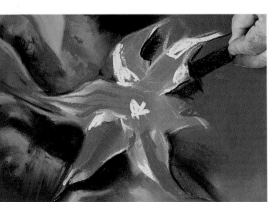

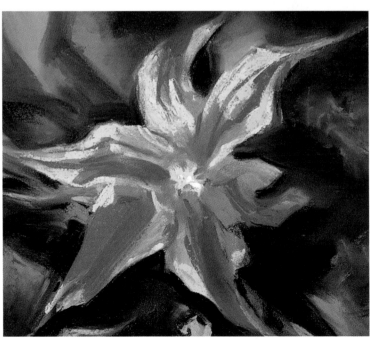

3. Black is applied to the background in wide strokes and different densities that allow the color of the paper to suggest that of the rock. Two shades of green, light and dark, are used for the leaves of the plant in areas of shadow. Notice the decisiveness of the lines of yellow on the petals. This work is being painted expressively and it is best to avoid making corrections.

4. In the final work you can see how we sometimes used blends to spread out color to contrast with the thickness of the pastel strokes in some intensely painted areas. This is how the painterly quality has been achieved in pastel. The spontaneity and energy of the unblended pastel strokes should also be emphasized.

FLOWERS | **DAHLIAS**

Flowers growing outside must be painted as they are, in natural light without artistic arrangements or special illumination. These apparent inconveniences, however, can sometimes become advantages, since there is no light that can compare to natural light and you don't have to compose your image, only choose and interpret it.

This bunch of dahlias is exceptionally bright under the sunlight; the individual blooms made up of thin petals look as soft and bright as little pompons. Their luminous white against the dark green leaves is a compelling contrast.

NOTE

The color of the paper does not have to be an essential part of each work, although it is helpful in developing the range of tones and colors that will be used.

1. For this exercise, we have chosen a dark paper whose color approximates that of the real background. The sketch of the forms is done using a dark pastel. We distribute the flowers within the space of the paper and use a light blue to begin suggesting the blooms.

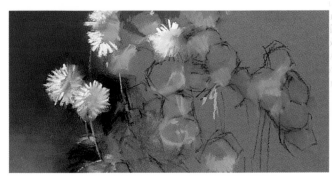

3. Since the tones of one area affect the others, working on them all at the same time makes it easier to determine the correct tones. This method helped us find the precise yellow for the center of each flower that would give a warm glow to the whole picture. Also notice how we use a finger to extend the black and how parts of a flower are implied by reserving some unpainted areas.

2. A sky blue indicates the lightly shadowed tones of some petals. With precise confident strokes, we apply white on top afterwards to suggest the texture of the brightest areas. We work simultaneously on the background, applying dense, blended black, and adding stems and leaves.

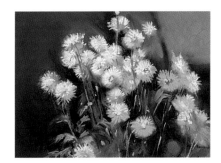

5. The work is now quite advanced. We should emphasize how blue has been replaced by gray at the base of the flowers to the right, and also point out how broken lines are used to suggest the stems.

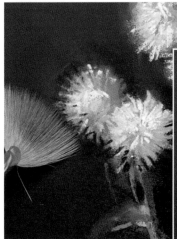

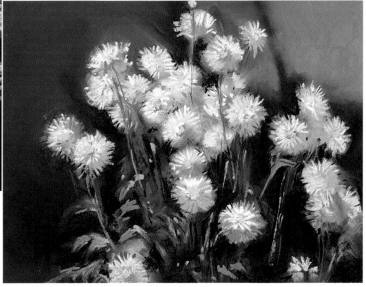

4. To create depth, the pastel strokes in the flowers are left thick with paint, while the background is softly brushed. At this time, we soften the outlines of the more distant flowers.

6. In the completed work, you can see how the interplay of colors like those at the base of the flowers (blue and gray) has created an area of cool and warm contrasts to the left, while the part to the right is much more neutral. This variety gives the whole group of flowers a special richness.

Bouquets of flowers are popular subjects, both for their beauty and vitality and because they are convenient to compose in a vase or laid on a table. The lighting, however, has to be considered, as much as the contrasts and harmonies of the colors in the bouquet. In addition to a variety of colors and tones, a bouquet will also have a range of types of flowers, presenting diverse forms and textures. The whole composition should convey a sense of beauty and harmony.

Sunflowers, *by Vincent van Gogh, has been chosen as our subject for the harmony of its yellows and earth tones. This will be an especially interesting exercise since we will reproduce in pastel an exceptional work that was painted in oil.*

1. The color of the paper will be light sienna since that color can provide some of the tones of the subject. The sketch has been made with a brown pastel. Afterward, the darkest areas of the flowers and the background are painted to establish the range of tonal values.

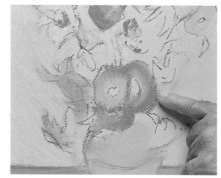

2. After painting the background and the flowerpot, we begin to work on the brown flowers, applying lighter tones, then blending them. For the sunflower petals, we apply a bright yellow directly on the background.

3. We continue to develop the flowers one by one. Green and red strokes have been applied to produce an interesting contrast.

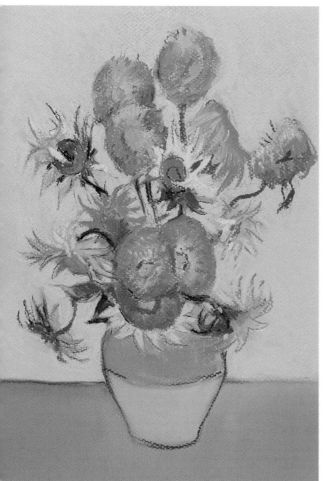

5. In the reproduction, you can see how the final touches of black contributed to the overall tonal balance, and how the splashes of green and red added important touches of contrast to the areas drenched in yellow.

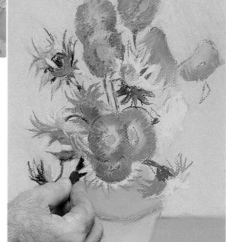

4. When the flowers are nearly finished, we can apply the necessary touches of black, which were left to the end to protect the other colors from smudges.

NOTE

When comparing the reproduction with the original, you can appreciate the differences, especially in the textures, between oil paint and pastel. Pastel, however, is versatile enough to achieve results very similar to that of oil.

Fruit

Fruit, like flowers and other types of vegetation, is also painted frequently. It gives us opportunities to play with color and volume. Its serene round or oval form encourages us to experiment with its basic shape.

While having a narrow range of forms, fruit astounds us with its wide variety of textures. Consider, for example, the lustrous surface of ripe, red cherries; the soft down on the skin of a ripe peach, the rough reticular rind of a cantaloupe; or the shiny, lightly pocked surface of a navel orange.

THE COLOR OF FRUIT

Painting fruit is similar to painting vegetation—we work predominantly with the contrast and variety of its color, both of its skin and of its pulp. The surface colors of fruit are often various shades of green, while the pulp of fruit is usually a bright, vibrant color. A watermelon, for example, has a thick, smooth rind of a shiny, mottled green that contrasts wonderfully with its wet, red pulp.

Some fruits, such as pears or citrus fruits, do not offer such contrasts. In these cases, you can experiment with the range of tonal values and use those contrasts to develop volumes and suggest textures.

COMPOSING A STILL LIFE

You can paint fruit still growing in its original setting or buy some pieces of fruit in the market and compose a still life with them in the

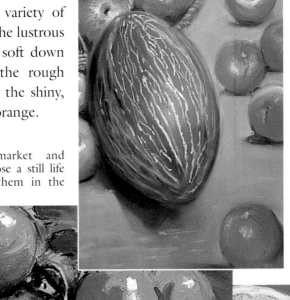

studio. Still lifes are particularly popular since they can be painted in the studio where the light can be controlled and the fruit carefully composed.

When composing a still life, keep in mind that using a background color similar to that of the fruit makes it more difficult to give the fruit volume since we usually rely on color contrast to do it. The wide variety of available backgrounds enable the artist to select a color and a texture that will enhance the compo-

sition. The fruit can be arranged in a bowl of ceramic, metal, or wood. In turn, the bowl (or the fruit itself) can be placed on a cloth that is smooth or textured, white or colored, patterned or solid. A wooden surface offers another range of possibilities in color, graining, and degree of luster.

Lighting is also very important. Some shadows should fall over and around the fruit; without dark areas, it will seem to be floating. It is also important to consider perspective. Since a still life can be arranged to enable you to paint it from any perspective—even from above—you should experiment with daring options.

In the studio you can manipulate the fruit to create compositions whose forms are completely figurative. You can also focus on the spherical shape of many types of fruit and experiment with their abstract, geometrical forms.

Experiment with the selection of fruit, its arrangement, the choice of background, the direction and intensity of the lighting, and the point of view until you are completely satisfied.

THE TEXTURE OF FRUIT

Fruits, whole, peeled or cut, offer a whole spectrum of textures to paint because there is usually an enormous difference between the skin of a fruit and its pulp. The skin whether it is thin, thick, smooth, or rough, does not have the unique characteristics of the pulp. You may want to experiment with some of the different textures you get by breaking open a piece of fruit or cutting it cleanly with a knife.

STILL LIFE WITH A MELON

Constructing your own still life with fruit gives you the freedom to play with composition so you can make a painting that is fresh, alive, and filled with color.

The shapes of fruit are diverse enough to allow a variety of forms to be introduced. Depending on your composition, you can change a commonplace image into an exciting interplay of geometric figures.

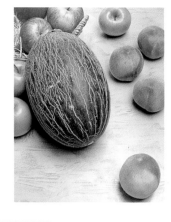

In this exercise, we will paint this interesting still life contrasting the size of the melon with those of the apples and peaches. Notice how the composition of ovals and spheres is enhanced by the unusual perspective.

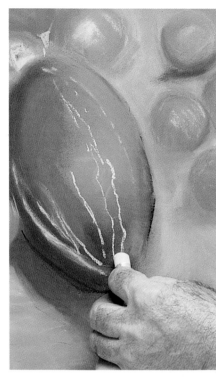

3. We give the melon texture by drawing lines on it with the edge of a light ochre pastel. As usual, we have been painting all the areas at once, so the background and peaches have already been painted in.

1. Paper is used with a green hue very similar to the color of the melon. The background color is applied first, allowing us to concentrate on the colors of the fruit.

2. The melon, previously shaded a very dark gray, will now be given volume. We add a light green, blend it, then reinforce the shadow with black. The apples are filled in with red, orange and yellow, which we only slightly blend.

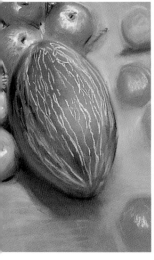

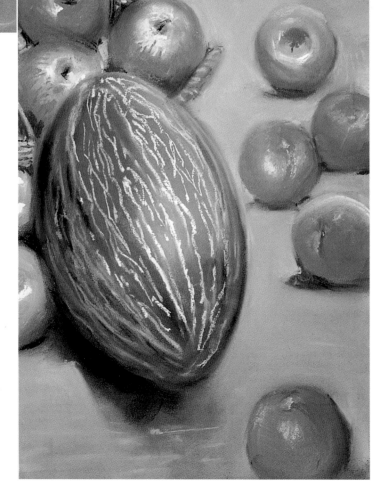

5. In the finished still life, you can see the differences in texture between the apples and the peaches. The velvety skin of the peaches is carefully suggested by the blending of the paint and the soft glazes of bright colors. Notice the importance of the shadows, added at the last minute to situate the fruit on the table and give it a sense of weight.

4. In this step, we practically finish the melon, as well as the apple in the background. Precise strokes suggest its thin skin and veined color. A few highlights give the other apples a lively, ripe sheen.

FRUIT **A CLUSTER OF CHERRIES**

Fruit, in its original setting, gives flashes of color to trees, bushes, and other plants. By painting it where it grows, you can take advantage of this surrounding greenery and render the entire plant or just the detail of a few leaves. Cherries, in particular, benefit from this treatment. Their vibrant color, intense shine, and clustered grouping stand out against the green leaves.

The image of this cherry cluster among the leaves is filled with lively color, including the strong contrast between the green leaves and intense red of the fruit.

1. We use a paper whose white color can show the bright spots of light that reflected sunlight produces on the cherries. The sketch is made with the dominant tone of the work, a strong red. When we apply it, we are careful to reserve areas of the white paper that will later represent the reflected light on the fruit.

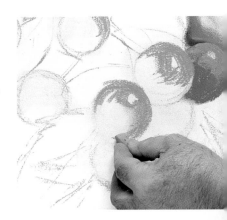

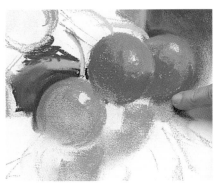

2. We painted a few of the cherries to determine the two basic tones that will compose them. A section of the background has also been painted to test whether or not the values of the fruit are correct. Notice how the pastel strokes are visible on the cherries, while the background pastel has been blended to create an atmospheric effect.

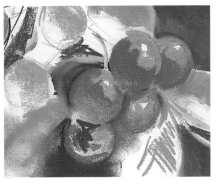

3. We continue painting the cherries, using the contrast of tones to give them a sense of volume. The background color and leaves have been filled in.

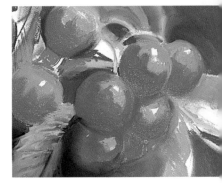

4. The leaves have been further developed, their texture suggested with small strokes of various greens. The background is completed when we apply some blue that increases its contrast with the fruit and further develops a sense of space and depth.

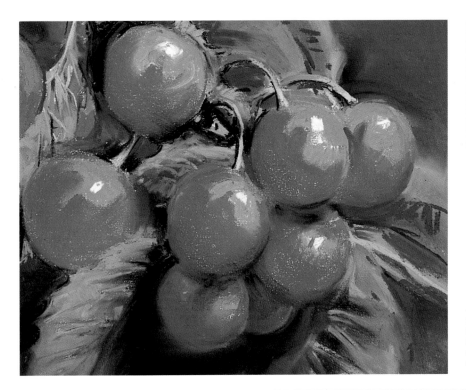

5. There is a substantial difference between this completed work and the previous stage. The textures have been developed in detail and the shadows darkened to make the lighter areas jump out at the viewer and give a three-dimensional appearance to the fruit.

NOTE

Here, the three-dimensional sense of space and depth is created by the tonal contrast of the shadows with the fruit, as well as the use of warm hues in the foreground and cold ones in the back.

FRUIT **CITRUS**

The skin of citrus fruits, whether thick or thin, dimpled or smooth, is shiny enough to reflect direct light. Colors include reds, oranges, and yellows. The pulp has basically the same colors as the skins, although it looks different and has a different texture.

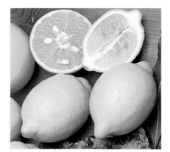

Studying the contrast of texture between the skin and pulp of citrus fruit and composing a work with them is an ideal exercise.

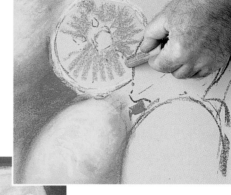

1. We choose a neutral-colored paper after considering the range of colors that are going to be used. A sketch is made of the forms, and the first color applied. We imply texture from the outset, according to the types of strokes we use.

3. We begin to indicate the texture of the lemons simply by adding small dots of yellow over the base color. These dots suggest the small highlights on the lemon skin and make the tones in other areas now seem dark and medium-dark.

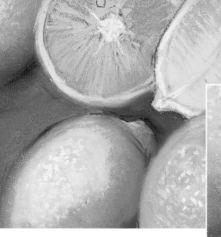

2. We have applied the general colors to most of the paper, leaving the strokes intact in some parts of the lemon skin and blending other parts. The background color is blended completely so that the fruit stands out.

NOTE
When painting elements without significant color contrasts, as in the case of our citrus fruit, keep in mind that you can develop forms and suggest textures by contrasting tonal values.

4. We continue to work on the orange pulp, applying orange and some yellow. The lemon skin gets a few strokes of a green shade. These last strokes are slightly blended.

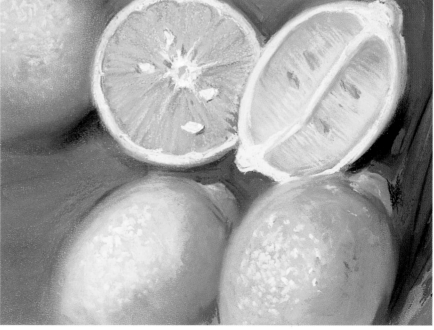

5. To finish the exercise, we add detail with thin strokes of pastel. We have also retouched the background, and, at the same time, the shadows closest to the bay leaf. This shows how seemingly complicated textures can be rendered simply and effectively.

Painting Skin

Painting the human figure realistically, especially the skin, requires practice, though not necessarily with nudes because the color and texture of skin can also be captured in portraits.

The human body, however, is one of the most popular subjects for pastel artists because it gives us the opportunity to demonstrate pastel's versatile range of textures, colors, and techniques.

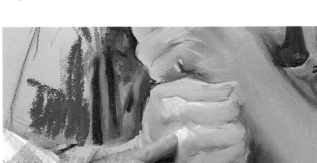

areas of medium light will all have different tones under the same source of light.

For these reasons, no one really has one particular skin color, only a range of tones and shades and textures. The challenge for the artist is to convey this range.

TECHNIQUE

The techniques used fo painting the human body i pastel are more or less th same as those for paintin other subjects—the differenc is the range of colors usec Since pastel is difficult to mix painters who regularly pain figures and portraits usuall have some of the ranges c colors that are manufacture specifically for this purpose.

While color is importan one of the keys to successfull rendering the figure is blenc ing. Expert blends can sho the soft, smooth texture c skin or create the subtl changes of tone that sugges the curves and volumes of th human body.

Special sets of pastels fc painting skin usually includ wide ranges of tones betwee white and red, in addition t yellows, pink and many type of orange. Thes colors are als accompanied t other shades th can be used t suggest hair, eye and shadow Some sets wi need to b supplemente with red-brown browns, an blacks to pair medium-dar and dark ski tones.

SKIN COLOR

Although there are special pastel sets of colors and tones designed just for painting it, human skin really doesn't have any one color or even range of colors. Both race and age play a role in the colors and character of skin; it also varies from one part of the body to another. One variable that affects skin color dramatically is light. Its tone, color, and the warmth or coolness of its hue, change skin color from one situation to the next. Of course, shadows, reflections, and

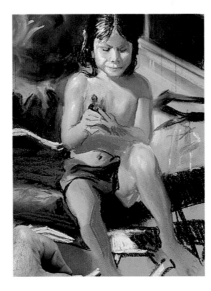

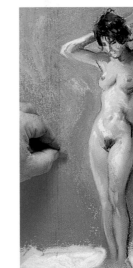

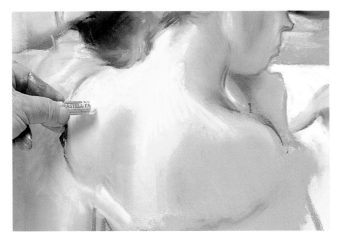

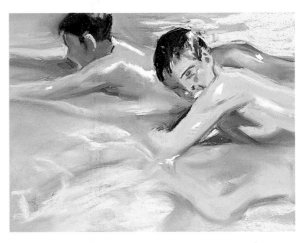

PAINTING SKIN WET SKIN

The characteristics of skin vary from one individual to another, and from one part of the body to another. Other factors, such as water, also affect the appearance of skin. Wet skin, for example, reflects more light than dry skin and is usually covered in tiny beads of water that make it look smooth and polished.

These characteristics, especially the reflections that are brighter and more common on wet skin, are what convey the idea of wet skin in a painting.

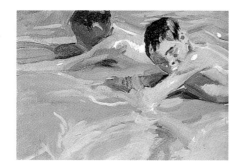

A fragment from the work Boys on the Beach *(1910), by Joaquin Sorolla. We will be copying it for our exercise on wet skin.*

NOTE

Wet skin produces brighter reflections than dry skin; showing these reflections is how we suggest wet skin.

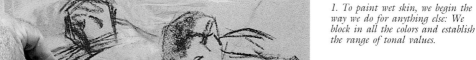

1. To paint wet skin, we begin the way we do for anything else: We block in all the colors and establish the range of tonal values.

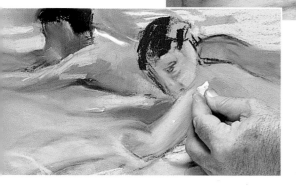

3. To the base colors that normally suggest dry skin, we add strokes of white that indicate the reflections.

2. We continue by developing the volumes, applying new colors and tones and blending the paints.

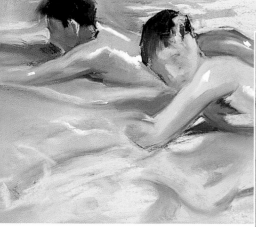

The white of the reflections has been applied in heavy, confident strokes. We lightly blend the edges of the strokes into the surrounding pastel.

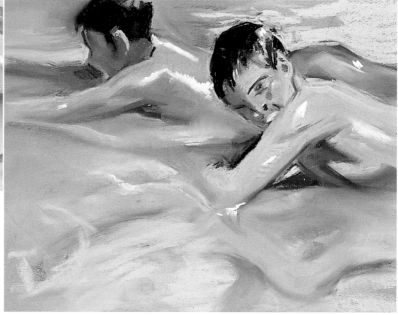

5. In the finished picture, you can see how we further developed the volumes and how the reflections have been retouched.

PAINTING SKIN | **DELICATE SKIN**

Most human beings have at least some delicate skin, usually in areas that are normally protected from the sun by clothing. In general, women and children also have more delicate skin than men.

Delicate skin looks soft and smooth, with a certain sense of fragility. Edgar Degas (1834–1917), the famous pastel painter, portrayed women particularly well. His specialty was showing the delicacy of skin, conveying its characteristics through the combination of blended and unblended strokes typical of impressionism. In this exercise, we are going to reproduce a fragment of one of the works of this extraordinary artist.

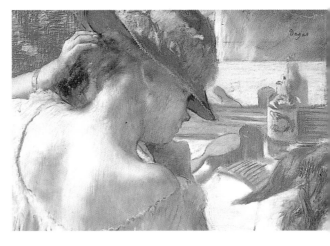

To understand how delicate skin is painted using pastel, we are going to copy a fragment of the work Woman Before the Mirror, *by Edgar Degas.*

1. A light-colored paper is most appropriate for reproducing the subject's fair skin. The first strokes of color are applied in a pale yellow.

3. Part of the woman's neck has been painted. Now we paint the background to test whether or not the tones for the skin are correct.

2. A slightly tinted gray, and that gray mixed with ochre, are the colors used to suggest the areas of shadow. Notice how the face is painted with cool hues, while those of the shoulder become warmer when gray is applied on top of the ochre.

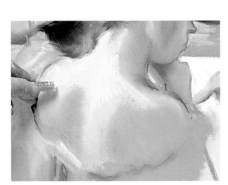

4. The last touches of light are applied directly, without blending, in an impressionistic style characteristic of Degas.

NOTE

Cool hues seem farther away and warm ones closer. Notice how we used these facts in this exercise, giving the face cooler hues, the shoulder warmer ones.

5. In the finished reproduction, you can see all of the work completed in the last step, including the directly applied pastel and how we carefully used the direction of these small strokes to reinforce forms.

PAINTING SKIN **WEATHERED HANDS**

Skin that is damaged by repeated exposure to the sun, harsh weather, or just the passage of time, has a rough, wrinkled texture and a particularly intense color. We find it on those parts of the body normally unprotected by clothes: the face and hands. For this reason, rendering these particular areas of the body is often considered the most difficult.

In any technique, hands are usually difficult to paint and require special attention. Their size—small in relationship to the rest of the body—and their complicated structure make them difficult to paint. If we aren't careful, they will look more like claws than hands!

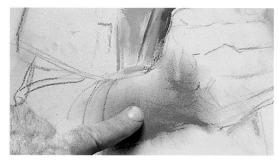

The hands of this old countrywoman are particularly rough and gnarled. They are clasped in a complicated position.

NOTE

The procedures for painting medium- to dark-toned skin are the same as those used to paint light skin. The only difference between them is the range of colors used and how tonal contrasts are established between the reflections and shadows.

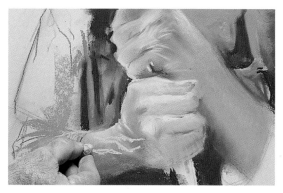

1. Since the tones of the skin and background affect each other, we have to test the colors of both areas until we find the right range.

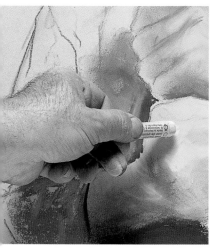

3. After developing the background forms and defining the areas of light and shadow, we begin to suggest the textures of the wrinkles and the protrusion of the veins.

5. The finished exercise shows the extensive detail work done in the last stage. Small strokes in various tones show the lines that separate the fingers and the light shadows between them.

2. These hands display such a wide range of skin tones that we will have to layer one tone over another.

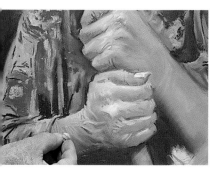

4. We continue to develop the rough texture of the skin, adding final details.

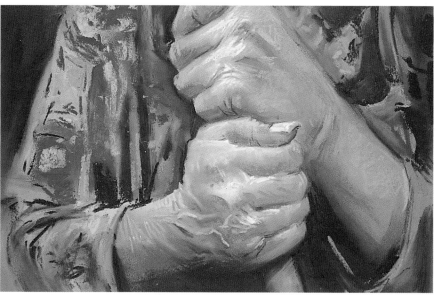

| PAINTING SKIN | MEDIUM TO DARK SKIN |

Painting medium to dark skin basically involves using a range of colors that includes that of the subject.

The one significant difference is that reflections, and other light components, such as teeth, will look brighter. Also, the shadows the body produces will probably be darker. This means that you will have to take special care to keep the tones of the skin and the shadows distinct or the forms will melt into each other and be distorted.

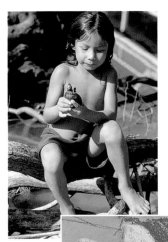

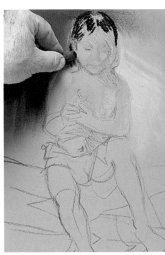

This Amazonian boy has some very bright areas on his torso, while the shadows on his legs are quite dark.

1. A dark-colored paper will be a good background. We begin by applying the first layers of color, testing tones and creating the background.

2. The background is simply areas of light and dark.

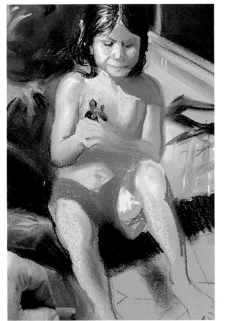

3. New, intermediate tones are applied on top of previous layers to develop volume. The background around the boy is filled in so we can adjust the skin tones.

NOTE

The procedures for painting medium to dark skin are the same as those for painting lighter skin. The only difference between the two is the range of colors used and how the tonal contrasts are developed between areas of light and shadow.

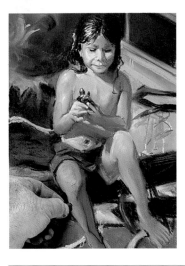

4. The areas of shadow on the body need to be darkened. To prevent them from dissolving in the background, we draw a faint line to define the silhouette of the leg.

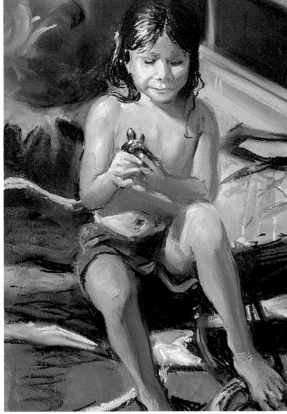

5. Once the picture is finished, you can see the wide range of hues and tones used to suggest the color and character of the boy's skin. Notice also the tonal contrasts between the bright areas and dark shadows.

PAINTING SKIN USING UNUSUAL TONES

When painting the figure, we usually choose colors as close as possible to the subject's skin, but we also try to convey the exact character of the body—its shapes and forms and the luster and glow of its skin, none of which requires a realistic treatment of color. In fact, using imaginative colors beyond the range of actual skin tones can result in a dynamic work that is propelled by contrast.

Complementary colors—those that contrast most with each other and are opposite on the color wheel—produce striking effects when used together. Using complementary colors to paint flesh is one more tool with which you can vary your treatment of the figure.

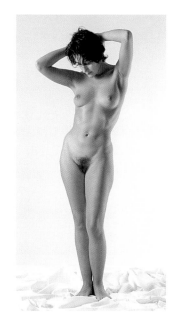

A large part of the work in this exercise is to translate the lights, shadows, and natural hues of the model into colors that produce strong, vibrant tensions.

NOTE

The contrasting colors are the main subject of this exercise. The picture has been developed with colors that vibrate next to each other, especially green with pink and orange-red with blue. These contrasts create the volume of the figure and suggest the various planes of the painting.

1. A base of light pink, indicating the lightest tones, is applied to most of the figure. The medium-lit areas are painted with green to create a strong contrast. Blue is tested for the shadows.

2. We continue creating vibrant contrasts by painting the background in orange, blending its first layer of paint.

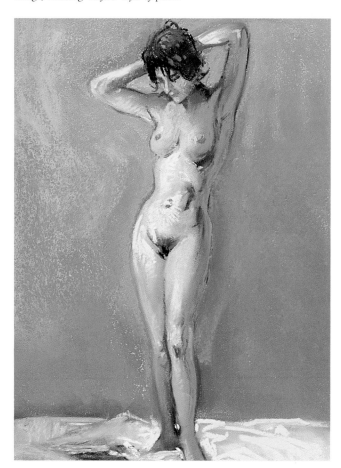

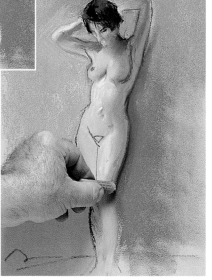

3. Another bright color is added to the background, defining the lightest areas.

4. Blue is used for the shadow at the figure's side because it contrasts naturally with the orange-red, both because they are complementary and because one is warm and the other cool.

5. In the finished exercise, you can see that the orange-red of the background, which we even used for the shadows of the left arm, created an essential contrast with the green.

Portraits

The portrait has been one of the most popular kinds of paintings throughout the history of art, primarily because most artists earned their livings by doing portraits of their wealthy patrons. Portrait painting, however, became less popular with the invention of photography, becoming just one subject among many that artists could choose to paint. Pastel is one of the best mediums for executing portraits. The simplicity of the process, the ease of transporting the materials, and the versatility of the pastel stroke all favor portrait painting. Although portrait painting presents more problems than other kinds of painting, the opportunity to portray human personalities and emotions is extremely compelling.

and this text is designed to aid everyone who wants to make the effort.

TECHNIQUE

As with other subjects in pastel painting, a portrait is begun by blocking in the basic forms with color, determining the general hues and tones, and establishing the volumes through the contrasts of light and shadow and color. While a sketch is always the basis for

a successful pastel painting, it's absolutely essential when you're painting a portrait.

The structure of a human face is sufficiently complicated to require a detailed sketch, especially if you want to paint a good likeness of your subject that includes a characteristic expression or gesture. Your precision when applying color, blending pastel strokes, or tracing a line is linked to your mastery of the sketch; a good sketch is the foundation for a good portrait. Remember, an eyebrow can be suggested with a single pastel stroke, but if that stroke is uncertain or simply crooked, the expression of serenity that you intended may look more like one of anger or surprise.

THE CHALLENGES OF A PORTRAIT

Portraits are considered one of the most difficult subjects to paint—in pastel or any other painting medium—not just because you have to find the right skin tones, or even because you have to establish physical traits with enough skill to make your subject recognizable, but because you must convey some part of the personality and emotional state of your subject.

This does not mean that you have to know a person intimately before you paint them; body language and facial expressions will reveal to you the character traits that are essential for the portrait. The main factors for a successful portrait are careful observation of

the subject and a basic mastery of pastel; your hand must obey your brain. This requires a lot of practice.

Attempting a portrait is a rewarding experience for artists at all levels,

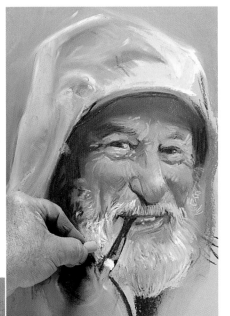

THE POWER OF THE GAZE

The gaze, or expression of the eyes, is what gives life to a face and reveals the personality of the subject. Although eyes can be painted quickly and occupy a relatively small proportion of the paper, you should take the time to get them right. The expressiveness of the eyes usually determines the quality of the portrait.

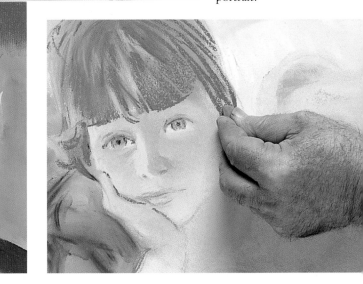

PORTRAITS — WOMAN FROM INDIA

As we have discussed before, the procedure for painting different colors of skin is basically the same, regardless of tone. The techniques that may vary in portraits are for other features, such as wrinkles or hair texture. In this exercise, we are going to paint the portrait of a smiling woman with shiny, black hair. The smile is the real focus of the exercise. The tensing of facial muscles that creates a smile affects the forms and shapes that make up the face. The biggest challenge we face is conveying the spontaneous pleasure of the expression. A slip of the pastel will make that happy smile look like a frozen grimace.

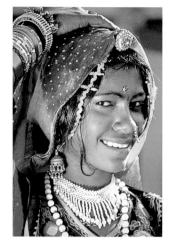

1. After making a detailed sketch, we begin to apply what will eventually be the background color. We use a red and an earth tone. The brightest areas have been painted with yellow.

2. Pastel is applied to the background and to the veil so we can assess the tonal values that will be used for the face. The hair is painted after we retouch the lines of the eyes.

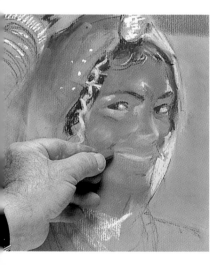

3. Once the general tones are determined, and basic forms suggested, we add new colors.

NOTE

Normal brown wrapping paper is economical and a good color for painting portraits; however, its surface can't hold a lot of paint, so you should take care not to fill it.

The smile of this young woman is bright against her dark face, which also contrasts with the colors of her clothing.

5. The last touches have been put on the finished exercise. The subject's dimples have been suggested with a daring red, more white has been applied to the teeth, and extensive detail has been added to the clothing.

4. We work on the rest of the portrait as we work on the face. The eyebrows have been retouched and a reflection has been highlighted in the left eye.

PORTRAITS CHILD WITH TEDDY BEAR

The skin of children is soft, smooth, and delicate. Their gestures are unself-conscious, their open-eyed gaze, innocent. These are the most important characteristics to convey in a child's portrait.

Props in the portrait can be used to reveal the child's personality. Just as musicians are painted with their instruments, or book lovers surrounded by their books, children can be painted holding their favorite toys.

We will suggest this boy's sweet nature in this portrait of him with his favorite teddy bear by minimizing shadows and working with a palette of soft tones.

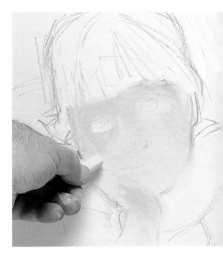

1. We block in the face using the proper flesh tones for each area of light and shadow.

2. The base color has been smoothly blended and we've begun to paint the hair and the other areas around the face. We have drawn the pupils of his eyes with a pastel pencil.

3. Using a pink pastel, we draw in part of his nose and the contours of his mouth, giving the face a coherent structure. The tone of his hand has been adjusted.

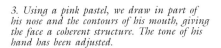

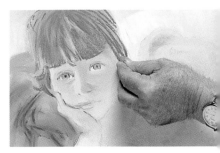

4. The cheeks have been painted with soft strokes of pink smoothly blended. The hair is textured with thick strokes.

NOTE

Notice how, as the exercise progressed, the expression of the child was gradually perfected to look like the photo.

In this case, we decided to make the boy look a little sleepy. You can take some artistic license with expression to make your painting more interesting, as long as it is in keeping with the subject's personality.

5. In the finished portrait, you can see how the face was improved by the final touches—a bright tone added volume to light areas, and details completed the mouth and eyes.

PORTRAITS **BEARDED FISHERMAN**

Faces weathered by time and exposure are often deeply wrinkled, adding an element of complexity to the painting process. The texture of facial hair, such as mustaches or beards, also challenges the painter.

Such extraneous props as spectacles, cigarettes, or pipes, which artists sometimes include, complicate things further because they must be integrated naturally into the portrait.

This fisherman's face, with its wrinkles and beard, challenges us with its complexity. The pipe must also be considered.

NOTE

Start developing the shadows of the portrait as soon as you begin blocking in forms with color. This way, the correct balance of tones is established and you can minimize adjustments.

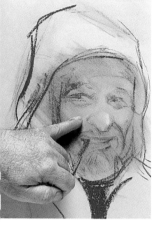

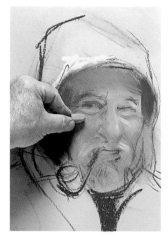

1. As always, we begin by making a detailed sketch of the individual's features, applying the first basic tones over it, then blending them slightly.

2. We test the color for the raincoat and continue working on the face with yellows, oranges, and a touch of pink.

3. We begin work on the beard with firm, confident strokes. The shadows have been darkened.

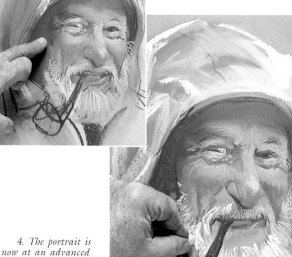

4. The portrait is now at an advanced stage and we can add more details. Short strokes convey the textures of the skin and hair.

5. The finished work reveals the completed pipe and shows how texture was suggested in the beard with simple strokes in bright tones. The teeth have been painted and highlights added to the lower lip with touches of white.

The Clothed Figure

Although pastel artists practice and master the drawing and painting of nudes, the clothed figure is also important. It can appear in any kind of painting, including portraits, domestic scenes, landscapes, and seascapes. You might imagine that the clothed figure is easier to paint than the nude, but, the complexity of folds and wrinkles in clothing, the texture of materials such as denim, and suggesting the human body underneath the clothes presents an entirely different set of challenges.

TECHNIQUE

The first step in painting a clothed figure is observation. You have to observe the subject until you understand his or her forms and proportions. Most importantly, you must keep in mind that under the clothing there is a human body that is composed of bones and

muscles, filling out the clothes.

The volume of the clothing's folds, creases, and wrinkles will be established primarily by the interplay of light and shadow. You should use confident, precise pastel strokes to suggest the variations in tone and texture from the beginning so you can avoid the woodenness and muddy tones that result from too many corrections.

FOLDS

Most clothing shows a variety of folds and wrinkles, caused either by the pose of the subject or the nature or design of the garment. Sometimes these folds reveal the form of the body underneath; in other cases, they completely conceal or distort it.

The execution of these folds and the relationship between the garment and the body that fills it are the keys to painting clothed figures, regardless of their pose.

NOTE

When painting a clothed figure, remember that there is a human body filling out the clothes. This means you have to pay as much attention to the muscles and bones of your subject as you do to the pose.

THE CLOTHED FIGURE | **A WET SHIRT**

Clothes look different wet than they do dry. The added weight of the water makes the drape of the garment more pronounced and the wrinkles sharper. Water also gives clothes a sheen. On occasion, thin wet cloth will adhere to the body, accentuating its lines and forms and revealing the skin tone underneath.

This man's shirt, soaking wet and sticking to his body, has become translucent in places from the rain.

1. After painting the background, we apply a pale yellow for the shirt. We blend most of it, leaving some strokes sharp to indicate the wrinkles.

3. In the two previous stages, we laid down the base colors over which we will paint the details and the textures. Now we apply white, the color of the shirt, and further develop the folds and wrinkles.

5. In the finished work, you can see the tones used to paint the shirt and how strokes were used to suggest the drape of the cloth and its folds and wrinkles. They were also used to render the wetness of those areas where the shirt clings to the figure's body.

2. A blended earth tone suggests the areas where the cloth sticks to the body. Some heavy strokes on the right sleeve begin to indicate the wrinkles.

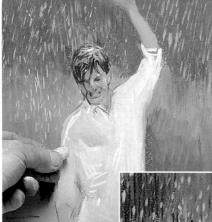

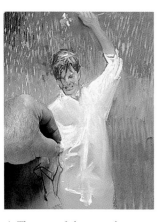

4. The area of the stomach, seen through the shirt, has been rendered by simply applying a flesh tone. The left arm has to be outlined to separate it from the background.

NOTE

Skin tones softly blended into the color of the garment suggest wet, semitransparent clothing that is sticking to the body.

Remember, wet clothing is heavier than dry. The way you render the drape of the folds is what conveys that additional weight.

Some types of clothing, such as robes or habits, conceal almost the entire body. When rendered in pastel, the long, deep folds they produce can make the fabric look flat and stiff. You can prevent this by working with confident, precise strokes and carefully developing the folds to convey the human figure beneath. A wrinkle might indicate a shoulder or a knee.

This monk's robe is made of so much fabric its folds and creases are almost countless.

1. During our sketch, we test several colors to use for the skin and tunic. The color we had selected for the tunic is too similar to the hue chosen for the skin.

2. We make more tests to determine the best color for the fabric. We finally draw the folds of the cloth with a dark brown so that they will be seen through the red of the tunic.

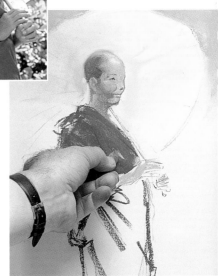

3. We use our red strokes to suggest the drape of the fabric and the most delicate creases.

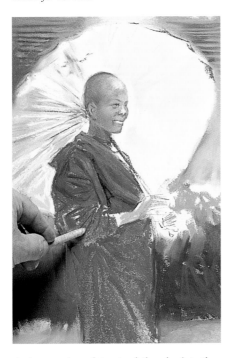

4. A stump is used to extend the color into the smallest spaces, including wrinkles, where neither a finger nor the pastel stick can reach.

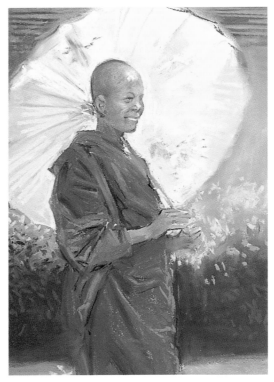

5. The work is finished when we retouch the folds, using a lighter red in the brightest areas.

NOTE

One way to suggest the folds of clothing is to use the sketch lines. If you deepen the tone of the sketch with a dark pastel, it will remain visible through the subsequent layers of paint.

THE CLOTHED FIGURE **A MAN IN JEANS**

Because blue jeans are internationally popular, it's likely that you will find some of your subjects wearing them. The rough texture of the denim and its characteristic color are important to render. The highly visible seams that produce distinctive folds should also be considered.

Painting denim is even more of a challenge if we combine its characteristics with a complicated pose, like crouching. Don't worry, the secret to this exercise is the interplay of tones and easy, confident strokes.

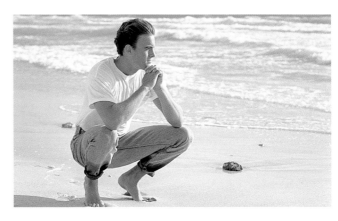

This man's crouching position produces a variety of creases and shadows in his jeans.

NOTE

The mixture of the two blues and the black on the pants produces enough tones to suggest the volumes without relying on color contrasts.

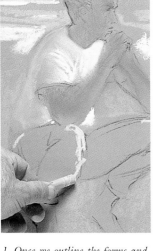

1. Once we outline the forms and determine the basic tones, we apply a sky blue to the brightest areas of the pants.

2. A darker blue is used as the medium tone of the jeans. Black suggests the shadows and seams.

3. Sky blue on top of the previous base indicates the creases.

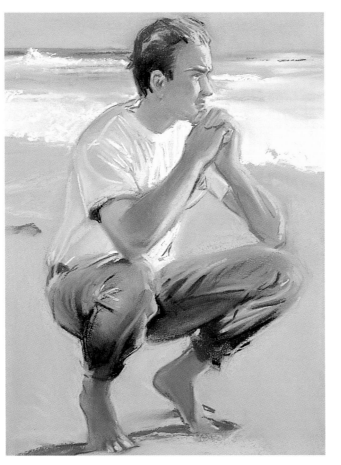

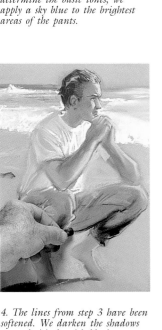

4. The lines from step 3 have been softened. We darken the shadows more decisively with black.

5. In the finished painting, you can see how the final touches have conveyed both the color and texture of the blue jeans. Notice also how the blue in the shadows of the white T-shirt unifies the painting.

THE CLOTHED FIGURE A BABY IN A PLAYSUIT

Babies have significantly different bodies than adults—their forms are softer and rounder; their heads are disproportionately large for their bodies.

This playsuit covers everything but the hands and head. It fits tightly enough to reveal a child's body, but still produces a large number of folds and wrinkles.

This baby is dressed in white, a color that is very similar to that of the surrounding room.

1. We test several colors, trying to determine how to keep the white shape of the baby from dissolving into the white floor and background. When a decision is reached, the darkest creases are suggested with black.

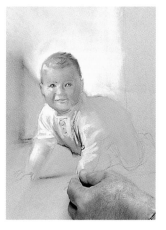

2. The playsuit is painted alternately in white, cream, and blue tones, suggesting the wrinkles with the first strokes.

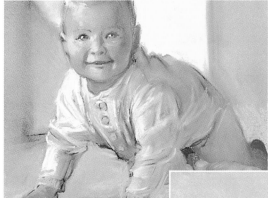

3. We continue to develop volume and depth by adding a warm hue, red, to contrast with the cold blue of other areas.

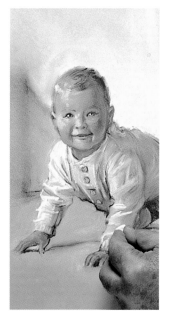

4. White is used again to further develop the folds.

NOTE

When you paint form-fitting clothing, you must work the creases with special care, because, aside from suggesting the characteristics of the clothing, creases also reveal the body underneath.

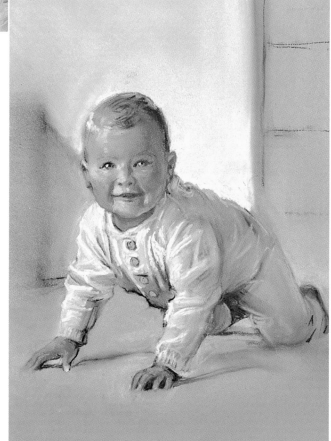

5. In the final painting, you can see how important the wrinkles were in conveying the shape of the baby underneath the playsuit.

THE CLOTHED FIGURE | A GIRL IN BAGGY SHIRT AND TIGHTS

Comfortable clothes are often either baggy or soft and stretchy. Baggy clothes conceal the forms of the body and create long folds in almost every direction.

Tight, stretchy clothes, on the other hand, cling to the body, revealing in full its contours and forms. Since both types of clothing have different characteristics, they must be rendered differently in pastel.

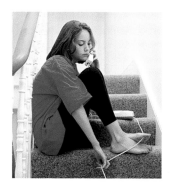

This girl is wearing a baggy T-shirt. Its loose folds contrast with the smooth surface of her tights.

1. We block in the base colors of each item of clothing, already taking advantage of our pastel strokes to develop volume. Notice how the sketched lines of the T-shirt have been followed carefully, as we begin painting the folds.

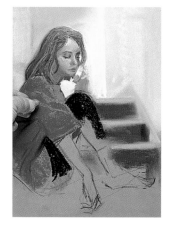

NOTE

You will have to use special tricks to suggest the volume of dark, form-fitting clothes that don't offer enough variety of either color or tone to do it via contrasts. We solved the problem by incorporating a blue line running along the contour of the leg.

The volumes of the T-shirt, on the other hand, were easily established with an interplay of red tones.

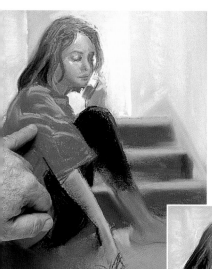

2. We use a lighter tone to paint the brightest folds.

5. This exercise shows the different ways the two types of clothing can be treated. The baggy T-shirt was characterized by large folds concealing the contours of the girl's body. The elastic tights, on the other hand, displayed absolutely no creases, hugged her body, and revealed the contours of her legs.

3. A white has been applied and blended on top of the vermilion folds. A blue line is added to the tights to indicate their slight sheen.

4. The tights and the arm have been retouched, primarily to define their outlines. We also retouch the foot to separate it from the stairs.

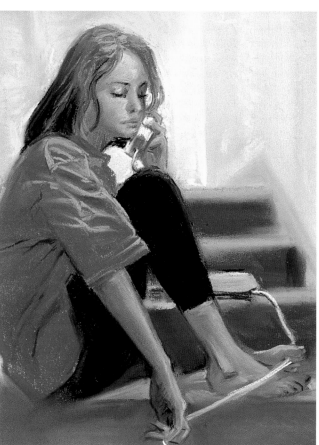

Animals

Wild animals are covered with an enormous variety of textures and colors of fur, feathers, scales, and skin; there are even significant differences among a single species.

This diversity is an interesting challenge for the pastel artist who wants to paint animals or experi-

ment with textures, because knowing how to render snake scales or the plumage of an owl, may not solve the problems of suggesting the short, shining pelt of a bull or the luxurious fur of a well-fed house cat.

While the painting processes are more or less the same, rendering the unique textures and characteristics of each different animal may require a wide variety of techniques.

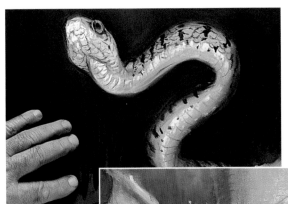

ANIMAL ANATOMY

Animal species differ anatomically, in addition to varying tremendously in size and appearance.

You should keep this in mind as you begin to sketch a particular animal. Underneath the animal's skin, fur, scales, or plumage will be a specific skeletal structure. You will also be able to see a certain amount of muscles.

Watch out for anatomical drawing of animals that show the skeleton or the musculature. These frequently appear in books dealing with natural history subjects.

Studying the anatomy of an animal and sketching it in different poses and from different perspectives will help you understand its structure and paint it convincingly.

TECHNIQUE

Although techniques will differ from subject to subject, the basic process for painting animals is still the one you have been learning—you make a preliminary sketch, block in the forms with their basic colors, establish your tonal range, and use it and color contrasts to develop volume. In the last step, you add the details that indicate the subtle differences between one texture and another.

The various exercises in this section will demonstrate how to develop the textures of scales, fur, feathers, and skin.

SCALES

Some animals have developed scales to protect their bodies from both predators and the elements. A scaly skin looks like it is composed of small units and has a rough and often uneven surface. Scales come in a range of different sizes and a rich variety of colors. Animals with colorfully patterned scales can be especially interesting subjects for the pastel artist.

The best way to suggest scales is to apply the base colors first and develop the texture later, using the edges of the pastel sticks. Dots of paint can be used to show the small areas of reflected light.

Once you have created the proper surface pattern, avoid touching it with your hand or sleeve. Smudges will destroy the scaly effect, which requires sharply defined areas of color.

SCALES A SNAKE

The snake, one animal that uses scales as protection, is particularly interesting to artists, not only for the fascinating pattern of its scales, but because it has no appendages to interrupt the long, sinuous curves of its body.

The snake we are going to paint has a bright, lively coloring that stands out well against a dark background.

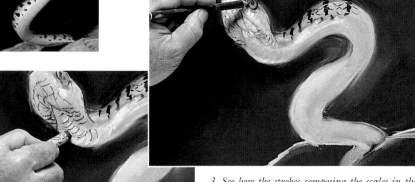

3. See how the strokes composing the scales in the area under the head have been lightly blended. With a pastel pencil we add the finer lines that you can see around the eye.

1. We've chosen black paper for this exercise. That means we will have to work in reverse, filling it with light. We also have to avoid smudges, since they are extremely obvious on dark paper. We sketch the reptile's silhouette using a pink pastel stick, apply the first layer of color, then blend it.

2. The edge of a black pastel on top of the lightly blended base color suggests the scales.

4. The head is finished by applying some touches of pink and yellow between the lines that suggest the scales. The rest of the body is painted in the same way, suggesting with these small dabs of color the reflections on the scales.

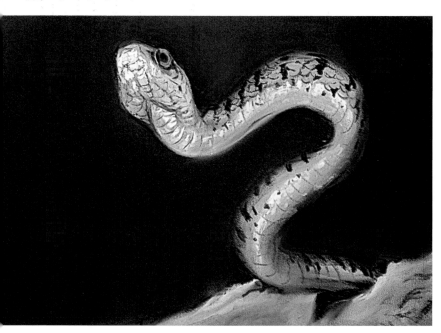

5. In the finished exercise, you can see that touches of black have been used again toward the back of the snake to develop the texture of the scales. You can also see how the treatment of scales varied—those with reflections have been suggested by touches of color, while others have simply remained the base color.

NOTE

Smudges on a dark background are extremely noticeable. If they are a problem, you might want to apply a matching coat of paint as a final step to recover the homogenous tone of the paper. It also intensifies the color.

HAIR AND FUR

Most mammals are covered with hair or fur. The color, length, thickness, and texture of it are the characteristics that distinguish a variety of animals from each other.

Not all pastel artists paint animals. Some are emphatically not interested; others simply prefer other subjects. Still, learning to render the characteristics of fur and the forms of the animal under it will give you a greater understanding of pastel techniques in general. Painting animals will give you practice choosing ranges of colors and tones as well as an opportunity to master many kinds of strokes as you suggest various textures. These basics will always come in handy, and you may even find yourself painting a household scene that includes a cat or dog.

HAIR A BULL

It's important when painting short-haired animals like cows, bulls, and horses to capture the slight fuzziness of their hide, as well as the reflections produced on their hides by light.

We are going to paint this bull when the sun bathes its body in light, creating contrasts of bright areas and shadow. We take advantage of this tonal range to develop the volume of the bull, and suggest its hide.

1. We've chosen a paper whose brown color provides a tone that is useful for both the meadow and the bull. We draw the sketch, then test and apply the first colors.

2. After determining the right range of tones, we block in bright areas with a yellowish ochre. Special attention is paid to the stroke to suggest the volumes and texture of the bull's hide.

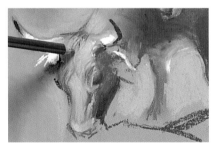

3. For the horns and ears, we use a white that is slightly mixed with the brown from the sketch. The hair on the bull's forehead is drawn in with a pastel pencil.

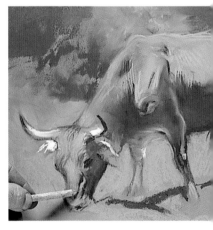

4. We use a thin stump to blend some of the pastel strokes on the head.

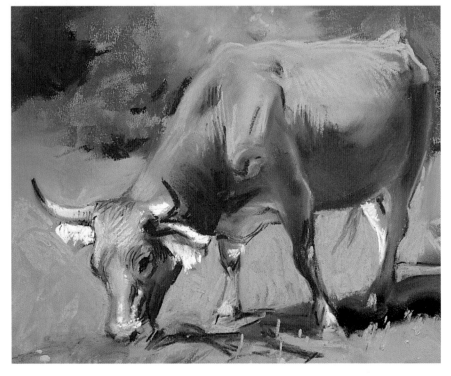

NOTE

Pastel pencils are sometimes the best tools for suggesting texture. In this case, they were used to render the hair on the bull's head.

The character and direction of the pastel stroke should also be a fundamental tool for suggesting texture.

5. In the finished work, you can see how we carefully developed both the image of the animal and the background, adjusting the tones of both as the exercise progressed.

FUR **A CAT**

Paintings of domestic scenes often include cats. Their soft and shiny fur and direct gaze make cats wonderful subjects. They also ingratiate themselves with artists because they remain still for long periods of time, making it easy to paint them.

This long-whiskered house cat has soft, reddish fur with bright, tiger-like stripes.

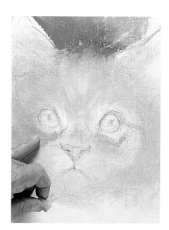

1. This painting will be executed on canvas, the rough surface of which will give the work an unusual character. The first colors are applied and blended. During this early stage, it is easy to see how the texture of the canvas affects the pastel.

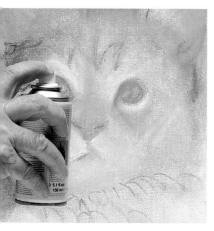

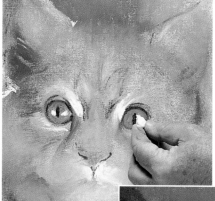

NOTE

Applying a fixative over the base layer keeps it intact and gives subsequent layers something to stick to when the surface fills with pigment.

2. The rough canvas shaves off a lot of pigment from the pastel. The loose pigment might bleed into the colors that are applied later or fill the tooth so that subsequent layers of paint won't adhere. We apply a fixative over the base layer so that details can be safely added on top.

3. After working on the eyes and their reflections, we begin to apply the touches that add a sense of volume to the work.

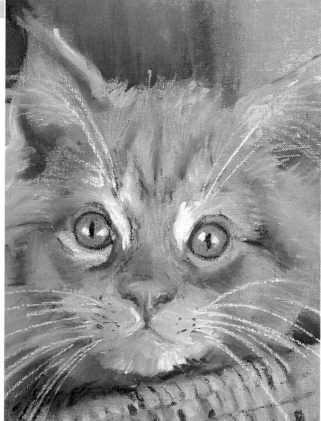

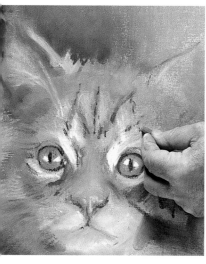

4. Varying the thickness and length of our pastel strokes conveys the quality of the fur. We also suggest the lighter areas between the stripes in the fur using these principles.

5. Finally, we give texture to the fur with thin strokes of ochre. The whiskers are painted with pastel pencil. The texture of the canvas prevents the addition of a lot of details, so we create our effects by using different kinds of strokes.

FEATHERS

Birds have more and wider-ranging color combinations than almost any other group of animals. Although there are a few single-colored species—such as the white swan—others, such as the macaw, display an unparalleled array of colors and contrasting hues.

Most plumage is soft, like some furs, although the size and shape of the individual feathers can vary enormously from one part of the bird to another. Generally, the feathers on the head are the shortest, forming small round shapes. The longest feathers, used for flying, are found on the wings and tail. You will have to use a variety of techniques to suggest the different feathers, including short strokes and dots in some areas, and long, linear strokes in others.

FEATHERS — A MACAW

The macaw, a bird with bright plumage, will make a beautiful subject for a painting. To keep its contrasting colors bright, we have to use pure colors and avoid mixes and blends.

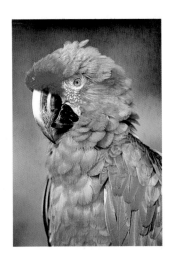

We are going to paint a macaw. There is a lot of detailed work to do on the head feathers. We will also pay special attention to the longer feathers of the wings.

1. The colors applied over the outlines of the sketch are not blended, except for the white of the beak.

NOTE

This exercise perfectly illustrates how to develop a work by superimposing layers of color that become almost an impasto.

4. New tones have been added to the head. We suggest the feathers with small strokes and dots of color. The color of the breast is adjusted by adding red. A touch of white applied gently with a finger gives form to some feathers.

2. The background is developed at the same time as the parrot. Its plumage is developed through strokes of color that suggest the direction of the feathers as well as their form.

3. The colors of the wings have been applied and only slightly blended so that the direction of the pastel strokes remain visible. The area of the breast is also blended.

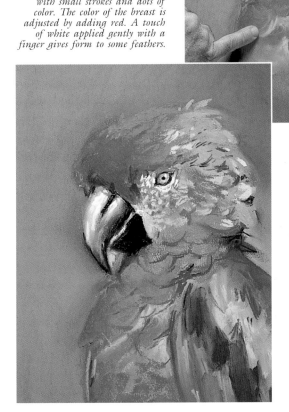

5. To see the details that have been added, compare the finished painting to earlier stages. Small touches of color were used to develop textures, suggest the form of feathers, and indicate light. This painting also relied on the character and direction of the pastel stroke to suggest textures.

FEATHERS AN OWL

The owl is an interesting subject, not only for the unusual combination of its long and short feathers, but because of its intense gaze and enigmatic expression created by the short, strong beak and from plumage radiating out from each eye.

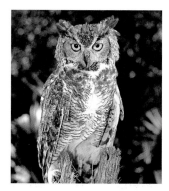

The plumage of the great horned owl is usually composed of earth tones and broken grays. The feathers around the eye give this bird a particularly mysterious, restless expression.

NOTE

A dark, blended background makes the central figure stand out. The bird's light color also makes it seem to approach the viewer.

The contrast of the smoothly blended background with the defined parts of the subject also produces a sense of depth.

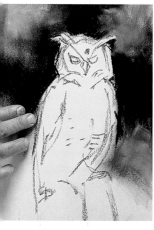

1. After drawing the preliminary sketch, we paint the background with dark tones, then blend it. This reinforces the shape of the owl by contrasting its light color with the dark tones that surround it.

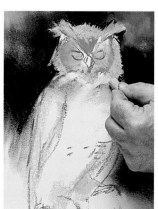

2. Next, we begin to work on the head, applying ochres and browns as the base coat. We use each stroke to indicate the direction of the plumage radiating out from each eye.

3. The breast and abdomen of the owl are developed with small strokes, suggesting the mottled feathers. The wings are also rendered. The cream color on the abdomen is lightened in different areas.

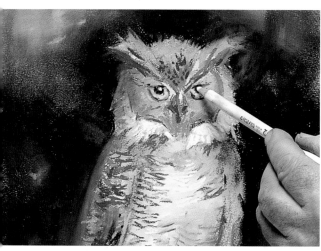

4. After adding detail to the head feathers, we give additional attention to the eyes. Remember, capturing the gaze of this bird is essential. A stump loaded with paint is used to color the sphere of the eye.

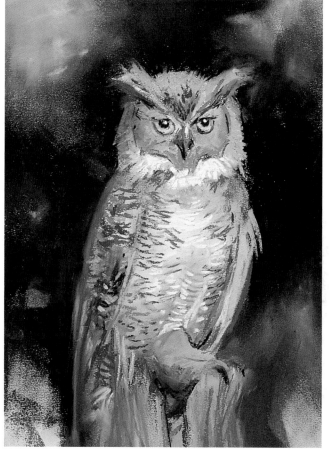

5. The finished painting is quite detailed. The combination of small strokes of different tones and shades conveys the texture of the bird's plumage.

SKIN

There are many kinds of skin in the animal kingdom.

Frogs, for instance, have thin, damp, delicate skin suited both to the water and the land. The thick, rough, sturdy skin of elephants is perfect for them. You will have to use an assortment of methods to convey all these different characteristics. Smooth, shiny skin, like that of aquatic mammals, will require you to work with reflections. Skins that are extremely wrinkled need a different treatment.

SKIN A CHIMPANZEE

Humans and monkeys have some anatomical similarities. A monkey's face even has wrinkled skin, while the rest of its body is covered in thick hair. It will be a challenge to work with two such dissimilar textures in the same image.

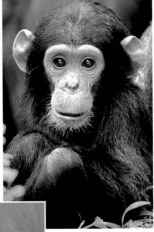

Our subject will be this young chimp. We will pay particular attention to the hairless, wrinkled texture of its face and how that contrasts with the rest of its furry body.

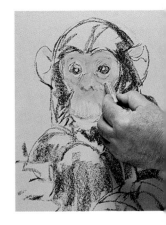

1. A light orange is applied as the base tone for the face. We use these strokes and the underlying strokes of the sketch to suggest wrinkles.

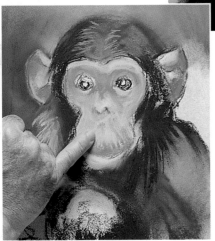

2. We develop the dark hairy areas and the background, so that we can determine the right tones for the skin. A darker orange and an earth tone are used to suggest the crevasses of the ears, the eye sockets, and the area above the upper lip.

3. A stump loaded with pigment is used like a pencil to trace the lines of the wrinkles.

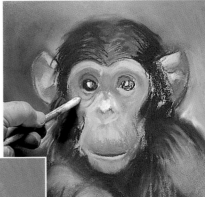

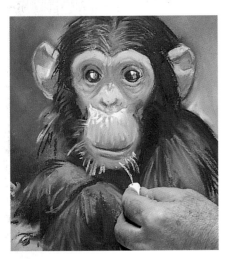

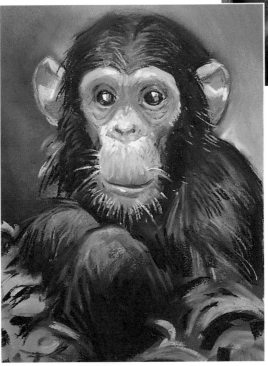

NOTE

When painting animals that have two different textures, you should take care to develop them both at the same time so that they can be integrated naturally.

4. A white pastel stick is used to suggest the areas of light on the nose and the whiskers sprouting from the chin.

5. Notice how the monkey's skin required the same tones that we have used to suggest human skin, although the tones have a different effect next to the dark hair.

SKIN **DOLPHINS**

Dolphins are aquatic mammals with smooth gray skin on their sides and lighter skin on their stomachs. Underwater, their skin looks velvety. On the water surface, the skin looks more like satin and is covered with reflections of light.

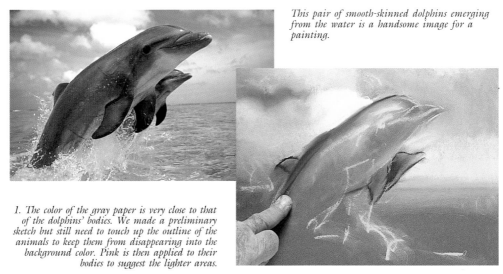

This pair of smooth-skinned dolphins emerging from the water is a handsome image for a painting.

1. The color of the gray paper is very close to that of the dolphins' bodies. We made a preliminary sketch but still need to touch up the outline of the animals to keep them from disappearing into the background color. Pink is then applied to their bodies to suggest the lighter areas.

2. We paint the water, then outline the silhouettes of the dolphins in black.

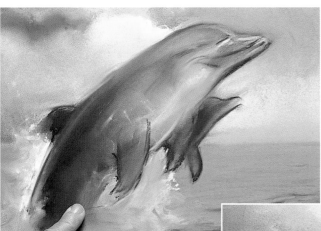

3. The forms are constructed with dark grays and a touch of red, then the tones are blended and mixed.

4. Capturing the foam and spray of the water will convey a sense of movement. Pale yellow and white are used to suggest the water droplets on and around the dolphins.

NOTE

When silhouettes are drawn in background colors, you will usually have to redraw them, as we did in step two of this exercise.

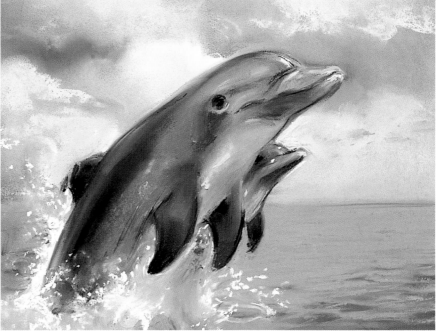

5. In the finished exercise, you can seen how detail and shadows have been used to give depth and realism to the image.

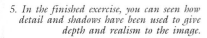

Drapery

Drapery often appears in paintings. It is inescapable in portrait work and when painting clothed figures, as well as in interior scenes where you usually find curtains and upholstered furniture.

Every fabric has a unique weight, luster, and texture. Accurately painting folds and creases is the best way to convey these characteristics. You should pay special attention to making their weight realistic.

abstract image into something with weight and texture. It is also important to consider what function the fabric has and what forms are hidden beneath it.

As you begin to observe it, you will notice that each type of fabric produces a particular kind of wrinkle—thick cloth creates large folds; thin cloth creates many small creases.

Drapery affects each scene differently. It can impart a sense of energy through the directions of its lines or a sense of serenity through the soft curves of a fold.

TECHNIQUE

Techniques for painting fabric depend upon your preferred method of painting. You can start with base layers, then develop the volumes of the folds with another layer of lights and shadows and add the details that convey textures at the very last. Or, you might prefer to start off at the beginning defining the forms that create the folds and wrinkles, suggesting them with a dark tone that will show through the subsequent layers of color and will be part of the final tone of your shadows.

FOLDS AND WRINKLES

Since virtually every fabric develops folds or wrinkles, you should know how to paint them; besides, it is their flowing and evocative forms that make fabric so interesting.

To paint fabric well, you have to study it carefully, transforming its hodgepodge of lines and shapes from an

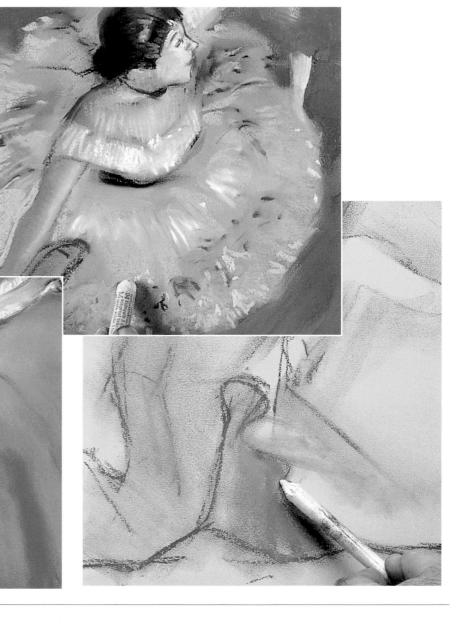

DRAPERY SILK

Silk combines weightlessness with a satinlike surface that can produce soft folds or sharp wrinkles. Rendering these characteristics can be complicated if there is also a pattern in the fabric.

The secret to successfully rendering silk is careful observation and good technique, since the process depends on a combination of precise blends superimposed over layers of color.

In the work Portrait of the Marquise of Pompadour *(1755), by Maurice Quentin de La Tour, the subject wears a spectacularly patterned silk dress whose many creases and large folds shimmer with light.*

1. We have chosen a paper whose ochre color is very similar to that of some parts of the fabric. After we draw the preliminary sketch with an earth-toned pastel, we lightly blend the color of the strokes with a rag, spreading it over the paper.

NOTE

The shine from a fabric such as silk usually appears on the edges of the folds or wrinkles. To suggest these areas, you simply apply light tones along the edges.

3. We develop depth by contrasting tones, especially accentuating the shadows. The work begins on the pattern.

2. The first strokes of color are applied, determining the light, medium, and dark areas of the work.

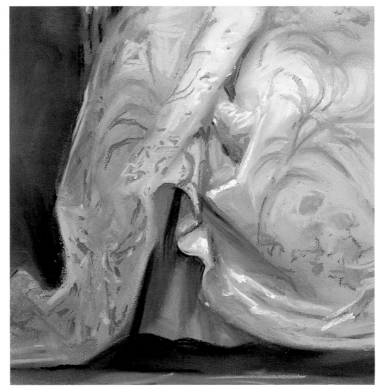

4. The pattern is suggested with ochre. We use the sketch lines as we further develop the volumes of the folds.

5. We have finished reproducing the fragment of the portrait. You can see that the pattern was suggested, but not rendered stroke for stroke. The tone of the shadows was darkened and we suggested the sheen of the fabric with touches of white on the edges of the folds.

Thick fabrics usually hang heavily and form large folds; these characteristics are the key to rendering them realistically. Both towels and sofa coverings are made of fabrics of considerable thickness and weight but, while a towel can be folded several ways, the fabric of an upholstered sofa always has the same tucks and folds.

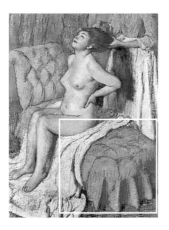

We are going to paint a fragment of the work by Degas, Nude Having Her Hair Combed, where the subject is seated on a thick towel laid over an upholstered divan.

NOTE

When working in layers of superimposed colors, you might want to apply fixative over the first layers to keep them intact. You have to take into consideration, however, that fixative sometimes slightly changes the color of the paint.

1. The sketch has been drawn on reddish-colored paper and the first layers of pastel have been applied. We apply fixative over them to make sure that this color doesn't blend into those that will be applied later. Color is applied to the form of the towel with energetic strokes that begin to suggest its texture. The area of the divan is blended.

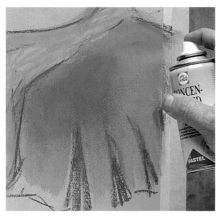

2. We now apply light yellow to the towel with irregular strokes that imply the weave. Red and yellow is applied to the divan, paying careful attention to the pastel strokes that will be blended later.

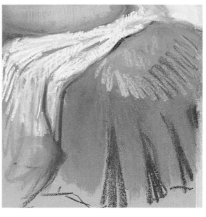

3. We now blend the pastel strokes on the divan, trying to capture the texture of the upholstery with its uneven tone and dark lines. The shadows within the folds have been brought out with a dark red. The towel is painted with the short, crossing strokes that suggest the texture of the fabric.

4. The towel is finished with touches of three colors: the background shade, cream, and black. Black makes the folds more pronounced. The divan has been further developed along similar lines; the folds of the upholstery are suggested with a dark tone, and a pair of lines.

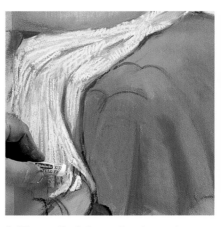

5. Once the exercise is finished, you can see how we suggested the texture of the velvet with red and yellow strokes on the earth-colored background. The sense of volume and depth was further developed by darkening the shadows and adding dots of light with yellow strokes. In the towel as much as in the divan, you can see the short strokes and optical mixes that are characteristic of Degas. By following this exercise step by step, you will understand why each of the fabrics was developed using a different method.

Gauze and lace have a weightlessness, delicacy, and softness that is unlike other fabrics. The consistency and techniques of pastel make it a good medium for rendering these fabrics. Most useful are blended strokes, impasto, and layered tones.

 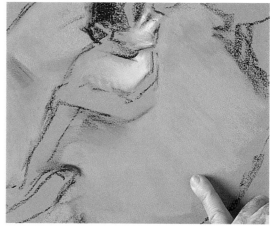

1. We chose a paper with an ochre tone that is close to the ballerina's skin and the background, but not the dress. A blue is applied at the center of the dancer's body with a pastel stick. The strokes radiate out from the waist to suggest the drape of the tulle and the direction of the folds.

2. The colors of the dress are blended along the direction of the sketched lines.

NOTE

You should begin to suggest the texture and direction of the folds with your first strokes, adding the remaining details, if any, in the last stage.

3. The bodice is painted with white, which is also used to suggest some folds.

5. You can see Degas' unmistakable style in the finished work, especially in the treatment of the colors. Small, energetic strokes suggest the glow of the skin, the texture of the bodice, and the movement of the tulle.

In the 1879 painting of ballet dancers by Edgar Degas, the ballerina is wearing a dress made of a soft and wispy tulle, perfectly rendered in pastel.

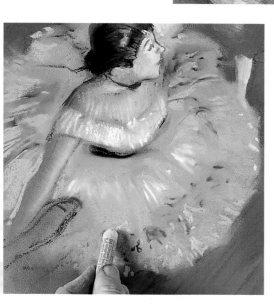

4. The touches of garnet and yellow suggest the ruffles and movement of the tulle.

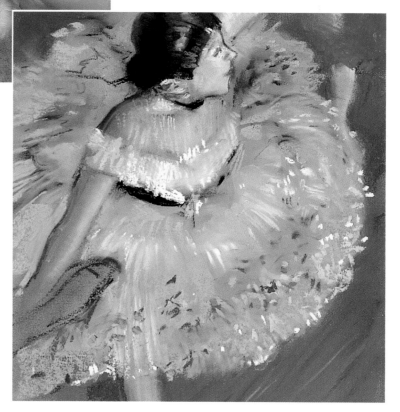

Metal and Glass

Metal and glass are both hard, shiny materials that can reflect light and any objects near them. When you paint either material, you will need to capture its reflective capability. This sometimes means you will need colors that are not in your box of pastels; the only solution is to mix them.

THE COLORS OF METAL AND GLASS

Since clear glass has no color, it is rendered by using the colors of the slightly distorted objects seen through it.

When you paint tinted glass, you can, of course, use its color to develop its form but you must also convey its transparency by suggesting whatever is inside or behind it.

As for metal, you will need to approximate the colors that you see, using a yellow for gold, gray for silver tones, browns for rust, and so on, making mixes to get the full range of tones needed.

REFLECTIONS

Polished metal and glass are extremely shiny, reflecting both light and objects. Learning to show this characteristic is the key to painting these materials realistically, whether they are transparent or opaque.

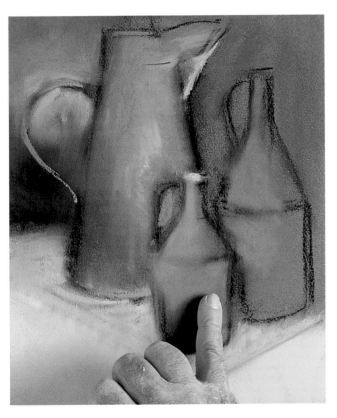

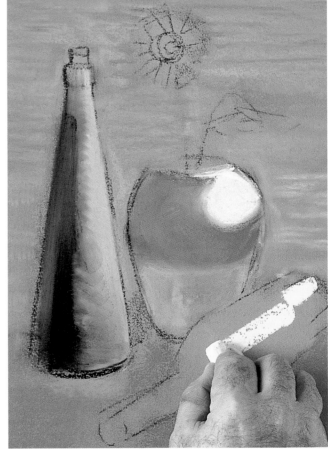

METAL AND GLASS **A MOTORCYCLE**

Metal and glass are often found side by side; a lamp, a clock, or a car are all composed of both elements. It is quite a challenge to paint them both in the same work. Metal must be rendered by using its color, and the reflections it produces. Glass is treated similarly but you also have to suggest its transparency or it will look just like metal.

The metal and glass on the front of this motorcycle have a challenging combination of reflections and textures.

NOTE
One of the fundamental ways to convey the characteristics of metal and glass is to realistically render both the reflections of objects and of light.

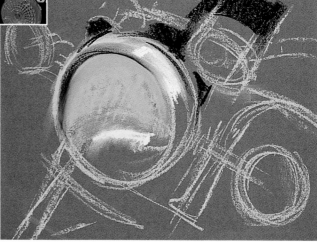

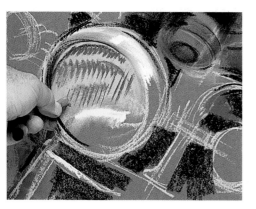

2. The body of the motorcycle and the background have been blocked in. Now the texture of the glass is suggested with some gray lines.

1. We use light-colored pastels over the sketch to block in the brightest areas of the motorcycle. Notice how we've distinguished the areas of chrome from those of the glass by using cool colors in the former and warm in the latter.

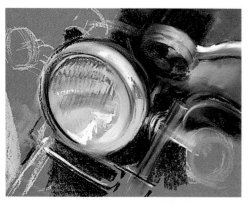

3. Some blue is applied over the warm tones of the headlight to indicate the metal behind the glass. The body of the machine is painted at the same time.

5. You can appreciate how the various reflections of light have been combined with reflections of objects.

4. The rest of the glass and chrome is developed in the same way. The forms are drawn, then reflections added over the base layers.

RUSTED METAL PITCHER AND JUGS

Polished metal always gives off a cold, hard feeling that is easily conveyed through the reflections it produces, but the character of rusted metal is quite different and calls for a different treatment. You will have to use color, blending, and the stroke to evoke the rough texture and the weight of the old metal.

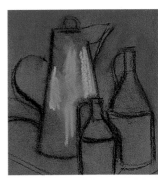

This group of a pitcher and jugs, all rusted to different shades of brown, do not reflect much light, but are still heavy, like other metal objects.

1. A paper is used with a color quite close to the general rust tone of the work. The background is painted and a mixture of pink and blue colors is applied.

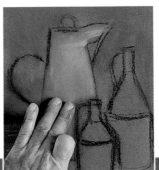

2. We blend the applied colors, allowing the color of the paper to bleed through the thin layer of paint.

5. In the finished exercise, you can see the wide range of hues used to suggest the colors of rust. Notice also how the semiblended paint conveys the texture of the rusty metal.

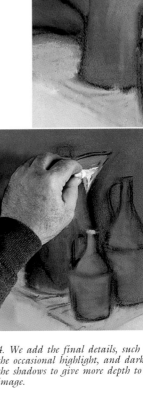

3. In fact, we blend slightly after each application of paint. The dominant color of the painting is actually that of the paper, which is shaded with tones that suggest rust's range of colors.

4. We add the final details, such as the occasional highlight, and darken the shadows to give more depth to the image.

NOTE

There are no specific colors of pastel paint to render metal and its distinctive characteristics so you have to rely on mixtures and the color of the paper.

GLASS

DIFFERENT KINDS

Realistically painting a colorless, transparent object like glass is one of the biggest challenges an artist faces. The only way to suggest glass is by rendering the reflections on it and the colors of the distorted objects seen through it.

Tinted glass allows you to define its form with its color but the shapes and colors visible through the transparent glass must still be rendered.

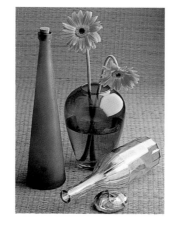

NOTE

When suggesting the transparency of glass, you have to consider the effect of its color or lack of color, as well as the distorted objects that are visible behind it.

Keep in mind, however, that the reflections on the glass are not transparent so nothing behind the reflections will be visible.

To paint this still life, we will have to paint the distinctive characteristics of each object, including the opacity of the triangular glass bottle and the transparency of the bottle lying on its side on the floor.

1. After filling in the background, we block in the bottles and begin to establish the different tones of each bottle.

2. Each object is developed differently, depending on its characteristics. The process for the opaque bottle is to paint in the reflections first and add the shadows later. For the vase, we reserve the area of reflection to paint later.

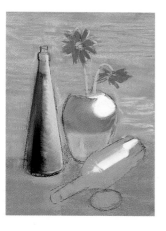

3. We paint the reflections of the vase and transparent bottle with white, allowing the white on the bottle to be tinged with green from the blue bottle.

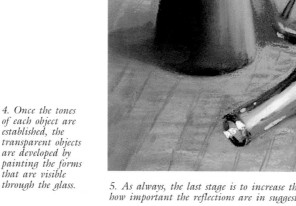

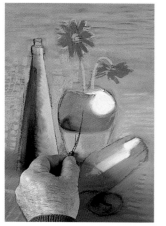

4. Once the tones of each object are established, the transparent objects are developed by painting the forms that are visible through the glass.

5. As always, the last stage is to increase the sense of volume and add detail. Notice how important the reflections are in suggesting the character of glass.

EVERYTHING YOU EVER WANTED TO KNOW ABOUT PASTELS

Topic Finder

Original title of the book in Spanish: *Todo sobre la técnica del Pastel.*

© Copyright Parramón Ediciones, S.A. 1997—World Rights
Published by Parramón Ediciones, S.A., Barcelona, Spain.
Author: Parramón's Editorial Team
Illustrators: Parramón's Editorial Team

© Copyright of the English version 1998 by
Barron's Educational Series, Inc.

All inquiries should be addressed to:
Barron's Educational Series, Inc.
250 Wireless Boulevard
Hauppauge, New York 11788

International Standard Book No. 0-7641-5105-1

Library of Congress Catalog Card No. 98-20374

Library of Congress Cataloging-in-Publication Data

Todo sobre la técnica del pastel. English.
 All about techniques in pastel / [author, Parramón's Editorial
Team ; illustrators, Parramón's Editorial Team].
 p. cm.
 ISBN 0-7641-5106-1
 1. Pastel drawing—Technique. I. Barron's Educational Series,
Inc. II. Parramón Ediciones. Editorial Team. III. Title.
NC880.T635 1998
741.2'35—dc21 98-20374
 CIP

Printed in Spain
9 8 7 6